"I fee~~l humble, almost insignificant, faced with the~~ dignity and the courage of the writer and journalist Roberto Saviano, the man who has mastered the art of living"
JOSÉ SARAMAGO

"We must thank Roberto Saviano for having returned to literature the ab~~il~~ity to open eyes and minds"
MARIO VARGAS LLOSA

perceptive and sympathetic critic and reader . . . Saviano writes very ? . . . what he has to say demands to be read. Like Primo Levi, his ~~testi~~mony pricks our conscience, tests our resolve, makes us examine ~~ours~~elves . . . At once deeply disturbing and illuminating"
ALAN TAYLOR, *Scottish Sunday Herald*

~~H~~e is determined to show the Camorra that he will not be silenced ~~by~~ their threats – this book is his 'sod 'em' to their Gomorrah . . . It is ~~go~~od to be reminded of the raw bravery of the Savianos of this world ~~an~~d to salute them for the sacrifices they have made in their challenges ~~to~~ power"
DUNCAN CAMPBELL, *Guardian*

'He never pulls his punches, his message is incredibly important, and the ~~f~~acts he includes – such as the increase in cancer rates due to the illegal ~~d~~umping of toxic waste – are like bombshells"
TOBIAS JONES, *Sunday Times*

~~i~~n *Beauty and the Inferno* – the title referring to the freedoms ~~. . . t~~he hell that seems to have become the norm' ~~. . . a~~n of bravery and an expression of rage ~~. . . WHIT~~EHEAD, *Times Literary Supplement*

~~wr~~ites: 'I do not care about ~~. . . o~~f our times. I ~~. . . t~~hieves

ROBERTO SAVIANO was born in Naples in 1979. As a journalist he writes for *La Repubblica* and *L'Espresso*, as well as for many newspapers around the world. After the publication of *Gomorrah* (now translated into forty languages) and its subsequent film adaptation he received several death threats, obliging the Italian government to provide him with 24-hour protection. He has been living in hiding since 2006. In 2011 he was awarded the PEN/Pinter Prize.

OONAGH STRANSKY is the translator of works by Carlo Lucarelli and Giuseppe Pontiggia.

ALSO BY ROBERTO SAVIANO
IN ENGLISH TRANSLATION

Gomorrah (2008)

Roberto Saviano

BEAUTY &
THE INFERNO

Essays

Translated from the Italian by
Oonagh Stransky

MACLEHOSE PRESS
QUERCUS·LONDON

First published in the Italian language as *La Bellezza e L'Inferno*
by Arnoldo Mondadori Editore S.p.A., Milano, in 2009
First published in Great Britain in 2010 by MacLehose Press
This paperback edition published in 2012 by

MacLehose Press
an imprint of Quercus
55 Baker Street
7th Floor, South Block
London W1U 8EW

This book has been selected to receive financial assistance from
English PEN's Writers in Translation programme supported by Bloomberg.
English PEN exists to promote literature and its understanding, uphold
writers' freedoms around the world, campaign against the persecution
and imprisonment of writers for stating their views, and promote the
friendly co-operation of writers and free exchange of ideas.

ISBN 978 0 85705 010 6

2 4 6 8 10 9 7 5 3

Designed and typeset in Bembo by Patty Rennie
Printed and bound in Great Britain by Clays Ltd, St Ives plc

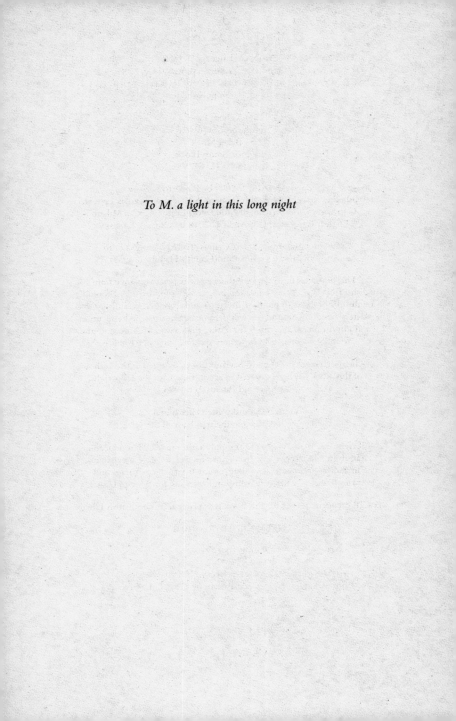

To M. a light in this long night

CONTENTS

BEAUTY & THE INFERNO

PREFACE

The Dangers of Reading

THE ACT OF WRITING HAS ALLOWED ME TO EXIST. ARTICLES, reports, stories, editorials – it's a line of work that has always been more than just a job for me. It has merged with my life. If anyone hoped that living under extreme circumstances would lead me to hide my words away, they were wrong. I have not hidden them and I have not lost them. Every day has been a struggle, it is true. A silent one-to-one combat. A kind of shadow boxing. Writing was the only thing that allowed me to survive. My words stopped me from losing myself. From giving up. From despair.

Over the past few years I have written from at least ten different apartments, none of which I inhabited for more than a few months. Most of them were small, some were minuscule, and all of them were infernally dark. I always wanted them to be lighter or more spacious, to have a terrace, or at least a balcony.

I wanted a balcony in the same way that I used to want to travel:

to see distant horizons. A chance to be outside, to breathe, to look around. But no-one would rent me an apartment with a balcony. And I had no choice in the matter. I have not been allowed to go out apartment-hunting on my own. I was never allowed to decide where I lived. And then, as soon as people found out that I was living on a certain street or in a particular building, I had to move.

I am not the first person to go through this, of course. I would visit an apartment that the *carabinieri* had selected and negotiated the terms for me, but as soon as the owner recognized me, he would say something like: "I really admire your work, but I can't get into trouble, I have so many problems as it is," or else: "If I was on my own, it wouldn't be a problem, but I have kids and a family, you see, and I have to think of their safety," or (the third and final variant): "I'd give it to you right away, and for nothing too, but the other people in the building would crucify me. You know, people here are scared."

And then there are the grave-robbers. They start off by siding with you – "Sure, I'll rent it to you, no problem" – and then they ask you for four times the usual rate. "I'm happy to put myself on the line for you, really, but you know how it is, it's so expensive here." These were the usual reactions, from people who did not want to take sides (in this case, mine), but there were also others – people I did not even know – who offered me refuge: a room, friendship, warmth. I have not always been able to accept their offers because of security concerns, but I always got some writing done in places that were filled with warmth and kindness.

Many pages among these pieces were not written in homes at all, but in hotels. I have been to so many in the last few years that they all look the same – and I hate them all equally. Dark rooms. Windows that don't open (sometimes no windows at all). No air. At night, you sweat. You turn on the air-conditioning so you can breathe, but then the sweat dries on your body and the next day it hurts to swallow. Abroad, when I travelled to one of those cities I had always dreamed of visiting, the only view I had was from my hotel room or the armoured car.

I am not allowed to go for a walk, even with bodyguards. Some-times I cannot stay in the same hotel for more than one night at a time. The calmer the place, the more civilized it is, the farther away it seems to be from crime and the Mafia; and the safer I feel, the more they treat me as though something might explode at any moment. They try to be nice about it, and they are well organized too. But you never really know if they are giving you the kid-glove treatment or if they are actually wearing bomb-disposal gloves. Are you a gift-wrapped present or a parcel bomb?

More often than not I have stayed in rooms in the *carabinieri* barracks. I smell the leather polish they use on their boots. I hear the football game on television. I notice how they curse when the other team scores a goal or when they have to go back to work. Saturdays, Sundays, every godforsaken day it's the same. I live in the hollow belly of a big old mechanical whale. Meanwhile, outside, people are on the move. You hear their voices. There is sunshine. It is summer

already. And you know that where you are . . . you know that if you could leave this place, you are only a few minutes away from the building where they once said, "Oh, you're going at last," and that only five or ten minutes down the road is the sea. But you cannot go there.

You can, however, write. You have to write. You have to and you want to. What you have to avoid is the cynicism that is the mark of many professional writers, barely concealing a disdain for anything that does not have a specific goal or plan. And equally there is the detachment of the writer whose aim is only to turn out a good book, to construct a story, to polish his words until they have achieved an elegant and recognizable style. Is that what a writer does? Is that what turns a text into literature? As far as I am concerned, if that is the case, I would rather not write. I have no wish to be like them.

Cynics feel the need to destroy everything that is wanted or desired. Cynicism is the camouflage that desperate people unwittingly wear. Cynics see everything in terms of sly manipulation leading to self-improvement, they treat people who want to bring about change as jejune young witch doctors, and they attack the ambition to write for a popular audience as a form of posturing fit only for a talking head. Nothing can be taken away from them, they with their constant sneers, because they know that everything will end badly anyway, and because they recognize nothing worth fighting for. They will never be chased out of their homes, homes that are often decorated with much thought and taste. Their art and their

ideas about language resemble their homes, and they never want to abandon the boundaries of these well-furnished spaces. Safe within their privileged disillusionment and well-cushioned lifestyles they can have no idea of what the business of writing really means.

Writing has become a way for me to express the pain that I felt early on, when the swirls of accusation and defamation increased in tandem with the sales of my book. At first, when the usual zealots wrote about my commercial success, I gave myself ulcers from the fury.

"He's written another one." "I am going literally to rewrite his articles." "I can prove he's a liar." "At twenty-six, you play soccer, you don't write like this." "He's a Latin lover." "He's a junkie in hippy garb." "He's some politician's puppet." "I made him who he is and, believe me, I know all his weaknesses." "That man's just after money and fame." Today, when I re-read these idiotic comments made by people who either craved publicity or were simply bitter, I feel like laughing. I have collected them in a sort of "stupidary", which I would recommend everyone keeps, especially anyone who comes from a South like my South, where you have to sell your soul and castrate your dreams simply to earn the right to breathe.

In my stupidary I have a space for the letters I received from lawyers of so-called friends or relatives of someone I wrote about, in which they say, in so many words: pay up or we'll accuse you of lying or plagiarism or else we'll get the press onto you and "the media will kill you". Reactions like this made plain to me just how much of a

nightmare I had become for people like that. People who thought they could control my stories. But my readers had already taken my words and turned them into instruments for change. They became *everyone's stories*.

The whole experience seemed unreal to me. Then, one day, when we were at the Swedish Academy, Salman Rushdie said to me: "The dead – that is, those people who have to prostitute themselves or water down their principles to write, people for whom your very existence means that an individual may behave differently – do not love life. You cannot have any idea how much you upset those people".

Over time I have come to appreciate just how much I upset those people. They detest my way of writing, being and appearing. They would like me to disappear. They want me to be more discreet. They would much rather I did not lecture at universities or appear on prime-time television. They would much rather that there were only escapism and entertainment on their screens, so they could have the monopoly on seriousness. Over time, I have learned to measure the value of my words by the enemies they make me. When someone tells me that I have been attacked in certain newspapers, by such and such a person, or on a particular television show, I know that I have done well. I know that the more people try to shut me up, the more fear my words inspire. The more drivel spouted by hot-and-bothered intellectuals, the more penetrating are my barbs.

All of this really does make me appreciate those who read me

without resorting to insult and slander, fabrications and lies. Only a loyal critic can help me grow and improve. The totalitarian mindset that lies behind the cynicism of certain media channels is my worst enemy, and it is also an ally (often without being conscious of it) of criminal power. If you are trying to show that everyone is dirty, everything is rotten, and that behind every attempt at change is a hidden lie or agenda, then one thing equals another and everything is fair and possible. This attitude is the means whereby people are "honestly" corrupted, to accept compromises, to retreat, somehow to survive the everyday pornography of seeing terrible things at close quarters, even getting pleasure from them. Everything can be justified by the belief that things have always been like this, everybody does it – or, worse still, there is no possible way out.

For me, the act of writing is the opposite of all this. It is itself a way out. It is a way of inscribing my words on the world, of passing them on like a clandestine message; one of those notes you have to read, memorize and destroy: chew it up, let your saliva break it down, so the message is properly digested. Writing is a form of resistance; writing *is* resisting. "Resistance and Resisting", Enzo Biagi's television interview with me, was built around this idea.

My work over the past few years has also allowed me to meet people I will never forget. Enzo Biagi, for instance. I had the chance to meet him and to have him focus his attention on me. I witnessed first-hand how this old man still made the effort to understand for himself our era and our country by asking questions of others. It is

not enough that I bade him farewell at his funeral or wrote a page or two about him after his death. We need to pay attention to him now, to keep him with us a little longer. This is what words can accomplish when they are brought together in a book, united in the name of something that lasts.

And then there was Miriam Makeba, the great "Mama Africa", whose voice sang for the freedom of her continent and who died in Castel Volturno after a concert she gave in memory of six brothers who were killed by the Camorra. She came to express her solidarity with me, although we had never met, even though she did not even know the name of my enemy. She was not well, but she came any-way. The woman who once filled whole stadiums sang for a small group of us. And she died in my land, which by extension also became hers. From now on, the struggle for that land, which is my own struggle and the struggle of anyone who chooses to make it theirs, will carry the name of Miriam Makeba on its invisible flag.

I was escorted into the Barcelona stadium by Mossos, the Catalan special forces unit. At first they insisted that I watch the match from a bulletproof glass cube, but eventually they were moved to compassion and spared me that grotesque form of imprisonment.

At the stadium I met Lionel Messi, Barça's Argentine forward, the boy who perfectly succeeded in recreating Diego Armando Maradona's famous goal. Messi's baby face reveals no hint of the

suffering he experienced from years of daily hormone injections, which helped him grow into a champion, one of the greatest players of our time. His nickname is still "the Flea".

Despite his prodigious talent, it seemed impossible that Messi would ever be able to compete alongside the titans of the game. But even football can be a kind of resistance, an art form that can come alive in every new centimetre of elongated bone and in every strip of flesh grown around it. If I could have one wish – and if this were a fairy tale – it would be that my pages resemble the way Lionel Messi runs towards his opponent's goal, faster and faster, the ball glued to his foot all the way. He would not have to score. He could pass it to one of his teammates. Because it is not the goal that counts. It is the forward movement. The dribbling, the feinting, never losing control of the ball.

Unlike Messi, I have to glance over my shoulder now and then. And that is how I know for whom this book is not written. I know it will not be read by all the people I grew up with, people who are happy enough just to get by, who spend their time sitting at the bar and cursing, day in, day out. It is not written for those who are resigned to keeping things the way they are, or for lazy cynics. For those who are content to spend an evening at the *festa di paese* or at the local pizzeria. For those who are still there after all these years, swapping girlfriends, choosing from the ones left over as if they were a pair of old shoes in a dusty box at the back of the wardrobe. For those who believe that becoming an adult means hitching up to the

failures of another, rather than joining forces in a shared challenge. This book is not directed to them.

Naturally, we know for whom we write, but we also know for whom we do not write. I am not writing for them. I am not writing for people in whom I recognize nothing of myself, nor am I writing letters to a past I cannot and no longer want to reconnect with. I know that if I look over my shoulder I risk ending up like Lot's wife, turned into a pillar of salt when she gazed upon the destruction of Sodom and Gomorrah. That is what pain does when it is senseless and has no outlet: it petrifies you. Your tears — especially those you cannot shed — run into your bitterness and hatred, forming small crystals that in turn become a fatal trap. That's why, when I glance over my shoulder, the only thing left in which I recognize part of myself and that manages to trace my perimeter and path like the chalk outline of a living and breathing body, are my words. For this reason I have chosen to include here a few pieces written before *Gomorrah*, as a gift to those for whom this book is meant.

This book is dedicated to my readers. It goes out to those who absorbed my words, who passed them on to friends and family, who used my book in schools. To those who gathered in piazzas across Italy to read aloud from it, proving that my story had become everyone's story, because my words had made it so. This collection goes out to all these people, without whom I am not sure I would have been able to carry on, to write, and therefore to resist, to exist, to think about the future. My readers reminded me that my life in a

bulletproof bubble is, after all, still a life. Without them I would never have received so much attention. I would never have made it on to the front pages or on to prime-time television. If I had not had so many readers who did something to my book – making it more than an object to put back on the shelf after reading – none of this would have been granted to me. And if I became a media sensation, it is thanks to my readers.

I have, over the years, come to realize the value of the media. When you take away the emptiness, the gossip, and the background dramas, which do nothing but distract and entertain people, and when there is the desire and will of people to learn and to bring about change, why cannot the media – the many mediums available to us – be used to unite those forces? Why are we so suspicious and afraid of it?

But I understand the fear. It reminds me of something strange, and difficult to explain. In all of my interviews, in every country where my book was published, I am invariably asked, "Aren't you afraid?" The question obviously refers to the fact that I might be murdered. "No," I reply, and stop there. Later I wonder how many people believed me. But it is true. I had – and still have – a lot of fears, but I rarely feel the fear of dying.

My worst fear – and it constantly returns – is that they will manage to ruin me, to destroy my credibility and drag my name through the mud. They did it with everyone who tried to denounce them. They did it with Don Peppino Diana, the priest they

murdered. They smeared his reputation the day after he died. They did it to the union leader Federico Del Prete, who was massacred in Casal di Principe in 2002 and slandered on the day of his funeral. They did it to Salvatore Nuvoletta, a *carabiniere* who was only twenty years old. He was murdered in 1982 in Maran, and was buried amid the busily circulated rumours that he was connected to the extremely powerful Camorra family.

I used to have another, more complicated fear: fear for my image. I was afraid that if I exposed myself too much – if I became too much of a celebrity – I would no longer be the person I wanted to be. Truman Capote once said something awful and true that comes to mind now and then: "We shed more tears for prayers that were answered than for those that go unanswered." If I ever had a dream, it was to carve out a space with my words, to show that literature can still have weight and change the world. In spite of everything that has happened to me, my wish has been granted, thanks to my readers. But I also became a different person to the one I imagined I would be. And this has been painful and difficult to accept. Then I realized that no-one chooses his destiny. You can, however, choose how to live your life. As far as I am concerned I want to do it in the best way possible, because I feel I owe it to the readers who have sustained me.

That is why, when they invite me to talk on television and I know that there will be a large audience, I try to do the best I can, allowing no polemics, sentimentality or simplifications. That is why

the contents of this book are not intended to be – and are not – homogeneous. My writings from the past have many voices and stem from a desire to explore things I am passionate about, as well as things I felt I had to write about. Seeing what was happening in Abruzzo after the earthquake, for example. Or continuing to follow criminal matters, especially those that are making some people rich while killing generations of others, as is happening with the toxic waste situation in my area. I am no longer afraid to use all kinds of media – television, the Internet, radio, films, theatre – because I believe that the media – used without cynicism or too-easy-cunning – is exactly what the name suggests: the means whereby we may break through a blanket of indifference and amplify the voices that should be heard from on high.

The title of this book has a very simple meaning. It reminds us, on the one hand, of the freedoms and the beauty that are vital for the living writer, and on the other hand of their opposite, their negation: the hell that seems to have become the norm. In one of his most important books, *The Rebel*, Albert Camus (a writer whose work I adore) tells the story of a German lieutenant who ends up in a work camp in Siberia where "cold and hunger were almost unbearable". Camus tells us how he "constructed himself a silent piano with wooden keys. In the most abject misery, perpetually surrounded by a ragged mob, he composed a strange music audible to him alone." Camus then explains that "for us who have been thrown into hell, mysterious melodies and the torturing images of a vanquished beauty

will always bring us, in the midst of crime and folly, the echo of that harmonious insurrection which bears witness, throughout the centuries, to the greatness of humanity." And right afterwards, he adds a little sentence that does not seem very important to the writer. For me, however, it has taken on a special meaning because it reminds me of the unforgettable words of a man – Giovanni Falcone – who said that the Mafia is a human phenomenon and, like all human phenomena, it has a beginning and will have an end. Camus said: "But hell can endure for only a limited period and life will begin again one day."

This is what I, too, believe, hope, want and desire.

SOUTH

I

Letter to My Land

THE GUILTY PARTIES HAVE NAMES. THEY HAVE FACES. THEY even have souls. Well, maybe not souls. Guiseppe Setola, Alessandro Cirillo, Oreste Spagnuolo, Giovanni Letizia, Emilio Di Caterino and Pietro Vargas are all engaged in carrying out an extremely violent military strategy. They have been given the green light from fugitive bosses Michele Zagaria and Antonio Iovine, and they have made their base in the area surrounding Lake Patria. Among themselves they probably feel like renegades, warriors, eager to make people pay, ready to claim vengeance in one of the most wretched and ferocious regions of Europe. At any rate, that is probably how they see things.

But Guiseppe Setola, Alessandro Cirillo, Oreste Spagnuolo, Giovanni Letizia, Emilio Di Caterino and Pietro Vargas are actually cowards: they are killers with no military training. When they have to kill someone they simply open fire on them. They pump themselves up with cocaine, gorge themselves on Fernet Branca and

vodka. They kill unarmed people, catch them off guard or shoot them in the back. They have never faced anyone armed. That would frighten them. It makes them feel tough to shoot down defenceless men. Their victims are often elderly or else very young. They trick them, then shoot them in the back.

It makes me wonder: here is a group of killers freely roaming around your land – our land – and massacring mainly innocent people. There are five or six of them, and they are always the same ones. How can this be? It makes me wonder: how does this country see itself? How does it imagine itself? How do you think of this country? How do you feel about yourself when you go to work, take a walk, make love? Do you even bother to ask yourself or do you just say, "It has always been this way and it always will be this way"?

Can you really believe that none of this depends on you, or on your want of indignation? Do you really think that worrying about your everyday life is enough? Are you satisfied by the answers to these questions? Does saying, "I'm not doing anything wrong; I'm an honest person," allow you to feel innocent? Can you let the news wash over you, over your soul? It has always been this way, hasn't it? Or maybe you hand over the task of making accusations to various organizations – the Church, militants, journalists and others? Does that make you feel better? Reassured enough to go to sleep at night? Perhaps not happy, but at least at peace with the world? Is that really enough for you?

This wild bunch has killed mainly innocent people. In any other

country, the knowledge that killers like this are at large would have generated debate, political meetings, deep reflection. But here we simply think of them as a group of criminals operating in the arse-end of Italy. The magistrates, *carabinieri*, police, and the four journalists that are following the story are entirely on their own. People in the rest of the country – even those who read newspapers – have no idea that the killers always use the same trick: they pretend to be police-men. They have cherry tops and batons. They say they are from the Direzione Investigativa Antimafia (D.I.A.) or that they are doing a routine paperwork check. It's a cheap trick that lets them kill more easily. And they live like animals: in sheds, remote areas, garages.

They have killed sixteen people so far. The murders began on May 2, 2008 at around 6:00 in the morning at a cattle farm near Cancello Arnone. They killed the father of Domenico Bidognetti, an informer, cousin and ex-right-hand man of Cicciotto 'e Mezzanotte. Umberto Bidognetti was sixty-nine years old. Domenico's son usually helped him with the farm work, but could not get up that morning to help his grandfather.

On May 15 in Baia Verde, a hamlet near Castel Volturno, they killed Domenico Novello, the sixty-five-year-old owner of a driving school. Eight years earlier, Domenico Novello had fought back against the racket. He had been under police protection, but the term of his protection had expired. He did not know he was being watched. He had no idea it was coming. They shot him twenty times. He was in his Fiat Panda and had stopped for a coffee on his way to

open the driving school. His execution was meant to send a message to the police who had intended to honour him at Casal di Principe three days later. It was also a statement: ten years can go by, but the Casalesi never forget.

A few days before, on May 13, they set fire to a mattress factory owned by Pietro Russo in the town of Santa Maria Capua Vetere. He was the only one of their targets who had an escort. He was the only one who attempted, together with Tano Grasso, to try and stop the racket in the Casalese territory. Then, on May 30, in Villarica, they shot Francesca Carrino in the stomach. She was twenty-five years old, the granddaughter of Anna Carrino, the ex-companion of Francesco Bidognetti, and also an informer. At home with her mother and grandmother, she was murdered because she was the one who opened the door to the killers, who claimed to be D.I.A. agents.

Less than a day later, in Casal di Principe, Michele Orsi, a businessman in the waste industry who had connections with the clan, was shot on his way to the Roxy Bar after lunch. The year before he had been arrested and had started collaborating with the magistrates, revealing information about the connection between politicians, the Camorra and the waste industry. His murder was exceptional in that it had an effect and even got State representatives involved, but it did not stop the killers.

On July 11 they killed Raffaelle Granata at the beach resort he owned, La Fiorente di Varcaturo. He was sixty years old and the father of the mayor of Calvizzano. He, too, paid a high price for not bending

to the will of the clan. On August 4 Ziber Dani and Arthur Kazani were murdered while sitting at a table at the Kubano Bar in Castel Volturno, and on the 21st, Ramis Doda was killed at the Freedom Bar in San Marcellino. These last two victims were Albanians who tried to augment their wages by selling drugs, but they also had residence permits and worked on various constructions sites as builders and painters.

On August 18 the Casalesi opened fire indiscriminately on the home of Teddy Egonwman, the president of the Nigerian Association in Campania, seriously wounding him, his wife Alice and three of their friends.

The Casalesi reappeared in San Marcellino on September 12 to kill Antonio Ciardullo and Ernesto Fabozzi while they were working on one of several trucks owned by Ciardullo. He, too, had not obeyed the clan. Whoever happened to be standing next to them was murdered too because they were witnesses.

Finally, on September 18, they opened fire on Antonio Celiento, the owner of a gaming hall in Baia Verde. Fifteen minutes later they fired 130 bullets from a handgun and a Kalashnikov at some Africans gathered in and around a clothing store, Ob Ob Exotic Fashion, in Castel Volturno. They killed twenty-six-year-old Samuel Kwaku and Alak Ababa, both from Togo; Cristopher Adams and Alex Geemes, both twenty-eight and Liberian; Kwame Yulius Francis, thirty-one, and Eric Yeboah, twenty-five, from Ghana; Joseph Ayimbora, thirty-four, from Ghana, was seriously wounded. Only one, possibly two of

them had anything to do with drugs. The others were there by chance. They worked on construction sites and wherever else they could find jobs, including the clothing shop.

Sixteen victims in less than six months. Any other democratic country would have taken action. Here, in Italy, nobody said a word. No-one even knew – in Rome and all points north – about this trail of blood, this brand of terrorism that does not speak Arabic, that does not wear a five-pointed star, but that commands and dominates without any resistance.

They kill whoever fights back, whoever is in their sights, and they listen to no-one. The list of the dead could be much, much longer. And for months now, no mention has been made of this *paranza* of destruction. A *paranza* is a fleet of boats that go out fishing together, but this *paranza* catches humans in its nets. No-one even uttered the killers' names until the massacre at Castel Volturno.

And yet, it is the same men time and again. They use the same weapons, modifying them each time in order to deceive the police, which suggests they do not have many guns. They do not communicate with their families and they keep to themselves. Every so often someone sees them in the bar of a big town, stocking up on alcohol. And for six months they have been on the loose.

Castel Volturno, where most of the murders have taken place, is your typical city. But it's not a rundown neighbourhood, not a ghetto full of outcasts and the dispossessed, even though some parts of it look more like an African township than a seaside resort, which was

why it was originally built. Castel Volturno is where the Coppola family built the largest unauthorized housing complex in the world, the infamous Villaggio Coppola.

Eight hundred and sixty-three thousand square metres of cement. Erected with no concern for building codes or regulations on one of the largest maritime pine forests in the Mediterranean. The hospital was never sanctioned, the *carabinieri* station breaks every building code, even the post office flouts the regulations. Everything is illegal. N.A.T.O. families lived here until the Cold War ended, then it was totally abandoned and became one of the feudal holdings of Francesco Bidognetti. At the same time, it also came to be a stronghold for the Nigerian Mafia.

The Nigerians have a powerful Mafia, with whom the Casalesi family sensibly formed an alliance, as Nigeria has become a hub for international cocaine trafficking. The Nigerian clans are well organized, investing their resources in wire transfers of money, the same services that immigrants around the world use to send money home. This has granted the Nigerians control of both money and people. From Castel Volturno cocaine is shipped mainly to Britain. Therefore, the taxes that the Italian clan imposes on the drug trafficking are not just the icing on the cake, but in every respect a form of joint venture. The Nigerians, meanwhile, have grown even stronger. So have the Albanian Mafia, with whom the Casalesi also attempted to join forces.

Basically, the Italian clan is losing its shape. It is afraid of no longer

being recognized as the first and biggest family in the territory. And that is where the *paranza* comes in. They kill the little Albanian fish as a signal. They slaughter the Africans – though none of them actually came from Nigeria – and they wipe out the lower-ranking criminals and ethnic outsiders. Innocent young men end up dying, and as always seems to be the case in Italy, nobody asks why.

It also takes so little to be slandered. The African men who were killed were immediately labelled "traffickers", while Guiseppe Rovescio and Vincento Natale were called "Camorristi", simply because they were drinking a beer next to Francesco Galoppo, who was affiliated with the Bidognetti clan. They were instantly tagged as criminals.

These were, of course, not the first immigrants to have been massacred in Castel Volturno. In 1990 Augusto La Torre, the boss of Mondragone, drove to an Italian-owned bar that was a known meeting place for African dealers. The deals took place on the Domitiana motorway, in Pescopagano, a few kilometres north of Castel Volturno, in Mondragone territory. La Torre and his men killed six people, including the owner of the bar and his fourteen-year-old son, whose spinal cord was severed by a bullet. It was one of a series of attacks on foreigners, although the Casalesi family, who might have approved of the message, did not approve of the slaying. At the time, La Torre received heavy criticism from Francesco "Sandokan" Schiavone. But now things are different; a group of armed cokeheads can freely practise indiscriminate violence.

Again, I ask my country what image it has of itself. I ask the groups of men and women who work and fight here the same question. I ask those few politicians who remain honest and resist corruption by continuing to fight the clan. I ask those who work hard, who try and live honestly, as in every other part of the world. I ask them all. The more we are, the more we are alone.

How do you see Italy? If it is true, as the so-called "Gandhi of Sicily" Danilo Dolci said, that a child only grows if someone dreams for him, what do you dream for these places? Never has so much attention been paid to our land, to what has happened here and to what is happening here. But it has not changed a thing. Two bosses continue to rule freely: Antonio Iovine and Michele Zagaria. Twelve years on the run. People know where they are. Iovine is in San Cipriano d'Aversa. Zagaria is in Casapesenna. Why can't they find them? In an area no bigger than a handkerchief.

It is an old story: they search for years for the fugitives – only to find them in their own homes. But it is a new story when they keep talking about it on television and in the papers. When politicians of every stripe promise to arrest them. Time passes, nothing happens. They are still there. They take walks. They talk. They meet people.

A lot of graffiti about me has appeared in my land: *Saviano shit*; *Saviano the worm*; a drawing of an enormous coffin with my name on it. The insults, the continuous denigration, starting with the most frequent and banal: "He made tons of money." It's true. I am now able to live off my writing, and pay my lawyers. My good fortune.

What about Iovine and Zagaria? They run business empires. They have built themselves pharaonic palaces in towns where there aren't even paved roads. They said they would dispose of toxic waste, pocketing up to €500 million in one fell swoop, and then they stuffed our land so full of poisons that the rate of tumours has increased by 24 per cent, while congenital birth defects have gone up by 84 per cent. According to the epidemic reports in Campania alone, the money given to Iovine and Zagaria generates an average of 7,172 deaths from cancer each year. And they're worried about me, with my words, making money out of all the horrors of this land? They attack the very people who denounce what's going on: the *carabinieri*, the magistrates, the journalists, the film-makers and writers. How can reality get so twisted? How can honest people put up with this? Even though I know how things are in my country, when faced with this situation, I am so incredulous, disappointed, and wounded that it becomes hard to find my voice.

Pain leads to silence. Hostility breeds isolation. To whom can I turn? What do I say? How can I tell my land to stop being oppressed by the arrogance of the strong and the cowardice of the weak?

Today is my birthday. I am writing in a room like so many others have been in, where I am a guest of my protector. I think of all the birthdays I have spent – anxious, sad, alone – since being forced into hiding to live with a police escort.

I think about how I will never spend another normal birthday in Italy. How I can never go home. Like a terminally ill patient, I now

regret all the birthdays I once paid no attention to or snubbed because they were just a date, because I knew there would be another one the following year. A rupture in the time–space continuum has occurred. I have a wound that will never heal. I think about the others who live like me, but who do not have the privilege to write or speak about it as I do.

I think of Raffaele, Rosaria, Lirio, Tano. I think of Carmelina, the teacher in Mondragone who exposed a killer and who, ever since, has had to live far away, alone. Her fiancé left her, while her friends felt overwhelmed by her courage and their own mediocrity. There was no show of solidarity for her gesture, just criticism and abandonment. Carmelina simply followed her conscience, and she has had to survive on a meagre State salary ever since.

What did she do? What have these people done to be uprooted and to have their lives destroyed, while fugitive clan bosses continue to live like respectable individuals under complete protection on their own land? I ask my country: what do we do now? Tell me. Should we just carry on? Pretend everything is normal? Should we climb the hospital stairs that are washed down by clan-owned cleaning crews? Fill our tanks with the petrol that spills out of clan-owned pumps? Live in houses built with clan money? Drink the coffee the clan tells us to? (They decide which coffee brands are sold in bars.) Cook our meals in saucepans made by the clan? (The Tavoletta clan produces and sells the highest-quality brand of cookware.)

Should we eat their bread, their mozzarella, their vegetables?

Vote for their politicians, who (their informers tell us) go on to win the most important national seats? Should we work in their malls, which were built to create jobs, which in turn created loyalties, which were not that important since all the shops, and therefore all the profits, were theirs anyway? Are you proud to live in an area that boasts the largest mall in the world as well as the highest poverty index? Do you enjoy spending your time in places they run or own? Sitting next to their sons or their lawyers' sons, or their henchmen's sons? You might even say to yourself, "What a nice guy. He's not so bad. He's just a kid. He's not responsible for his father's actions."

In fact, it is not about who is guilty or innocent. It is about putting a stop to this blind acceptance and submission. People have to stop being content with the sense of order behind things, with the justification that at least there is work. They have to scratch the surface, tear the veil, and make their own road. If we all did it, our lives would change. We are already in the best possible world, or at least the only possible world.

How much longer do we have to wait? How much longer do we have to watch the best among us leave the country and see only the acquiescent remain? Are you certain that this is the way it should be? Are you sure that the evenings you spend courting, laughing, fighting, swearing at the smell of burning rubbish, or exchanging a few words, are enough for you? All you want is a normal life, a life made of small things. Yet there is a war going on around you and those who fight back lose everything. How did we get so blind? So servile, resigned,

bowed down? How is it that the Africans of Castel Volturno, the weakest of them all, who are violently taken advantage of by both the Italian clans and other African mafias, knew how to respond with more anger than fear? Personally, I cannot believe that a South as rich in talent as ours can be content with the way things are.

Calabria has the lowest G.D.P. in Italy, but "Cosa Nuova", also known as the 'Ndrangheta, makes more than an entire Italian financial institution. Alitalia might be going bankrupt, but in Grazzanise, an area filthy with Camorra, they are about to build the biggest Italian airport, actually the biggest in the Mediterranean. This land, which is used to circulate enormous capital, never shows any hint of real development. Money, profit and the cement smell of destruction, but never growth.

I cannot believe that only a few exceptional individuals fight back. Or that only priests, teachers, doctors and a handful of honest politicians, plus some groups that understand the role of civilized society, are prompted to expose the truth. What about everyone else? They sit quietly by, stunned by fear into silence. Fear. The biggest alibi of them all. Fear makes everyone feel safe. It governs your family, your affections, your own sacrosanct right to build your life and live.

It would not be hard to stop being afraid. We just have to act, but together. Fear and isolation go hand in hand. Every time someone retreats, more fear is created, which only adds to the existing fear, which grows exponentially; immobilizing, eroding and slowly creating ruin.

"Can we build the happiness of the world on the tears of a single mistreated child?" Ivan Karamazov asks his brother, Alyosha. But you're not asking for a perfect world. You just want a simple, happy life, an acceptable quotidian existence, the warmth of a family. You think that being content will protect you from anxiety and pain. Maybe you are right, maybe you find serenity. But at what price?

If your children are born with an illness or if they become ill; if you have to turn to a politician yet again for a favour in exchange for your vote, so that your little dreams will not fall apart; if you have to struggle to obtain a mortgage, while the bank's directors bend to the will of some shadowy organization; if you see all of this go on around you, maybe you will begin to realize that there is no safe haven. There is no protection. And your attitude, which you once thought so realistic and wisely jaded, has made your soul so resentful and bitter that there is no joy left in life. If that sounds sad, think about it as a habitual way of life. People get used to the idea of giving up, or of managing with things the way they are, or of leaving.

I ask my country if it can imagine choosing. I ask if it is capable of exhibiting the first sign of freedom: thinking you are different, that you are free. Not giving up and accepting what other men have created as your natural destiny.

Those men can tear you away from your land and your past. They can take away your peace of mind. They can stop you from finding a home, scribble insults about you on the walls of your town. They can isolate you. But they cannot eradicate that which remains a

certainty and which consequently is a hope: that it is not fair or natural to keep down a region using violence and exploitation. Things cannot go on like this simply because they always have. And that is not even true: things have changed. They have got worse.

The devastation has grown in proportion to the growth of their business, and it is irreversible, like the damage inflicted on the planet, because they do not know where to draw the line. Six ugly and ruthless murderers are out there with a licence to kill. They will stop at nothing. Today, they have made the world in their image. They will make it again tomorrow and all the days after that. We need to find the strength to change. It is now or never.

2

Miriam Makeba:
The Anger of the Brotherhood

"WHAT ARE THE BLUES?" THE AFRICAN-AMERICAN WRITER
Ralph Ellison once asked. The blues are what blacks have instead of
freedom.

What he said came to mind when I heard that Miriam Makeba
had died. Mama Africa was, for a long time, what South Africans had
instead of freedom: she was their voice. In 1963 she took her story to
the Anti-Apartheid Committee at the United Nations. In response,
the South African government banned her music and condemned
her to exile. For thirty years.

From that moment on, her biography reflects a life of social and
political battles, an itinerant life, like the life of her outlawed music.

When they searched the homes of militant members of Nelson
Mandela's party, her records were sequestered, proof of subversive
activities. The sound of her voice could get you stopped by the white

South African police. But the power of her voice also granted her universal citizenship: thanks to her, South Africa became everyone's country. And even more significantly, the hell of apartheid became everyone's hell.

Not long after landing on the shores of the United States in the 1960s she fell in love with Stokely Carmichael, the leader of the Black Panthers, prompting the American music industry immediately to cancel her recording contracts. They knew Mama Africa fought militant politics with her voice and that scared some people. But her music reached people anyway. She had international hits, like "Pata Pata", which everyone danced to and loved. She exploded onto the scene with such force that the apartheid government and racists all over the world had no idea how to contain or fight her.

At the age of seventy-six she came here, to this godforsaken place, to sing. A group of conscientious people had organized a concert in an effort to bring dignity to a region that has been brought to its knees. And just the other evening Checco, one of the organizers, called me to tell me that la Signora was not feeling well, but that "she wants to sing anyway, and she wants the English version of your book in her changing room – she's tough, Rob!"

Originally, when they told me Miriam Makeba had agreed to come to Castel Volturno to sing at a concert for me, a concert for which they had decided to close all the schools in the South, I simply could not believe it. But the woman who had fought so hard, who had travelled around Africa and the rest of the world, absolutely

wanted to come here to this place where almost two months earlier six Africans had been massacred. And they were Africans to her – they were not citizens of Ghana or the Ivory Coast or Togo. She believed in Patrice Lumumba's vision of pan-Africanism that today, now more than ever, seems to have vanished.

Mama Africa sang only a few metres from the spot where they killed Domenico Noviello, an innocent businessman from the area; a man who died alone, who had no interest in collective action, no thought of revolution, no belief in universal brotherhood. The death of Miriam Makeba, during the concert, she who came here to show solidarity for me and for the Italian and African communities working to resist the power of the clans, brought me a sadness that was as immense as my amazement at the show of support and strength that South Africa has expressed to me in recent months through Archbishop Desmond Tutu. Thanks to their life stories, people like Tutu and Makeba know better than anyone else that when the eyes of the world are upon you, when you get the right attention and assurances from people, when people feel committed, problems can be solved, even if they are happening on the other side of the world. But if you isolate yourself or do not care, or ignore what's going on, nothing will happen.

These days South Africa is home to some of the world's most powerful criminal cartels, but the country's intellectuals and artists continue to be vigilant, vital and combative. Desmond Tutu himself called South Africa "the rainbow nation" embodying the dream that

one day the country would embrace all colours and classes, that there would be much more than a simple reversal of the blacks vis-à-vis the whites. Miriam Makeba was – and remains – the voice of that dream. If there is to be any consolation in her death it is that she did not die far from home. She was nearby, close to her people, Africans of the diaspora who come here by the thousands; people who have worked together, lived together, slept together, surviving in the abandoned buildings of Villaggio Coppola, creating their own reality, the Soweto of Italy. She died trying to bring down another township with only the power of her voice. Miriam Makeba may not have died in geographical Africa, but she died in the Africa transported here by her people, which has mingled with our earth and which some months ago taught people the dignity of anger. And, I dare to hope, the dignity of brotherhood.

3

From Scampia to Cannes

THEY FAILED TOTO AND SIMONE, THE TWO ACTORS WHO appeared in both the stage and film versions of *Gomorrah*. President Napolitano, who went to see them on the first night of the play's run, shook hands with the whole cast, one by one, and complimented them on their work. The president even let a nervous Pulcinella paint his face black during the performance. At the Cannes Film Festival, the international film festival that matters most, they were awarded one of the three most important prizes: the Grand Prix of the Jury. But the teachers at the Carlo Levi Middle School in Scampia chose to fail the boys anyway.

I travel with the boys and the rest of the troupe to Cannes. Matteo Garrone, the director, drives up from Rome in a van. The flight we are on echoes with the shouts and laughter of Toto, Simone, Marco and Ciro. Everyone is excited – the hairdressers, the costume artists and the crew – and nervous, both for the flight and for the days ahead. When we land, we split up and go our separate ways.

Waiting for me on the tarmac are the men from the French special services, two bulletproof cars and three motorcycles. I have never seen anything like it. Right away they let me know that they do not usually accompany film stars or divas. "Private companies do that, not us," the senior officer tells me with the help of another agent who translates for him in an odd Neapolitan dialect tinged with a French accent. "I learned Italian from the music of Pino Daniele," he says in explanation, adding that he had been an interpreter also for Vincenzo Mazzarella, a Camorra boss from San Giovanni di Teduccio who was arrested in Cannes not long ago. They are also quick to let me know that the Mafia love Cannes. In fact, my bodyguards seem a little on edge.

Luigi Facchineri, a boss of the 'Ndrangheta, lived in Cannes from 1987 until his arrest in 2002. The Mafia has investments in the major hotels, beach resorts and restaurants of the city, and also provides enough cocaine for all the holiday makers, tourists and Festival people who now swarm along La Croisette.

Lined up on the pavements outside the hotels are hundreds of people, cameras, mobile phones and camcorders in hand. But they are interested only in the Americans. Catherine Deneuve walks by, then Kusturica – a few cameras click and whirr. Little interest. If any Hollywood stars are following them, the masses urge them on as if to say, "Get out of the way! Move on! I want to get a shot of the star – but not with you in it."

When the Festival cars drive up, the people press their noses

against the glass to see who is inside. If they don't see Johnny Depp, Tom Cruise or Angelina Jolie they look crestfallen, and insult whoever it is inside. They humiliate Asian or European actors, saying things like, "Oh, it's no-one." Toni Servillo laughs it off elegantly and even announces to the camera-toting public, "We're no-one, don't bother, but Indiana Jones is on his way." In fact, the not-American actors are frequently upset about it. No-one seems to care a hoot for them. They are a second-ranking, supporting cast. European actors are approachable. They are made of flesh and blood. They wear clothes and perfume. They work just like everyone else. Hollywood stars, on the other hand, are genuine heroes. The critics and the public care about what they do and what they say. No-one wants to hazard a guess at how much they earn. No-one imagines for a moment that a flop or a blockbuster hit could mar a talent that can always be resurrected. They can do anything they want. They are beyond good and evil. And this power of theirs casts a spell on everyone in Cannes, from the toughest critic to the tourists with digital cameras taking a hundred pictures every few seconds.

As we arrive, Indiana Jones is all that anyone minds about. I see him up close. Harrison Ford is shorter than I imagined; a puffy older man, and far from the image of the first Indiana Jones that I worshipped as a kid, in the sidecar with Sean Connery. He has a paunch. The contradiction between the immortal image of the hero and the mortal image of the actor, even as they compliment him on his latest success, leaves the fans with a strange aftertaste. People crowd around

him. He introduces himself as Indy. He's almost cute, like one of those Santa Clauses you can hire, who walk into someone's home with a big hearty "Merry Christmas, everyone!"

I wonder if I should be sad that Toto, Simone and the others were not there to see Indiana Jones in the flesh, or if it is actually better that way. Even though they missed him, even though it has been ages since they believed in Santa Claus, the *Gomorrah* kids are more fired up in Cannes than they probably ever were as children on Christmas Eve. After the press screening we receive our first huge round of applause. The conference is overflowing with people. I dedicate the film's success to Domenico Noviello, the businessman who was killed shortly before our coming to Cannes. Even though the film has been well received, I have to banish the thought that it all seems like a huge mistake. It is so absurd.

Outside, the secret service are waiting on their motorbikes. The agents are tense and yet at the same time always ready to tell me more stories about the worst criminals of the worst criminal organizations that have come to invest in the Côte d'Azur. And here I am, standing in front of the *crème de la crème* of international cinema critics, next to those who gave life to this film, including the children of Montesanto and Scampia. The most talkative one is Ciro, nicknamed Swee'pea by his uncle because he resembles the child that Popeye and Olive Oyl received as a package in the mail. He has a classic face; with his pale colouring and long nose he looks like someone from the seventeenth century, a Pulcinella or a saint in a Spanish master's

painting. Ciro works as a seller of fruit at the Pignasecca market in the historic centre of Naples. It's a tough job. He has to get up early every day, but he is happy. He has earned the respect of his mates and keeps out of trouble.

The journalists pound him with questions. "What would you do if you weren't a fruit seller?" He replies drily: "I'd be a barman." "Alright, but if you weren't a barman?" He understands what they are getting at. "No way! I'd never join the Camorra. Apart from the money, it's a terrible life. My mother is still crying because she saw me get killed in the film. Just imagine how much worse it would be if it happened in real life!"

He gets a big round of applause.

Ciro and Marco – who are older than the other two – come from the poor neighbourhoods of central Naples. Toto and Simone are from Scampia, so for them life has been a little easier: their family situations, while not idyllic, are less difficult than the older boys'. For the younger children, the play, based on both Aristophanes and Alfred Jarry, and then the film, and now this trip to the Cannes Film Festival, were not supposed to be simply a holiday from a life that even at the age of twelve or thirteen had already been mapped out for them. No, this was their opportunity to see what it felt like to step into a different world, or at the least to imagine the possibility of its existence. As Danilo Dolci says in his most beautiful poem:

There are those who teach
by leading people like horses
each step of the way:
and there are those who like
to be guided like that.
There are those who teach by praising
the good and by having fun:
and some people enjoy
this kind of support.
And then there are those
who educate without hiding
the absurdities of the world, open
to change yet sincere
with others as with themselves,
who dream for others of a different life:
people only grow if dreamed for.

No-one ever dreamed of anything for these children. But even so, they did their best to show what they could do. They tried to show the world their qualities so that someone would dream of a different life for them than the one which had already been chosen for them. They are not model students. They cannot even sit still in their chairs and do their work. They answer the teacher with a grunt and a sneer. They egg on their mates to do terrible things. But that is just one side of them. The teachers who failed Toto and Simone

simply cannot accept that they did their best work out of school. What difference does it make to them if their worst pupils stand next to some film stars for two days, and are allowed to feel a little bit special?

At dinner, Ciro announces that now he is an actor and not just a fan, Monica Bellucci will not be able to ignore him. They are colleagues now. And besides, everyone from Montesanto to Pignasecca always told him that he looks like Vincent Cassel. The next day he happens to cross paths with Monica Bellucci. "You know," he says to her, "everyone says that I look exactly like your husband." And Monica kisses him. She praises his bravura as an actor and maybe even his resemblance to her man.

Being here with all of them has a strange effect on me. The city – which looks a lot like Riccione, only fancier, more rotten and more pretentious – is a total hole. But I like spending time with all these Neapolitan kids. I have not been able to do something like this in a very long time. Cannes is one big circus. The magic of this place is that even the most obscure film, the most arcane director and the most sophisticated actor can all be noticed, get an audience, get reviewed. The world of art films exists alongside blockbusters, radical directors stand side-by-side with the self-important and conservative ones; there are masters of the craft and documentarians, mediocre directors and big-budget screenwriters. Tiny producers rub shoulders with the big guys. Indiana Jones next to Manoel de Oliveira; Marjane Satrapi next to Nick Nolte. Everything exists in a precarious

balance. The dialectic benefits everyone and damages no-one. It is incredible. Everyone does their job: the most spectacular film attracts public attention and resources, as does the slowest and most complicated documentary.

This strange alchemy is composed of precise ingredients. Everything at the Cannes Film Festival is exactly measured. This way, the organizers assure equal visibility to all, letting the box-office hits carry the more demanding films. The system allows the fat-cat films to be effectively ignored by the jury yet devoured by the public, while allowing the demanding ones to be weighed by the critics, and that in turn gets them attention from the media and, in due course, the public. It is a strange machine, but it works. The Festival manages to take advantage of the market, while promoting work that is not fuelled by the big advertising agencies.

In the morning I want to enjoy my breakfast in the main lobby of the sumptuous and historic Hotel Majestic, but the French agents hurry me through it. I order a glass of juice that costs a mind-boggling €20. A girl asks if she can sit down. The agents have to frisk her and I am embarrassed by it all, but since I do not speak a word of French I do not know how to excuse myself. She asks me about my book and various other things and then says, "If you're not too busy, I'd like to spend the day with you. All you have to do is pay my taxi fare back to Nice – €800." That's when I understand. "Did they move Nice to Corsica? Is that why it costs so much?" Later I ask a barman, who turns out to be from my part of the world, and he spells

it out for me: "All the girls you see in the main lobby are hookers." They look to me like the daughters of lazy, pot-bellied men, and the ones I saw seem a bit stoned. They come from all over. It is wretched to watch them sidle up to the men they probably think are the owners of a yacht waiting in the marina.

This is only the most obvious example of how you cannot find anything truly chic or elegant in Cannes. It is the same idiocy as everywhere else, only to an elevated degree. Cannes might seem like the most snobbish place in the world, but it is really one big village. You see the same people, the same python boots, the same tanned women outside any club in any European city. It's schizophrenic.

Marco starts whining. He misses Naples. Only two days away, but he is already homesick. After the official screening of the film they take us for dinner at a pizzeria called Vesuvius. Matteo Garrona, the director, sighs with exhaustion: "We tried so hard to avoid clichés and yet, in all of Cannes, where did we end up?" The whole evening I ask myself, "What am I doing here?" and "What's my role in all of this?"

The bodyguards accompany me into a reserved room where we all toast the film. Suddenly, I realize that I have not been in a situation like this for two years, and I freeze. I am not used to it. I turn to ice. I am a statue, not used to eating with anyone other than my bodyguards. The children are great, but they treat me as if I am their employer. I actually have very little to do with the film, but Marco does not believe me and proclaims, "The man who feeds me is my

father." I feel a strange sort of loneliness in the midst of their happiness, and especially with these kids who do not mind at all that they have ended up at Vesuvius. For them, the round of applause in the morning, and now the most recent one, confirms that they have accomplished something big, and in addition to being happy they are also rightly proud of their work.

On the flight back to Italy, again with the children, the noise level is even greater than on the way to Cannes. When Simone lights up a cigarette, the whole plane starts to panic – there's smoke, fire, oh God, something's burning! "*Mannamell' a casa*," he says carelessly to the hostess who tells him repeatedly that he is not allowed to smoke. *Send the fine to my house.* But they do not understand his Neapolitan. Afterwards, even though no-one else tries to light up, people are still nervous. It is a long one-and-a-half hours. Luckily, a steward knows how to handle them. "Aren't you guys film stars? And you're still behaving like this?" It seems to work.

A few days later I am in the apartment that they have chosen for me. It is hot. I have no shirt on. I am in my shorts, and I cannot go out. I have a bottle of Peroni beer in front of me. I get a telephone call from Tiziana at Fandango, the producers of the film. She is crying. There is a lot of noise in the background. I can barely hear her and then she hangs up. It appears that they have won something at Cannes. I did not understand which prize it was and later I looked on the Internet. "Was it worth it?" I ask. And then: "Maybe not for me, but for others, certainly." And I finish my beer.

The only time that the Festival fulfils my expectations of glamour and grandiosity is at the evening showing of the film. I have to wear a tie. Something I have never done. Not even when I graduated. Not even when I gave the Lectio Magistralis at Oxford. I do not know how to tie it. Xavier, the senior special agent, helps me, not without some embarrassment, because men do not tie each other's ties. I decide not to walk the red carpet, both because I do not want to and I do not have the right to – I am a writer, not an actor or director – they let me in through a side door. I expected a cinema; bigger maybe, maybe even huge, but a normal cinema. Instead, it's an ultra-modern version of an amphitheatre, with hundreds of people in front of the largest screen in the world.

When the film ends, the music of Massive Attack starts up. It is a piece I particularly like because one the group's members, Robert Del Naja, wrote it after reading *Gomorrah* and dedicated it to me. His father was born in Naples.

Then comes the applause. At first, a smattering. Mere hiccups in that immense space. Then slowly, like dominoes, all the rows begin to applaud. And it never stops. As soon as it slows down in one area, it picks up in another, infecting the whole theatre anew, like a wave rising and breaking.

After fifteen minutes of applause, all the children start to cry. The only one who does not is Toto. He holds back, his eyes bright, and he does not cry. I ask him, "Hey, are you crying?" And, always playing his part, he says, "Who, me? This clapping don't do nothing for me."

Maybe Toto understood something. Maybe he realized that nothing that happens in Cannes, in Hollywood, in a cinema or in a theatre in any part of the world, has anything to do with him. Only Scampia is real for him. The rest is fiction.

4

Fighting Evil with Art

WHEN FACED WITH IMAGES FROM THE DOCUMENTARIES AND films of Vittorio De Seta, a certain feeling pulls you in and compels you to look. It is an entirely new experience, highly visual and scarcely physical, at least at first. And it does not seem to affect any other senses either, or emotions. The first few minutes are all about sight. You have to adjust your vision accordingly, because what you see at first comes at you like a fistful of sand.

The images are different from those you usually see in documentaries. They are different from films. Different from action films or investigative reports or dramas. Different from the anonymous immobility of television programmes that try to cover everything. Something else is at work in De Seta's cinematography.

Vittorio De Seta is a great and much revered master of the documentary. But the term "documentary" seems reductive when applied to his art. De Seta never ignores beauty. The alchemy of his work

derives from his capacity to look simultaneously at the hell of mankind and at the wonders that flow out from its pulsating life. He never betrays either vision. Never gives in to mere information. Never relies solely on aesthetics. De Seta's success in the United States – and Martin Scorsese's love of his films – comes from his bicephalous vision: he is obsessed with authenticity, yet distracted by beauty. And this distraction is vital, because it generates continuity between the spectator and the film.

Watching a De Seta film you often wonder why you are not sobbing out loud. Why you do not have to blow your nose or cough at the end to mask your emotions. It is hard to understand why we keep it all inside. Gradually it becomes clear. You are so involved in every moment of the movie that there is no room for an emotional reaction. You stuff yourself with truth. You understand how people survive. You come to an understanding of how some people strip others of their dignity, the way a dog gnaws at a bone. You are one of the "Farmers of the Sea", one of "The Forgotten". While watching his films you cannot absent yourself from their reality.

What I have come to understand from this – or at least, what I feel – is that Vittorio De Seta is a master of method. He enters into his subjects not like some intellectual tourist eager to explore unknown lands, but like someone who chooses to talk about the things that are his alone. He speaks about things he has tasted, with both his experience and the gaps in his experience, with his gaze, with his bibliographies. His work is neither travel documentary nor

reportage. De Seta becomes part of the place. He is in it personally. He frequently quotes Mayakovsky: cinema is an athlete. It leaps, it runs, it stops in exhaustion. It catches its breath. It regains strength. It competes with reality, not in order to beat it, but to follow it. I have always tried to remain faithful to this image. I believe it is the same with writing, and I have tried to make it my own. You need to be able to distance yourself, to take leaps, to stop, and most of all to do battle, to fight without having to beat anyone, to trigger new movements, to make energy jump off the page, not shut itself in.

De Seta once told me that the journalist and historian Indro Montanelli (whom he considered to be "the person most responsible for Southern Italy's bad reputation") wrote that the criminals on the Supramonte of Sardinia should be firebombed. De Seta told me about it grimly: "I've always been in favour of athletic filmmaking. I run between history and reality. I react. I don't put up with anything and most of all I don't fool around with reality by pretending to be an intellectual with facile recipes, polemical statements and storytelling."

De Seta was always a committed director. Although his documentaries and his films are invariably cited separately, I cannot tell them apart. They have different methods, but the material he uses is the same. They are profoundly lived stories, a combination of investigation, reportage and narrative: they reveal how reality is creative and mixing genres is beneficial. And yet knowledge is essential – the *sine qua non* of mastering a story and having the right to tell it. Not just simple curiosity, but an understanding of its mechanism, followed

by the need to tell. When he filmed "Bandits of Orgosolo" (1961) De Seta spent nine months in Barbagia in order to understand that world, to know it and tell it. There is an urgency in his work, a determination not to separate knowledge from the story. He did the same thing when he filmed "Diary of a Master" (1973), going to live in the neighbourhood of Pietralata, that moral and material apocalypse, with children who were ferocious on the outside, but tender and gentle on the inside.

Many images have stayed with me from De Seta's films. Beyond the most tragic ones are the amazing details that you never find in Italian cinema. For example, the scene in "Letters from the Sahara" (2006) when the protagonist, a Senegalese boy with a face of sculpted ebony, finds a wild orange tree in front of a Greek temple and tears at it out of hunger. He strips the oranges off the plant with all the voracity – not violence – of a starving boy who sees food, and in food sees life, not a just meal. Vittorio De Seta was one of the few directors able to tell this story of our basic needs.

It seems to me that De Seta's cinema is driven by this constant desire to tell stories based on real life, to show them clearly, and not to fall back on the notion that there is some antidote to evil. He managed to see beauty and to find salvation in it. De Seta had the sort of talent that has disappeared in Italy over the years, the kind that led Primo Levi to pronounce: "I entrust you with these words. Carve them into your hearts." De Seta entrusts his audience with the images he has sought out.

5

Truth, Despite All Else, Exists

THE IDEA THAT *GOMORRAH* MIGHT BECOME A PLAY SEEMED
part of its destiny. The book had not been published when two
people, a director and a young actor, approached me about adapting
it for the stage. They knew what they wanted to do with it from
the moment we met. They felt compelled to produce it. It was one
of those things you have to succumb to utterly, or not at all.

I liked the idea that the book's metamorphosis into a drama
would be handled by Mario Gelardi, a young director who was
obsessed with the theatre as a kind of ultimate medium capable of
expressing that which can still be expressed, and who started in the
world of documentaries, the kind filmed in Africa under harsh condi-
tions and for very little money. His work on documentaries meant
that he listened to his gut without giving in to his eye. He would
not get lost in posturing. This was a guarantee, of sorts, for me. When,
with the help of Ivan Castiglione, we agreed to turn *Gomorrah* into

a theatrical event, I envisioned using a group of young people –
actors and non-actors – who wanted to challenge themselves and
gain an entirely new experience of the theatre, thereby allowing us
to distance ourselves from the traditional paths and sacred cows of the
theatre.

Theatre is a marginal space. It lies beyond the reach of the broad-
cast media and the newspapers. It is neither entirely public nor
private. I like to see the word "civic" next to the word "theatre".
Most directors and actors do not like that, much as some writers do
not like any other words to be attached to the pure word "litera-
ture". As if it would somehow pollute it. However, in my view it is
good to put opposites together, not only because that adds to a
project and reveals new artistic dimensions, but because it helps to fill
a gap. Beyond theatre and art, nobody investigates or tells stories
about the tragedies of the world. No mapmakers of possible happi-
ness. No-one to echo the howls of pain. No-one to take the time to
tell stories, to name the guilty, to chronicle events or compile a biblio-
graphy of witnesses – but when these empty spaces have been filled
by theatre and literature, they reveal the enormous gaps that were
once there. That is why I am not bothered in the least by the term
"civic theatre".

We gathered in the theatres we called *Tangentopoli* after the finan-
cial catastrophe. We went to the theatre to listen to those who had no
other platform from which to speak. The theatre lets us explore new
directions because it allows us to look each other in the face, to hear

words bounce off one another, to sniff each other out. The paradox is that the theatre – the locus *par excellence* of lies and fictional representations – becomes a place of possible truth. And consequently, of truths.

Truth obsesses me more than anything else. It is the *idée fixe* behind my book. Truth is not measurable: parameters, proofs, results of research never actually reveal the truth, but they can get close to it, they can circumscribe it. What ends up getting measured is the possibility of actually articulating the truth, its spaces, its perimeter, the conditions it needs for it to be generated. We can understand the time that is spent on research and reflection, or the path that might lead to a truth. We can argue about it, struggle to find a way of saying it. Above all, we can find the instruments that will help us focus on it; find a perspective that does not just simplify what is complex but allows it to become visible and legible. Yes, because the truth – any kind of truth – needs first and foremost to be read. How much space does the truth occupy today? How much time does the telling of it take up? Can all truths – from the obvious to the most obscure – be revealed?

The job of international research institutes is to monitor all aspects of the social, political and economic life of either a single nation or its interactions with others on the global stage. These institutes have constantly to gather data, update their findings and report on them as fast as possible. What the data does not reveal is what parameters were used to arrive at the final evaluation, how it should

all be read. To do this we need a key, a yardstick, parameters. The parameters that the research institutes use – their lightsabers to slice through a thicket of data – are of a disconcerting simplicity. To arrive at an immediate understanding of a country's rate of economic growth and compare it to the inequalities of wealth on a planetary scale, they use an index based on the price of a Big Mac. The more expensive the McDonald's hamburger, the better shape the country's economy is in. In the same vein, to judge to what degree human rights are being observed, they look at the price of a Kalashnikov. The cheaper the weapon, the easier it is to buy one of these light weight killing machines, the more human rights are violated. In Somalia a Kalashnikov may cost about $50. In Yemen, however, you can get a second- or third-hand A.K.-47 for $6.

How can we measure the status of truth in Italy? How can we measure the degree to which it is possible even to utter it? How can we trace its contours? To find truth's weak pulse one would need to look beyond the situations usually covered in the local papers: random spikes on a seismic graph of truth, seemingly forgotten episodes. A judge (and not just one) who narrowly escapes being blown to smithereens by several kilos of T.N.T. A priest forced to leave his own parish, or another who has to be careful what he says in his sermon or he will not be allowed to deliver the next one. A union leader killed for defending the rights of some people who wanted to set up their own market stall. If I talked about these events at a dinner party in any city in Italy, my fellow diners would be

puzzled. They would only reluctantly believe me. Or else they might object that those stories are from an old time. They happened decades ago, and in remote parts of Italy.

"They're Sicilian stories," they would say. "Things of the past."

"No, these things are happening now," I would reply, "and in your country."

Often, when I hear people complain about Italy as if it is an inferior part of Europe (but a part of Europe nonetheless), with its extensive disorganization, its bureaucratic dramas and unregulated urban sprawl, the chaotic driving which causes huge delays and claims so many lives, it feels to me as if they are talking about a country that I do not even know.

In my country a person's life is based on the choices they do not have. You can't emigrate. You can't ask for overtime without being fired. You can't open a shop without ordering your goods from specific providers. You can't be a witness without fearing repercussions. Whatever might be sanctified somewhere else as "rights" – a mechanism that might work by default (as I.T. specialists would say) in that other place – here means nothing at all. There are places where you cannot utter certain names, situations in which just doing your job puts you at risk. Places where you cannot let people know that a mistake has been made or that a disaster has occurred, that somebody did something wrong. You cannot say, ask or expect anything without putting yourself on the line. There is danger. You run. You might get killed. This is what happens in Italy.

We should be asking ourselves (and I often do) if it takes anger to reveal evil. Perhaps anger develops a kind of wall eye that can detect something which is hidden, which only anger allows us to see. As if that feeling in your stomach, like a beast inside you trying to find a way out, is forcing you to think of nothing else, to obsess about what cannot be said, to wonder how anyone can exist while being crushed by powers that are even more intrusive and do not allow us to live our lives the way we want to. And yet, to ignore this grumbling beast is impossible.

There is a Catalan expression that helps me appreciate how difficult it is to understand the truth: "After a flood, the first resource in short supply is drinking water." In the constant flow of news stories you want to know exactly what is happening. You want drinking water. How much is truth worth in this country? Where can we go for the stories we need to be able to shine a light on the truth? Our attention is a determining factor, because it decides which stories fall into oblivion and which survive. But first we need the stories, before we can give them our attention.

Theatre lifts the word from the page and gives it voice. It gives faces. It dresses words in flesh without oppressing them. It allows words to reveal themselves. It lets stories that happen in one specific place become stories that could happen anywhere. One face becomes all faces – and this is what the powerful fear more than anything else. While their enemies might only have one face, they are reminded that any face can become an enemy. The power of theatre is that it

can break through isolation. It gives off the truth through sound and sweat, through fixed attention and dim lights, and it seems more needed today than ever. In many parts of this country, telling the truth is a crime. But if many people speak it, if other mouths savour it, if it becomes a shared meal, then it stops being just one truth and it can replicate, take on new forms, become multiform and no longer refer to just one face, one text, one voice. The symposium, the banquet, the dinner table where all this can happen, I like to think, is the stage. We need to demand that the continuous and over-whelming attention given to politicians' comments dries up, and that space be made for a constant and polyphonic account of the country. We need stories to multiply so that knowledge and understanding become the accepted conditions for citizenship. So that we can understand the dynamics, the mechanisms of the government of this country. So that we can really see what is going on beyond the political bickering. It is like something straight out of Victor Serge when, during a trial in Stalin's Russia, in front of a judge who has eyes only for the loyalists and the traitors, an innocent man, unfairly accused, being dragged into a cell, says through clenched teeth, "In spite of everything, truth does exist."

6

When the Earth Shudders, Cement Kills

"WE'RE NOT GOING TO LET THE SPECULATORS TAKE OVER OUR city – write that down. Say it loud and clear: there is no way they are going to fill our town with cement. We are the ones who get to decide how our city will be rebuilt . . ." They say this to me on the rugby field. They say it to my face. They are so close I can smell their breath. One man says what he has to, then hugs me and thanks me for being there. His fear did not end when the earth stopped shaking.

The devastation of an earthquake takes place not only during the actual quake, but also in the months that follow. Entire neighbourhoods will be demolished and rebuilt. Hotels need to be reconstructed. Money will flood in, but while it might help to heal the wounds of the city, it can also poison its soul. The people of Abruzzo are afraid of the help being offered to them by speculators.

While visiting the region, I recall the story of a famous local hero, Benedetto Croce, who was born in Pescasseroli, and whose entire

family was killed in an earthquake. "We were at the dinner table: me, my mother and my sister, and my father was about to sit down. Suddenly, I saw my father fly up into the air and then come crashing down to the ground, like a wave, but landing up in a twisted position. I saw my sister shoot straight up to the ceiling. Terrified, I went to look for my mother. We ran onto the balcony and threw ourselves off it, and then I fainted." Benedetto Croce was buried up to his neck in rubble. For hours following the quake, his father, who ended up near him, kept him alive by speaking to him before dying himself. The story goes that he kept saying the same thing over and over: "Tell them you'll pay them a hundred thousand lire to pull you out alive."

The people of Abruzzo were saved by teams of tireless volunteers who were far from the usual stereotype of selfish and lazy Italians. But the price this region might have to pay could be exceedingly high, much higher than Croce's father's hundred thousand lire. The earthquake in Irpinia thirty years ago – and the disaster, waste, corruption, and political and criminal monopolies that grew out of the rubble – intensifies the anxiety among the people of Abruzzo, who know what cement is and the strings attached to "emergency funds". What is a tragedy for them is an opportunity for others, an endless mine, a paradise of profit. Developers, surveyors, architects, planners and engineers are about to descend on Abruzzo to offer their services and draw up damage reports. That sounds harmless enough, but in fact it marks the beginning of the cement invasion. In the next few days these damage reports will be distributed to every

building office throughout the municipalities of Abruzzo. Thousands of forms, thousands of inspections. Whoever holds one of these forms is guaranteed a well-paid job financed by an incredible system.

"Basically, the more damage that gets reported, the more room for profits there will be," says Antonello Caporale, my travelling companion and a journalist. He covered the earthquake in Irpinia and is still angry about what happened there. To understand the danger facing Abruzzo you have to look back at what happened twenty-nine years ago to an area near Eboli.

"In Auletta we're still doling out parcels from the earthquake fund," says the vice-mayor, Carmine Cocozza. "For every €100,000 of State aid, the planner gets €25,000 in compensation." This year the government of Auletta divvied up the sums for the completion of the post-quake works: €8 million. "My municipality received €2.5 million. This money will help pay for the last houses and finance the final projects." It is hard to believe that twenty-nine years later the government is still handing out money for rebuilding, but that is what the experts get: twenty-five per cent of the total funds. You can study the graphs and, of course, all the buildings conform to the regulations. In addition to the planning costs, the foremen need to be paid, there are health-and-safety expenses, and inspection costs. The list goes on and on. The inspections are endless. The planner keeps planning and stamping his plans. The municipalities have to foot the bills.

This is the risk of rebuilding. When surveyors exaggerate the cost of the damage, the sums get bigger and the contractors start looking

for subcontractors, cement suppliers, bulldozers and earthmovers. And, sadly, these reconstruction efforts tend to attract Italy's avant-garde building subcontractors: the Mafia clans. Camorra families, the Mafia and the 'Ndrangheta are not new to these parts – and not just because Abruzzo's prisons house a veritable who's who of the Camorra business elite. The real risk is that the criminal organizations come in and split up the large business affairs of Italy while the country is in crisis. For example: they may decide that the 'Ndrangheta will take the Expo Centre of Milan, while the Camorra will get the subcontracts for Abruzzo.

The only thing to do is create a commission that can keep tabs on the reconstruction efforts. The president of the province of L'Aquila, Stefania Pezzopane, and the mayor of Aquila, Massimo Cialente, are clear about this: "We don't want to be controlled by anyone. There should be commissions to check on things . . ." But criminals can infiltrate organizations at any level. The Camorra has been building and investing for years. Paradoxically, the building where most of the cement bosses are currently located was one of the few properties in Abruzzo to remain intact: the prison of L'Aquila (eighty bosses are there facing 416 counts of Mafia-type associations). The prison stood up to the earthquake.

The Camorra's invasion of the area over the years has been significant. In 2006 we learned that the ambush on the Camorra boss Vitale was planned at a table in Villa Rossa di Martinsicuro in Abruzzo. On September 10, 2009 we discovered that Diego Leon

Montoya Sanchez, the drug trafficker who is on the F.B.I.'s Ten Most Wanted list, had a base in Abruzzo. Nicola Del Villano, an associate of the criminal business consortium of the Zagaria family in Casapesenna, escaped capture many times: his hideout was in the National Park of Abruzzi, where he roamed free. Gianluca Bidognetti was in Abruzzo when his mother decided to turn herself in.

Abruzzo has also become a strategic area for dumping waste, selected by the clan because it is sparsely populated and there are plenty of empty caves. The Ebano inquiry undertaken by the *carabinieri* showed that at the end of the 1990s at least 60,000 tons of solid waste from the Lombardy region had been dumped on Abruzzo's abandoned land and in its caves. Obviously, behind all this was the Camorra.

Until now, the city of L'Aquila has not been infiltrated to any great degree, the reason being that there were never any great business deals to be done there. But now there is a wealth of opportunities. For the time being, national solidarity keeps the danger at bay. The people on the Paganica rugby field show me the parcels they have been sent from rugby teams all over Italy, and the camp beds that have been set up by rescue workers and players. Rugby is the big sport here. It is practically sacred. In fact, when I first arrived, a rugby ball whizzed over my head as some children were playing nearby.

The united resistance of these people is the mortar that holds together both volunteers and citizens. When all you have left is life, you appreciate what a privilege it is just to breathe. That is what the survivors want me to understand.

The silence in L'Aquila is terrifying. At midday the evacuated city is entirely still. I have never seen a city in such crisis. Everything is falling apart. There is dust everywhere. L'Aquila is alone. Almost every first storey of every building looks as if it has exploded.

I thought things would be different. I thought the oldest parts of town would be most affected, the older neighbourhoods. But no. Everything has been touched by the earthquake. I simply had to come here to see it for myself. And the people are happy to remind me why: "You remembered that you're an Aquilan," they say to me. L'Aquila was one of the first cities to give me honorary citizenship years ago. And they do not let me forget it, as if it is my duty to witness what is happening, to tell their story. To keep the memory alive.

I stop at what used to be the university dormitories. The earthquake killed young and old indiscriminately. It killed people who were sleeping when their ceilings collapsed on them. It killed people who tried to escape by running down the stairs, but instead fell into an abyss, since the stairs are the most delicate part of a building's structure and the first thing to go.

The firemen let me visit Onna, the hardest-hit city. They recognize me. They welcome me with hugs. They are covered in mud and dust. They do not usually like having journalists around. "If a ceiling collapses and they get stuck, I have to go in and save them," Gianluca, a Roman engineer, says to me as he hands me a red fireman's helmet, the kind of present a child dreams of getting. Basically, the town

of Onna no longer exists. The term "rubble" is a cliché. It means nothing any more. I make a list in my Moleskine of all the things I see on the ground: a sink, photocopies from a book, a pram, and a lot of light fixtures. You do not usually see those outside. The most fragile things in the home usually give the first indication that an earthquake is happening. But by then it is already too late.

Life has crumbled. The firemen take me to a home where a baby died. They know all about it. 'This house was beautiful, it looked to be really strong, but actually it was built on old foundations." There just were not enough inspections back then . . .

A fireman tries to describe the extreme dignity of the people. "No-one asks for anything. They're just happy to be alive. An old man said to me once, 'Can you close the window for me? I don't want the dust to come in.' I closed the windows. The house had no roof and was missing two walls. Some people have yet to fully under-stand there was an earthquake."

Franco Arminio is one of Italy's major poets, and definitely the poet who has spoken most eloquently about earthquakes and their effect. In one of his poems he writes: "Twenty-five years after the earthquake there will not be much left of the dead. And even less of the living." We can stop this from happening. There is still time. We cannot let the speculators win, as they have in the past. It is the only real homage we can pay to the victims, who were killed not by the trembling earth but by cement.

MEN

7

Brittle Bones

MICHEL PETRUCCIANI'S PATERNAL GRANDFATHER TONY WAS
born in Naples. When Michel was a toddler, he would get all excited
and worked up watching Tony play the guitar. Everyone thought the
boy was just fooling around. He might not have been named after his
grandfather, but he clearly inherited his talent for music. And Tony
was the first to recognize it too. Michel recalls that his father Antoine
was "a very timid man, very reserved, and very Italian. At home, he
never talked about money or personal matters." Both father and
grandfather were great guitarists.

The Petrucciani family had to raise three sons on those guitars,
and what their mother earned from her work as a seamstress. While
there may have been times when they had only coffee and milk
for dinner, essentially they never lacked for anything. They had
telephones, cars and elegant furniture. One day they even got a tele-
vision. And not one of those small sets that make you go blind. They

got an enormous set. And Michel sat in front of it all day long. Television bewitched him and changed him for ever.

One evening, when he was only four, his father was watching a Duke Ellington concert. The child fell under a kind of magic spell. He desperately wanted a piano. His father could not afford one. The family was always very careful around Michel, because he was born with an unpronounceable illness: *osteogenesis imperfecta.* The name does not reveal much about the illness, but the common name leaves no doubts: Brittle Bone Disease.

This disease wears down bones in the joints, causing them to crack and break into fragments. It happens continually and for all sorts of reasons. The cartilage disintegrates. The first time Michel's bones broke was on December 28, 1962. It was in Orange, a quaint city in southern France. It was the day he was born. Michel arrived on earth broken, and from that day on he never stopped recomposing the fragments of his broken bones.

The piano that his father finally got for him produced notes in *falsetto*, and did not sound at all like Duke Ellington's. Little Michel played it so hard that he destroyed it. His father eventually managed to get his hands on an old piano that the nearby American military base was putting out. Michel, who was schooled at home and would drive teachers crazy with his impertinence, eventually started taking proper piano lessons. He went on to study classical piano for ten years and got a conservatory degree. He played jazz for the exercise. And for good reason: he needed to tone up his muscles so they could

support his fragile bones. He also practised the drums, so he could perform alongside his father and brothers.

Michel Petrucciani not only suffered from a rare illness, put up with a lot of pain, and spent much of his childhood in and out of hospitals – he was also destined to remain a dwarf. He never grew taller than one metre and never weighed more than somewhere between 25 and 45 kilos. In later years his stomach stuck out further than his chin. He spent months at a time in bed, his body in a cast to keep his neck perfectly still. He spent an age looking at the only bones in his body that did not break, his hands. His hands were not even that small. It turned out that his hands were his future. They were the only part of him that allowed him to make something of himself and not be a victim of his illness. His hands could change the rules. And they did. The piano was his territory: his hands were his weapons. However, when he sat at the piano, his legs were too short to reach the pedals, so his father built him a wooden contraption in the shape of a parallelogram that allowed him to reach them.

At the age of eighteen, Michel escaped. He boarded a plane in Paris, where he had begun to give his first concerts, and, without knowing a word of English and without any money, he travelled to the United States. When Tony found out, he quickly managed to put enough money in the bank to cover the blank cheque that his son had taken with him before setting out to conquer the land where jazz was born. The land where Michel, the most original

non-American jazz artist, would eventually become one of the biggest names in jazz.

He went to Big Sur, that wild strip of Californian coastline where Jack Kerouac and Henry Miller lived, and where Orson Welles built a home for himself and his wife, Rita Hayworth. Michel moved in to a friend's house and allowed himself to be adopted by the local hippy community.

He soon found a way of paying for his room and board by playing for a few hours each day in a clinic where extremely rich people went for various treatments. He even fell in love with a woman, Erlinda Montano, to whom he proposed. She agreed to marry him so that he could get his green card. It was more or less as in the film "Green Card", Petrucciani admitted years later, only Gérard Depardieu was not a nineteen-year-old dwarf and Andie MacDowell was not a Navajo Indian. Reality is wilder than imagination, and in Michel Petrucciani's case, a lot wilder.

One day some friends took him to meet Charles Lloyd, one of the greatest sax players of all time. A tormented and insecure man, Lloyd had his heyday when he played in a quartet with Keith Jarrett. But then, disgusted by the record industry and his fellow musicians, he gave up the instrument, moved into the woods to meditate, and made a living as an estate agent. Jarrett's celebrity status was one reason for Lloyd's decision to quit the business, yet when his strange guest said that he knew how to play, Lloyd asked to hear him. Erlinda put away his crutches, picked Michel up, who weighed

no more than a three-year-old, and arranged him in front of the piano, as she did during his concerts. Michel began to play. Lloyd was amazed. A few days later he came out of retirement and they performed together in Santa Barbara. The sax player, thirty years older than Michel, carted around his new partner, introducing him as the "child prodigy from France" who had convinced him to start playing again. It was a strange miracle and would even be a little too Californian if Michel, with his virulent humour and Mediterranean nature, had not been the polar opposite of all that. Petrucciani resuscitated Lloyd's talent, and Lloyd gave Petrucciani the light of day.

Petrucciani's career took off when they played together in Montreux in 1982. He went on to tour the world. His music became more and more technically advanced, freer and richer. He riffed off themes by the greatest jazz musicians of all time – Bill Evans and Miles Davis – and became famous for his renditions, including that of "Bésame Mucho".

He played with jazz legends Dizzie Gillespie and Wayne Shorter, Stan Getz, Sarah Vaughan, Stéphane Grappelli and many others. He performed at Carnegie Hall in New York and before Pope John Paul II. He made at least thirty C.D.s for the biggest record labels and was awarded the *Légion d'honneur*, the highest award from his native France. All in fewer than twenty years. It seemed as if nothing could stop him, as if there were an unending source of energy inside that tiny, delicate frame.

Sometimes, when he played, he looked as if he were drowning. He twisted his body into a strange position, tipped his head back, looked up into the sky with a mesmerized expression, as if reading sheet music that only he could see and interpret. He stuck out his tongue to concentrate. Michael Jordan, the greatest basketball player in the history of the American N.B.A., also used to stick out his tongue, like a thirsty dog. Petrucciani's tongue might have been shorter than Jordan's, but he did it for the same reasons: to breathe, to concentrate. Pure pathos.

His piano playing amazed the world. Critics objected that he was famous because of his illness and the hardships he had overcome to become a pianist. The truth was the exact opposite. He was a great pianist to begin with, and his bizarre, fragile, minute body threatened to obscure his talent. He had to run alongside the keyboard to keep up with his hands. A callous formation prevented him from spreading his arms, so he had to jump on the piano stool to reach the high eighths, then drop down again for the lower eighths. When he ran his fingers up and down the keys it looked as if he were scaling a mountain, shivering with vertigo. His music reached millions and his concerts always sold out, but he actually preferred playing in less glamorous surroundings. Jazz was for everyone. At the height of his popularity, he even chose to play in Aversa. He mentions it in his diary.

But on January 6, 1999 Michel Petrucciani died. Apparently, the pneumonia that led to his death was caused by the gradual

collapse of his rib cage over the years. His small bones squashed his internal organs. He never thought he would die young.

Petrucciani did not just love music – he could play for ten hours a day, he said, and it would feel like ten minutes – he loved life. And he managed to live it with all the passion a human being can possibly experience. He loved to laugh at his physical defects, as well as those of others. He loved to travel and see the world. He loved his homes and was tempted to buy one in every place he liked. Luckily, he did not handle his own money or he would have spent it all on houses. He loved being surrounded by friends. Most of all, he loved women. And they loved him. Michel had many, many girlfriends, wives and lovers. After Erlinda, he married Gilda Butta, a classical pianist and beautiful Sicilian. Then there was Marie-Laure, and finally Isabelle, who was with him at the end. He used to say that he loved them all and had a special friendship with each one of them, but he never stayed with a woman for more than five years.

People often wonder how Petrucciani, notwithstanding his great talent, could have attracted so many beautiful women. Naturally, there was the usual gossip about the sexual proclivities of dwarfs, but those legends were invented simply because people could not understand his beauty. It was not his music that bewitched women. As one of his closest companions said, "When I saw Michel, I saw everything that he imagined, everything he was. And he was beautiful." Beauty is not just a physical trait, elegance, lightness or charm. It is being able to show someone who and what you are, and to resemble everything

you imagine yourself to be. Whenever I think about beauty, I think about Petrucciani.

Michel had two children. Alexandre was born with his father's illness. In a documentary he is shown sitting in his father's lap at the piano. A father and son sharing something special – music and talent – but who love each other just like other fathers and sons. Some people thought it was wrong of Michel to risk fathering a child with the same disorder. And when it happened they tried to make him feel guilty. But how could such a creative person not take the risk of giving life? He had to try. He loved life too much to not share it and transmit it. Music taught him how to create.

Music, for Michel, was life. And even though Fate had dealt him a poor hand, he knew that the value and beauty of life lies in its wealth of creation, not some other distraction. For Michel, notes were like colours. He could improvise a Provençal landscape and its warm green hillsides in the chord of G. Thanks to music, Michel's condition not only became secondary (the same thing is said about Stevie Wonder's blindness), it allowed him to get everything out of life that he wanted. "My philosophy is to have a world of fun and not let anything stop me from doing what I want to do."

Once, after playing for nearly an hour without interruption, Michel stopped, turned to his audience and asked, "Ca va?" They just laughed. This is his way of thanking them and teasing them, too. They wonder how he does it. They worry about him, in case he is in pain, but he is actually never happier than when he is playing. It

is not about success or the pleasure of getting better. No, it's the notes that make him feel good. "It is like making love or having an orgasm: but it's legal to do it in public."

8

Playing It All

I MET LIONEL MESSI IN THE CHANGING ROOMS OF BARCELONA F.C.'s Camp Nou, the third largest stadium in the world. From high up in the stands Messi is a tiny, fast, unstoppable black dot. Up close he is a short and solid kid. He is shy and speaks in a lilting Argentine accent. His face is smooth and perfectly clean-shaven. He is the smallest world champion footballer alive. "La Pulga" they call him: the Flea. He has the body and build of a child. He was still a child when he stopped growing. While his friends' legs got longer, their hands grew stronger and their voices changed, Leo stayed small. Something was wrong, and blood tests confirmed it. His growth hormones were blocked. Messi had a rare form of dwarfism.

It was impossible to hide his growth problem. All his friends on the pitch noticed. "He just stopped," they say, as if he had simply been left behind. "I was always the smallest, wherever I went, whatever I did," Messi says. When he was eleven Lionel was barely one metre

forty. His jersey from Newell's Old Boys, his team in Rosario, Argentina, hung down to his knees. His shorts were enormous. Even when he tightened his laces all the way, his boots still looked like slippers. He was an incredible player, but he had the body of an eight-year-old rather than an adolescent. Just when he was ready to start dreaming about his future, right when he was supposed to develop his talent, his growth — arms, legs, chest — came to a halt.

Messi's hopes, which he had entertained from the moment he first stepped onto a football pitch at the age of five, looked to be over. He knew that if he did not grow he would never become the person he wanted to be. Doctors seemed to think the problem might be temporary if treated immediately. Years and years of injections might help him recover the necessary growth so that he could face the giants of modern football.

Unfortunately, the cure was so expensive his family could not afford it: each injection cost €500 and he had to have one every day. Messi needed to play football in order to grow, but he also needed to grow in order to play football — there was no other way. He could not even imagine a form of therapy that did not include football, his lifeblood and passion.

Messi needed a high-level club to take him on and pay for his treatment. At the time, Argentina was going through a devastating economic crisis — losing all its inward investment and savings when the State defaulted on its debts. The grandsons and great-grandsons of immigrants who had grown up in comfort and wealth were forced

to return to the lands of their ancestors to look for work. At that time no Argentinian team could take on the risks and costs of Messi's cure, even though they recognized his talent.

Even if Messi grew a few centimetres, they said, a footballer needs a seriously powerful physique. They assumed the Flea would be squashed by huge defensive players, that he would never be able to head the ball, that he would never be able to handle the anaerobic stress of being a forward in today's game. But Lionel Messi kept on playing. He knew that if he hoped to become a real player – a professional footballer – he had to play as if he had ten feet, run faster than a wild colt and never get tired.

Then, one day, a talent scout saw him play. In the life of a footballer, talent scouts are everything. Every game they see, every punishing workout that they take into account, every kid they watch, every father they talk to becomes a line in the overall trajectory of that player's destiny. First they sketch it out, then they open a door. But Messi's deal was unusually good. Not only was he offered the opportunity to become a real footballer, but he also was given the chance to heal himself and to lead a normal life. Before they actually saw him, though, the scouts were sceptical. "If he's too small he doesn't stand a chance," they said. "Even if he's a strong player."

"It took them five minutes to understand that he was made for football," Carles Rexach, the sports director of Barcelona F.C., remembers, after watching Messi play. "In a split second it was obvious how special he was."

They saw his unique talent and understood that it went beyond football; Messi's moves are like music or the pieces of a puzzle falling into place.

Rexach wanted to sign him straight away. "Anyone who saw him play would have paid his weight in gold for him." So he drew up an initial contract on a paper napkin from the snack bar. He and the Flea's father signed it. That napkin changed Messi's life. Barcelona F.C. believed in the eternal child. They decided to invest in the horrible hormone treatment that would become part of his life. But to get it, Lionel and his whole family had to move to Spain. They left Rosario with no documents, no jobs, only a contract sketched on a napkin. They put all their hopes in his little body. Starting in 2000, for three years, the club guaranteed Messi the medical treatment he needed. They believed a kid who was ready to play soccer to save his life had that special fuel that could get you anywhere.

The treatment, however, can split you in two. Nausea was the main problem. You vomit up your soul. Your facial hair does not grow. You feel your muscles popping out, your bones creaking and groaning. Everything gets bigger and longer in months rather than years. "I couldn't let myself experience pain," Messi says. "I couldn't let my new team see me suffer. I owed them everything." There is an abyss of difference between those who use their talent to become someone and those who have everything to lose. Art becomes your life, not because it brings everything together, but because only your

art can keep you alive and guarantee your future. There is no alternative to fall back on, no plan B.

After three years Barcelona F.C. summoned Messi to play. His family thought the club's expectations were too high. They feared the worst. They had abandoned everything in Argentina and they had nothing in Spain. If things did not go as they all hoped, Messi's health problems would once again become their responsibility. But when the Flea played, all their anxieties vanished. Training with the team's support, Messi managed to become not only a better player, but to grow in height, year after year, centimetre by centimetre. His muscles lengthened and his bones became stronger. Every centimetre he grew was torture, and even today no-one knows for sure how big he is. Some people say he is slightly above 1.50 m (4'11"), others say he is shorter. Some websites say that he has reached 1.60 m (5' 3"). Official calculations vary. Sometimes they add a few centimetres, as if rewarding him for his work on the pitch.

The fact remains that when two teams are lined up before the kick-off, everyone stands at about the same height – except Messi, whose head comes up to his teammates' shoulders. In a sport where power counts for so much, and where Ibrahimovic's almost two metres or Beckham's 1.80 are now the norm, Lionel still looks like a flea. "Sure, Messi would lose if there were body-to-body impact," says Manuel Estiarte, the world's greatest water-volleyball player, "and no doubt he'd get trampled by the defence too. But first they have to catch him . . ."

And the truth is, no-one can catch him. Because his centre of gravity is low, the defenders run into him, but he does not fall down. Nor does he move out of the way. He keeps on going, and keeps the ball. He bounces off the other players, dribbles, leaps, wiggles, escapes, feints. He is uncatchable. In Barcelona they joke that Roberto Carlos and Fabio Cannavaro, the stars of the Real Madrid team, have never actually seen Lionel Messi face to face, because they can never catch up with him. Leo is so fast, when he runs it looks as if his feet are holding on to the ball. When he feints, his opponents trip over their own size 45 feet.

Messi once had to sketch out the story of his life for an advertisement. It is charming, but also a little sad to see how he saw himself as a tiny child lost in a forest of legs and surrounded by enormous footballs that flew far, far away. However, when they did touch the ground, he managed to get possession and snake his way towards the goal. Whenever there is a throw-in or his opponents are busy catching their breath, Messi flashes by. When the centre-forwards think he is behind them, suddenly they see him five metres ahead. The most effective player is not the one who knows how to foul, but the one whom nobody can reach to trip up.

To watch Messi play is to go beyond football. It is a kind of grace. People who have the chance to see him experience almost a shiver of recognition, an epiphany. Watching him is to sense that there is no separation between yourself and the spectacle. You become totally absorbed in what you are watching. Messi's games are like Arturo

Benedetti Michelangeli's sonatas, Raphael's portraits, Chet Baker's trumpet, John Nash's mathematical theories, or anything else that ceases to be matter, colour, sound, and becomes something that belongs to every element, to life itself. There is no separation or distance. The first time you see it, it's hypnotic. Your intuition tells you what is going on. You see yourself as you really are.

Listening to the sports commentators following his every move you begin to appreciate Messi's epic status. During a match between Barcelona F.C. and Real Madrid, for instance, the commentator, seeing Messi surrounded by opponents trying to foul him, stopped describing the scene and just kept repeating, "He's still standing, still standing, still standing!" In another historic game the crowd's ecstatic cheer of "Messi! Messi! Messi!" ended with a final "ah" sound: Messiah. That's the Flea's other nickname, due to his grace on the pitch and the almost mystical state his playing arouses. "Man created God and He sent a prophet," said a television programme dedicated to "El Mesias" Messi and to the former divine incarnation of football: Diego Armando Maradona.

It seems impossible, but Messi has Maradona in mind when he plays, like a chess player during a difficult game, who gets inspiration from having studied a master's moves. The masterpiece Maradona achieved on June 22, 1986 in Mexico – the goal that was voted best goal of the century – was replicated in Barcelona almost perfectly by Lionel Messi twenty years later, on April 18, 2007. Like Maradona, Messi ran towards the goal from about sixty metres away, wriggled

free from two central defenders, then sprinted towards the penalty area, where an opponent tried to knock him over, without success. Three defenders surrounded him, but Messi slipped away to the right, throwing off the keeper as well as another player, then ran into the goal. When he scored the Barcelona team just stood there with their hands on their heads, looking around as if they could not believe what had just happened. They all thought only one man was capable of doing such a thing. But they were wrong.

The Press were quick to invent the nickname "Messidona", and the two Argentine players have so much in common it is even a little creepy. It seemed as if football's heyday had passed, but Messi's talent has reawakened a great myth, and not just any myth but one that is in marked contrast with our time: that of David and Goliath. Both men are small, come from poor neighbourhoods, are incapable of existing off the pitch, have similar expressions, the same anger and gruffness. Theoretically, they have it in them to get it wrong, to lose. They were not born to be legends. But it all happened so differently.

Messi was not even born when Maradona scored that famous goal in Mexico. He was born in 1987. And one of the reasons I went to Barcelona to meet him was because I grew up in Naples under the myth of Diego Armando Maradona. I will never forget the 1990 F.I.F.A. World Cup semi-final, when Azeglio Vicini's Italian team played against Maradona's Argentina, right at home in Naples' San Paolo Stadium. When Italy's Totò Schillaci scored the first goal, the whole stadium screamed with joy. But when Argentina's Claudio

Caniggia scored the next goal, something happened that had never happened before in the history of football, and it has not happened since: the home crowd started to shout "Diego! Diego!" Maradona had played for the Naples team, so they identified with him, even if now he was playing for Argentina. At that moment, Maradona represented more than a national team, more than a team made up of players from Rome, Milan or Turin.

Maradona was able to subvert the unspoken rule of all football fans. He paid for it later, in Rome, during the Argentina–West Germany final, when the Italian crowd, still angry that their team lost to Argentina and that some Italian fans had applauded Maradona, whistled throughout Argentina's national anthem. Maradona waited until the television cameras were on him to mouth the words "*hijos de puta*" ("sons of bitches") to the whistling fans. It was a terrible World Cup final. In Naples some Italians still cheered Argentina. But then, West Germany found itself in trouble and sought revenge for Italy's defeat. There was a questionable foul on the German player Rudi Völler. The penalty was taken by Andreas Brehme, and he scored the game's only goal. As one Argentine commentator observed, "That's the only way to beat Diego."

I recall those days vividly. I was eleven and I will probably never see football like that again. But now, with Messi, something from that era has come back. Maradona's second goal against England in the 1986 World Cup in Mexico – the one replicated by the Flea twenty years later – was one of the key moments of my young life. I wonder

how strange it would be for Messi to play in San Paolo. Maradona has even said that "watching Messi play is better than having sex". And Diego knows a good deal about both subjects. "I like Naples, I want to go there," Messi says. "It must be nice. For an Argentinian it's probably like being at home."

The best part of our meeting was when I told Messi his playing resembled Maradona's. I used the word "resemble" because I did not know how to express something that has been said a million times, but I wanted to say it anyway. "*Verdad?*" he replied with a timid and happy smile. "Really?" Lionel Messi agreed to meet me not because I am a writer, but because I come from Naples. For him that is like meeting a Muslim born in Mecca. Naples, for Messi and for lots of Barcelona fans, is a sacred place for soccer. It is where talent is baptized; where the god of football played the best years of his life; where he worked his way up from the very bottom to conquer the world.

Lionel Messi is the opposite of what you would imagine a footballer to be: he is insecure; he does not use the catchphrases they tell him to use; he blushes and stares at his feet, or starts biting his nails when he is thinking or does not know what to say. His life story is like the familiar bumble-bee paradox: conventional aerodynamics says the bumble-bee should not be able to fly because its body weighs too much for its wings to generate sufficient lift. But the bumble-bee does not know that and gets itself airborne anyway. Messi, with his tiny body, feet, chest and legs, with all of his growth problems, should

not be able to play today's football, which is all about muscle, might and mass. But Messi does not know that. And that is what makes him the greatest player of them all.

9

Tatanka Skatenato

"THINGS ARE NEVER AS GOOD AS WHEN YOU DO THEM WITH your own hands," Homer wrote in *The Odyssey*. Boxers would agree, because boxing is disciplined anger, structured force and organized sweat. It is both a muscular and an intellectual challenge. In the ring you either do everything you can to stay on your feet or you throw all your energy into the fight and plan on going down. In any case you fight, one against one. There is no other possibility, no mediator.

There will be two great amateur boxing champions on the Italian Olympic team in Beijing: the heavyweight Clemente Russo (91 kilos) and the lightweight Domenico Valentino (60 kilos). They are twenty-six and twenty-four, respectively. Russo is world champion and Valentino won the silver in the World Amateur Championship. They are both in the police force. Both have been closely studied by the Chinese. Russo and Valentino are from Marcianise, where young boxers are brought in as pups and trained before going on to

join either the police or the military, and eventually to try for the Olympics.

Marcianise, a large town of some 40,000 inhabitants, is one of the world centres for boxing, and definitely the Italian capital of boxing. Youngsters come from all over Caserta to work out in one of the city's three free gyms. There is a good reason why Marcianise is a breeding ground for Italian boxers. It all started when American soldiers from the nearby base in Campania sought out sparring partners from amongst the toughest labourers in the area, men who would fight a marine for a few dollars. And after beating many of the soldiers, these men continued boxing in the gyms and started to teach children from the area.

Mimmo Brillantino is one of the coaches who made the Excelsior gym famous. He is a sort of boxing guru and has trained European champions, Olympic boxers and world champions. He sniffs out young talent, follows them, looks deep into their souls. And then he raises them – part lion-tamer, part big brother. When he was training Clemente Russo, Mimmo would go to Clemente's house every morning to wake him up. A morning run at 6.00 a.m., then two and a half hours of training before school. After school Mimmo would be waiting. He would feed Clemente, watch him do his homework, and then training would start again. Short sleeves in the sunshine, a sweatshirt in the rain. Training, always training.

I met Clemente Russo and Domenico Valentino just before they left for the Olympics. They were in the Polizia di Stato sports arena,

where the police force work out, whatever the sport. You might see the great judo artist Pin Maddaloni or the fencing champion Valentina Vezzali. They are all part of the Golden Flames police force. This is where Clemente Russo got his nickname: "Tatanka", the Lakhota Sioux word for the male buffalo. One of his trainers gave him the name after watching "Dances with Wolves". Trying to communicate with his new friend Kicking Bird, Lieutenant John Dunbar gets on his hands and knees to imitate the buffalo, using his hands as horns. The tribal chief understands and says "Tatanka". Dunbar nods and repeats it.

Clemente earned himself that name because at times, when he is in the ring, he forgets he is a boxer. He lowers his chin to his chest, stares straight ahead, and starts hitting. They have to yell at him from the corner to remind him that he is an athlete, not a thug. "If you fight like that and don't knock down your opponent right away, he'll end up beating you," says Giulio Coletto from the Italian team. "Because you'll either run out of breath defending yourself or lose concentration. And then you collapse. Like a buffalo after charging."

Tatanka has a tattoo on his ribs: a running buffalo with boxing gloves on its front hooves. So why did Clemente start going to the gym? "I was an idiot!" he admits. "And I got bored hanging around outside bars." Today Clemente Russo's great strength is his ability to keep the big picture in mind. He seems to know what he has to do from first to last. He is powerful, too, but he does not consider this his greatest strength. "Strength is the last thing that matters," he says

to me. "It's the mind that comes first. That's the main thing, Robby."
Real boxers are not born with a mean streak. Often they start going
to gyms to build up their aggression, after which they have to learn
to control it. "The first thing is not to get punched. The second thing
is to land punches." Clemente and Domenico agree on this.

The gym that churned them out, the Excelsior, recently cele-
brated twenty years of activity, ten of them at the pinnacle of the
boxing world. However, unlike other sports, the trainers who follow
their champions with an almost missionary zeal earn very little, just
enough to live on. Yet they spend their days in the gym training
young boxers, counting push-ups, teaching boys how to punch the
bag, jump rope, run and build up their stamina. "How to be men,"
adds Claudio de Camillis, policeman, international judge and head of
the Golden Flames sector, who has seen them all through.

"They call us from Marcianise," Claudio de Camillis says. "They
point them out to us when they're still little squirts. We get a phone
call from Brillantino or coach Angelo Musone or from Clemente de
Cesare, Salvatore Bizzarro or Raffaele Munno – the Knights Templar
of boxing. We take them in because they can vouch for these kids,
their provenance, their seriousness." The police force enrols them
and believes in them. Without the Golden Flames, there would be no
amateur boxing. Basically, there would be no boxing in Italy.

Since the sport no longer attracts many sponsors, but for these
gyms the only alternative for boxers would be to head to Germany,
the country that has recently attracted the most feared boxers of them

all, the men from the East. Russians, Ukrainians, Kazakhs, Uzbeks, Belarusians. This new breed of ferocious fighters has tipped the balance of boxing and turned Germany into a promised land for the sport. While many Italians from Marcianise have become champions, others have simply gone on to become excellent athletes. All of them, however, have stayed out of the Camorra. You might see the sons of one connected family at the gym in the morning and the sons of a rival family in the afternoon, but boxing prevents boys from turning to crime. Removes them from the logic of confrontation.

This is because the rules of boxing are incompatible with the rules of the clan. Boxing is one on one, face to face. Training is tough. There is respect for the loser. The slow achievement of victory. "It's a life of sacrifices," Clemente Russo says. "For the past twenty years I haven't had the energy to go out at night. I don't even remember what it's like to hang out at a bar any more, the way they do around here." The Camorra have no interest in boxing, and for one simple reason, which Russo well understands. "There's no money in it. When I won my first Junior European title I was able to buy myself . . . a moped."

In Germany and Spain, meanwhile, the Russian Mafia have tried to infiltrate the sport. But in Marcianise the two main families that dominate the area – the Belfortes and the Piccolos – do not need boxing to make money. They have other interests. The Belfortes are the kind of people who wanted to bring television crews from the reality T.V. show *Life in Direct* for the wedding of Franco Froncillo,

brother of the emerging boss Michele Froncillo. They wanted the wedding – complete with a helicopter to drop petals on the happy couple and their guests – to be filmed not just by freelancers, but by a public broadcaster. So that Froncillo's relatives and Italian housewives everywhere could admire (and envy) the bride.

The Mazzacane and the Quaqquaroni, as the two rival families are called, dominate this vast territory through their control of medium- and small-sized businesses. This is the region with the largest commercial shopping centre and the largest multiplex cinema in Italy – not to mention the highest unemployment rate and rate of emigration. There are subcontracts to be earned, car parks to run and private police forces to mobilize. Above all, there are plenty of opportunities to run rackets.

In March 2008 the Municipality of Marcianise was dissolved because of Camorra infiltration. In 1998 Marcianise was the first Italian city since the end of the Second World War to have a curfew imposed by the city's prefect. Prior to that, in the 1990s, there was one homicide a day. When the Mazzacane began to massacre the Quaqquaroni, the boxing coaches played a crucial role in saving the region. Put simply, they applied the motto: "Everybody in the gym is equal." Or, as they say where I come from, "Inside, everybody's red."

In the afternoons Mimmo Brillantino would pick up his young boxers from outside the schools or the bars and in the piazzas. In doing so he saved them from being recruited by the clans. Boxing's

code of conduct protected them: a boxing ring is a better prepara-
tion than a university degree. Once you have fought with your own
hands, been drenched in your own sweat, signing up with the mob
would seem like a defeat.

In Chicago in 2007 Tatanka showed the world what it means to
come from Marcianise. He put on his blue boxing helmet and beat
the German Alexander Povernov, to whom he had lost in 2005 in
China. Russo dodged the punches of the Montenegrin Milorad
Gajovi, who had managed to win the European, World and Olympic
titles, and who had already beaten several promising challengers. And
then came the masterstroke against the powerful left-handed Russian
Rakhim Chakhiev, who held his ground in the first rounds, aided by
judges who chose not to record Russo's punches. Tatanka's tactic
allowed Chakhiev safely to reach 6–3. When it came to the last round,
Russo's corner were demoralized. They tried not to show it, but they
were preparing to lose. But Tatanka believed he would win. "He can't
go on," Russo said of Chakhiev. "He's run out of steam. I'm gonna
beat him." In the last two minutes Tatanka began to fight back: a
hook, a jab, he dodged a left and went straight for the Russian's
cheekbone. He picked up four points without his opponent landing
a single punch. But Chakhiev took a hailstorm of blows. He did not
know where he was any more. The fight ended 7–6 and Russo was
crowned world champion.

Domenico Valentino is the other great talent from Marcianise.
Everyone calls him Mirko. His mother wanted to name him Mirko,

but out of respect for her father-in-law she chose Domenico. As soon as she had registered the birth, though, she started calling him Mirko. He is the best lightweight I have ever seen. Speed, technique – he never eases up on his opponent. Touch and run, touch and run. "I used to be a women's hairdresser," he says. "Then I started training. I discovered a boxer inside me." It seems incredible that one of the greatest boxers in the world was once a hairdresser.

Mirko the hairdresser has become the most feared European lightweight. When he is in the corner he speaks Spanish. "I put an 's' at the end of all my words to help me channel the power of Mario Kindelán." Kindelán, a Cuban lightweight and Mirko's hero, won two Olympic golds and was three times World Champion. After winning a match he would stand over his opponent and whisper, "These fists aren't mine. They belong to the revolution."

Domenico Valentino watches himself in the mirror, studying his movements. A mirror is fundamental to boxing: you skip rope in front of it, throw punches towards it. It helps you keep your guard up. You watch yourself so much that you begin to see yourself as another. The body in the mirror is no longer yours. It is just a body: something to mould, to build, something that becomes insensitive to pain and is fast to react.

Boxing remains an epic sport because it is based on physical rules that force men to face up to their strengths and weaknesses. Anyone can prove his worth with his fists. Boxing is an anachronistic way to deal with issues. In the ring you realize who you are and what you're

worth. When you fight, the law does not count, morals do not count, nothing counts except your body, except where your hands and eyes are, the speed with which you hit and dodge, your survival skills. Physical contact does not lie. You cannot ask for help. If you do, you are already losing.

But it is not the outcome of the fight that actually decides who is the stronger. It is how you experience pain. It is the stoicism you need to climb into the ring and stay there. Claudio de Camillis grabs Mirko by the arm and says to me, "Look, this guy weighs no more than 60 kilos. If you saw him on the street you'd say to yourself, 'I could squash this guy.' But, believe me, he's an armoured car."

During the world championships in Chicago, Domenico Valentino, thanks to his speed, beat Hrachik Javakhyan, who had won silver at the European championships. Valentino pranced in front of him and when Javakhyan tried to land a blow, Valentino showered him with punches. Then he won against Kim Song-Guk, the North Korean. His punches, however fast, could not touch Valentino. In the finals against Britain's Frankie Gavin, Domenico had an injured hand. That is his weak point – he has small, delicate hands. Gavin took advantage of this weakness. Unfortunately.

"I never wash anything when I'm competing until I win," says Valentino. "Underwear, socks, shorts. If I lose I throw everything away. And when I win, you can't stand next to me I smell so bad."

When I meet him his hands are wounded. I ask why he didn't wrap them. "No," he says. "This is from something else." And then he

turns his head to reveal a tattoo which says "Rosanna", his girlfriend. A few minutes later he admits, "I got into an argument with her and I was so angry I destroyed a scooter with my bare hands. But if I win at the Olympics, I'm going to marry her."

Domenico Valentino has a great deal of respect both for the sport and for his opponent. "You'll never hear things like 'Kill him!' 'Slaughter him!' from my corner. Never. You beat your enemy. Full stop." He is still on good terms with Frankie Gavin and gets along well with the Uzbek national team, but adds, "I don't like Turks, because when they win they laugh at you. They wave their flag under your nose. Apart from them, we're all brothers in arms."

One memorable fight was against Marcel Schinske in Helsinki in 2007. Children from Marcianise still watch it on YouTube. The German boxer tries to attack. He gets feisty, wants to scare Valentino. He very soon learns that this is a fatal error against a quick boxer. Valentino punches him to the chin so hard that Schinske not only goes down immediately, but falls rigid, his arms still frozen in defensive position, his eyes staring upwards. Domenico Valentino will never forget that direct punch. "Robby, I felt an electric current run through my arm. I've never felt anything like that before. It was as if all his pain shot through me. I got scared because as soon as he went K.O. he started kicking like an epileptic."

As Claudio Camillis recalls: "I had to put my arms around him and slowly help him climb out of the ring. He was crying. He sobbed for forty minutes. He thought he had killed him. He only calmed

down when I assured him Schinske was alright." It might seem
incredible, but that is the way it is: you go into the ring to knock out
your opponent, but you do not want him to get too badly hurt. You
want him to keep being a man and a boxer. Like Joe Frazier, one of
Clemente Russo's heroes.

Joe Frazier was a compact, very black mass of muscle, but he was
nimble. He won the World Heavyweight Boxing Championship in
1970. In 1971 he fought with the then-retired Muhammad Ali,
because he realized that if he was going to call himself a champion
he had to fight Ali. After fifteen rounds he finally found a way for a
hook. Ali fell and lost. Four years later, Frazier challenged him again
in what is now considered the best match of all time. Neither of them
could outdo the other. Both Frazier and Ali were bleeding. Their eyes
were puffed shut. They were both out of breath. The referee did not
have the courage to interrupt a fight that the whole world was
watching. The trainers did not want to be the ones to chuck in the
towel. So it was Frazier who decided. Both of them were exhausted
and beaten, but Frazier was afraid of killing or of being killed. His
heart racing, with shortened breath, his jaw dislocated, blood spouting
from an eyebrow, Frazier knew it was up to him. So he backed off,
handing Ali the victory.

The laws that come into being when others are broken get
written on the body. Loyalty, anger, and respect for your opponent
all rise to the surface after you have tried to massacre him and he has
tried to massacre you. You are equal. "Underneath it all," Frazier said,

"it's not that hard to find a reason why. You know what's right, and you know what's wrong." Without knowing it, Joe Frazier had echoed Emmanuel Kant.

Domenico has an unforgettable face. A boxer's face. "No-one has ever broken my nose — that's just the way it is." He has one of those faces that fists and exercise have worn down the way that wind and water wear down stones. Piero Pompili aims his camera at him, then lets me look down the lens. Frazier's almost-Aztec face appears. Pompili is the best-known photographer in the world of boxing. He has photographed almost all of the big names when they were still knots of muscle and ambition. Pompili sees the work of the Old Masters in their faces. "Look at Guido Reni — here comes Guido Reni!" or else "He's a Caravaggio! You're a Caravaggio!" Boxers look at him. They like him, but they don't know what he's talking about. And he eggs them on, like a fashion photographer with a super-model, but using a different vocabulary: "Come on, Tatanka, give me a hook. Alright, Mirko, speed up now, faster. Get him! Get him!" Pompili sees something more: he captures the movements that define these men, and carries them into his black-and-white photographs.

I have mixed feelings watching Tatanka in the ring while Pompili takes pictures. I have never envied a man before, but now I envy Clemente Russo. His body transmits an archaic sense of familiarity. This is how you would imagine Hector or Alexander the Great or Achilles, the soldiers of Xenophon, the warriors at Salamis or Thermopylae. Later you learn that they were not really all that

muscular. That Achilles was no more than 1.5 metres, that Leonidas was chubby and bald – but, even so, no-one can take away the epic beauty of the fighter that Russo now embodies.

"Before a fight, I think of nothing else," Tatanka says. "I don't make love for a week before a fight. I just have to concentrate and imagine my punches, the ones that ought to decide the outcome of the fight." Mirko has a different strategy: "Me, I think about people that have died, my dead relatives." People have to fight for something, in the name of something, he says, but we do it intuitively. "We're like racehorses at the starting gate. That's what we're like before a fight."

The boxers Russo likes best are Roy Jones Jr, and Oscar De La Hoya. What about Muhammed Ali? "Ali fought with his head," Mirko says, "but there might have been greater boxers. Ali used everything – head, body, image, politics. Ali was a champion communicator. He wasn't just a boxer."

Roy Jones Jr brought break-dancing into the ring. His fights are real performances. Sometimes, before throwing a punch, he takes a few well-measured and rhythmic steps back, like a rap artist. When he fights, Roy Jones Jr keeps his guard low, opens his arms, sticks his head out and lets fly a flurry of jabs, with the left or the right. He often works out in water. "Punching in the water makes punching in the air seem easier," his trainer says.

Oscar De La Hoya, whom Valentino also admires, is an American boxer of Mexican origin who was compelled to change his weight

class and travel around the world in pursuit of new competitions to win. He is unbeatable. When Oscar De La Hoya climbs into the ring, his team carry a double-sided flag: one with the Stars and Stripes and the other with the tricolor and eagle of Mexico. Oscar dedicates every fight he wins to his mother, who died of cancer when he was eighteen. First, he works the sides, then he starts in with punches to the cheekbone. He blinds his opponents, and when they can barely hold on to the ropes any more, and then fall, Oscar De La Hoya steps back, waits until the referee has counted to ten, looks to the heavens and says aloud, "That's for you, Mamma."

De La Hoya is the complete boxer: fast, not mechanical, but dynamic and angry. "For me, the most beautiful fight was De La Hoya against Floyd Mayweather Jr," Mirko says. "They were like two soldiers. The best boxing ever." De La Hoya with his Indios face; Mayweather with his good-boy looks: the former representing the Mexicans, Puerto Ricans, Latinos, and every immigrant without a green card; the latter representing the African-American bourgeoisie: ebony-skinned, elegant men, the blacks who made it. The era of Malcolm X is long gone. And Mayweather is more elegant than O. J. Simpson, Puff Daddy or any of those other black yobs who flaunt money, women and success.

During the presentation before the fight, Mayweather pretends to be Ali and insults De La Hoya, but the Mexican simply says, "He looks more like a chihuahua than a tough guy." For a sport that has gone bankrupt, the purse for this match was pretty respectable:

$45 million. De La Hoya's trainer was Mayweather's father, but he had to end their relationship before the match. He simply could not train someone for a fight against his son. So De La Hoya found a new coach.

The fight was a real show. De La Hoya got aggressive, but Mayweather defended well and fought back. He showed the anger of ambition. He wanted to prove that he was Number One. De La Hoya already knew he was the more accomplished of the two. He had nothing to prove. He fought in a way that made it seem as if he was not interested in the outcome. As if it had all already happened. In the end the golden boy was beaten by the unbeaten boxer. "Fights are always won by the person who has something to prove, especially if it's to themselves," De Camillis says.

Russo and Mirko will arrive in Beijing full of energy, carrying all the anger of their land with them. People stop them in Marcianise and ask, "When are we leaving for Beijing?" They say "we" not "you". These two men are no longer alone in this undertaking. They have become the will of many, a collective will that reinforces the soul. And so it comes naturally to me to ask them to do something for us: take back the land that the Camorra have stolen from us; show everybody what it means to come from here; show them our anger, the loneliness, the nothingness. Because this is what you, Mirko and Clemente, are really made of. It is something unique to you and to this place. You are famous because you reached your goal, because you separated yourselves from the cowardice and weakness of those

around you. You measure life by every battle. Fighting means not trusting anyone. You know that life is one long uphill struggle and you have always to give yourself, while never forgetting those who did not make it.

Your ambitions represent the aspirations of an entire region, and carry the hopes of many. The punches you give and take in the ring are not just part of the sport, they are symbols. They become the punches of entire generations, the hooks and upper-cuts of people who are tired of climbing that hill, who get a little angrier each and every day. Don't fight for yourself, for your title, for your coaches, for the money, for the girlfriend you want to marry. Fight for everyone. As De La Hoya always fought for all the Latinos, with his fists, as Muhammad Ali paid with his blood the ransom of all African-Americans in the world, and Jake La Motta channelled the fury of all Italian-Americans.

Clemente and Mirko, weighed down with this history which is ingrained in your muscles – your gaze, your courage, your fast punches, your quick feet – you who have never sought to hide in the shadows, there is only one thing left for you to do, and that is to win.

IO

The Man That Was Donnie Brasco

WE HAVE TO MEET WHERE THERE IS A CROWD SO PEOPLE DO not notice us. Joe Pistone is nervous when he is in Italy. He scrutinizes the faces around him. He speaks in a low voice. He is on edge, but he tries not to show it. This is nothing new for him. I wait outside the restaurant, but he does not turn up. Joe is a sort of living icon, a walking conglomerate of legends, and I am a little on edge myself. I am worried about being in the presence of such a tragic and complex talent.

What fascinates me most about Joe Pistone is his capacity for mimesis: the way he transforms himself into the person he has to pretend to be. Or rather, how he manages to divide his soul into compartments to the extent that he lets you see the worst aspects of himself not as an external thing, but as an integral part of him.

It is getting late, so I go into the restaurant. There he is, sitting in a corner, his back to the wall, eating olives and spitting out the pits

into his hand. I had been waiting for him outside, but he had gone in and had been there for a while.

"It's better to wait inside and eat than stand outside, unless you want to be someone's target." We shake hands and he looks me up and down: "Rarely do you see an Italian so poorly dressed."

Joe Pistone is Donnie Brasco, the undercover persona made famous by Mike Newell's film. Actually, for many years his name was kept secret, known only to the Bonanno clan and the F.B.I. And only a very select few in the F.B.I. knew that Donnie Brasco was the cover name of an agent who for six long years had infiltrated the most powerful Mafia family in New York.

Joe looks nothing like Johnny Depp. He is more of a cross between Al Pacino and the man he played in the movie, Benjamin "Lefty" Ruggiero, the Mafioso who introduced Donnie to the clan under the cover that he was a gem trader. But Joe is clear: "The film is a film. My life is my own." We start to talk. "You know," Joe says, "when I went undercover, the Mafia in New York dominated construction and garbage. They practically monopolized those two sectors. They managed to do it because they controlled the trucks, unions and politicians. Now – thanks to the toughness of the police – it's not that way any more. Their presence isn't as strong.

"Now, everything's changed. The younger generation want everything immediately. And they can get it thanks to drugs. That's how they make fast money, right? My generation, when I went undercover, I dealt in drugs, obviously, but it was only the bosses who

controlled it. The rule at the time was 'no drugs in your neighbour-hood'. Sell them in Harlem. Sell them to the blacks. Or sell them to the rich kids on the Upper East Side. But not in our neighbour-hoods. The new generation doesn't care – they want the money immediately. They use drugs themselves: in the old days you'd never have seen a boss or his family members do coke.

"That's why there's a lot of friction between the old and new guard. It's sort of a generational conflict. The clans have lost control of the unions because the new generation don't have the experience and diplomatic skills to corrupt the politicians the way their fathers did. It would take too long. And they want things too fast. The younger people don't have political skills. Once they lost the unions they lost control over many of the deals that go on in the country. Once they lost the trucking industry, which is the business that moves things, they were no longer able to control the prices."

Joe is shaken by the extraordinary power the Italian cartels continue to have in Italy and around the world. All the mafias of the world model themselves on the Italians: they copy their organiza-tion, their movements, their investments – even if, nowadays, the Italians in New York have delegated everything to the Albanians, Nigerians and Russians. Joe asked me to bring him a copy of the English translation of *Gomorrah*. He places the book face down, hiding the cover. Another careful move on his part. "But Italians won't recognize this cover anyway, will they?" he says.

When he testified before the Senate, to talk about his undercover

work, Pistone described how the Mafia changed as it became more American and less Italian. Basically, the more American they became the less they trusted people. "In the States, at one point, the Bonnano clan called in a bunch of men from Sicily. It was a way for them to be sure of things. The boss Carmine 'Lilo' Galante brought them in. He saw where things were headed. How the young Italian-Americans were losing their 'culture'. The third generation had already distanced itself. That's why he brought in Sicilians. He knew they'd be more faithful. He knew the Sicilian Mafia would be able to travel around America and kill people when they were told to. If they were arrested, no-one would know who they were. And they were reliable: no drugs, no vices. Just discipline and honour."

In the six years that he was a mole Joe managed to see the whole organigram of the Mafia. "Gradually, the Sicilians became more powerful, to the extent that today inside the Bonnano clan there are two factions – the Sicilians and the Americans – and they don't like each other. The Americans were jealous of the Sicilians that Bonnano brought in, and the Sicilians thought the Americans were too soft. The Americans wouldn't kill politicians or policemen, but the Sicilians didn't have a problem with that. In the end the Sicilians killed Galante, the boss. And the Americans had to form a tight alliance with the Sicilians, who were promised positions of power within the Bonnano family."

Once in a while, as he is talking, I feel as if I am sitting with

Donnie Brasco. "Joe," I say, "in my region you're a hero for both sides – you're a hero for the *carabinieri* and for the Camorra kids. Donnie Brasco is Donnie Brasco because he has balls. The rest means nothing."

Joe laughs. "Forget about it!" – it is the classic phrase in the film that all the gangsters repeat continually and that kids where I am from repeat in imitation of Al Pacino and Johnny Depp. They have even translated it as "*Che te lo dico a fare.*" "A Porsche is a great car, *che te lo dico a fare.*" Or "The Yankees have a terrible batting record, but *che te lo dico a fare.*" "Alicia Keys has the best ass in the world, *che te lo dico a fare.*" It is an expression of affirmation. It confirms everything, and the opposite of everything.

I ask Joe if he ever received orders to kill someone when he was undercover. Again, but ironically this time, he says, "Forget about it!" He was ordered to kill people several times, he says, but he always managed to get out of it. "I was assigned 'contracts' and I had to say yes: you can't refuse or they'd kill you. But let me tell you this: if it had been between me and a guy from the Mafia, I would have killed him. I never got caught in that situation, though. One day I am hanging out in the club where we went. I get a phone call. The person on the phone gives me the address of someone I have to kill. The others say, 'O.K., let's go get him.' I knew I wouldn't be able to get out of it, because if we went there and didn't kill him, they would rub me out. I knew he had to die. But just as we were about to leave another phone call comes and they say the information was bullshit.

So we end up not going. But I had to keep in mind that I needed to be ready to do anything to save my life."

Keep it in mind. That is the hardest thing to do. Not in your chest or in your gut: in your mind. Inside his head he had to be Donnie Brasco, not Joe Pistone. For six years he had to forget about his family and who he was. If he thought about Joe Pistone he would have made mistakes, got sloppy, gone straight, the opposite of what he really needed to do. Six years of note-taking, recordings, observing moods, perceiving what was happening to him – and what could happen to him. Joe tried to do it all in good faith. In fact, he has faith in destiny. He is one of those people who never forgets that we all have to have to die at some point and that when it is his turn he won't be able to do anything about it. But until then, he will do everything to stay alive. "Once a guy looked at me and said: 'If you don't convince us that you're a jewel thief you'll find yourself wrapped in a carpet.' I had to prove myself with words, without letting anyone see through me. I had to be like: go ahead, if you want to kill me, here I am.

"Another time, a guy accused me of stealing drug money from the clan. To decide if it was true they held a meeting. If you panic they take you 'for a ride'. They drive you out of town and put a bullet in your head. So instead of leaving the place to avoid going for a ride, I stayed right nearby where they were meeting, right outside the door. I waited until they were done, and didn't give the slightest sign of fear. That's it. There's nothing else you can do."

I do not understand how he pretended not to be afraid. You can fake a smile. You can pretend to be happy. You can pretend to be a Mafioso. But I really can't imagine how you can pretend not to be afraid. Do you let yourself feel it, then banish the thought? It's impossible for me to get my head around it. It's something you can probably only live through – or rather, survive. If you're lucky, anyway. "I admire the way you were able to keep your two lives separate," I say. "That's probably what saved your soul." Joe looks at me with an air of sadness and mumbles a curt "Thanks."

We start to eat. Our voices get lower. The recording is full of sounds of cutlery on plates, of glasses that tinkle when we stupidly raise a glass to the most random things: "To Life." "Fuck the Mafia." "To Italy." "To the South." We manage to overcome any initial tension. I even say Donnie Brasco's name out loud. Joe glances quickly around the restaurant. No reaction. We keep on talking in a normal, conversational tone.

"Where I'm from," I tell him, "if you're part of the Mafia, you have sex appeal and groupies." Joe Pistone confirms the universality of this. "Same thing in America. When you're part of the Mafia and you go to a restaurant they give you the best table. The same thing when you go to a clothes store. When you're a boss, women hang off you like arm candy . . ." He uses this expression a lot, "arm candy", and it's a new one for me.

Does he ever miss that lifestyle? After all, he lived like that for a good number of years, even if it was hard. Joe is clear about this. "No,

I never miss it. It was just my job. I was lucky enough to have grown up in an Italian neighbourhood where the Mafia was a part of life: I knew what it was and it didn't fascinate me. It was never anything special."

In the film, the relationship between Depp and Pacino revolves around a kind of nostalgia. Brasco knows that he will eventually lose Lefty's affection. He also knows that Lefty will be killed as soon as Brasco's cover is blown. But that is not how it really happened. "When they make a movie, the hero has to show some kind of emotion. If the hero says to the police, 'Kill the idiot, I don't care,' the screenwriters will change the scene because the public won't like it. That's why they made it look as if I was sorry when people ended up in prison or dead. They didn't want to give the impression that my character was heartless. But when I became Donnie Brasco, I really did become heartless."

For me, born and bred in a place where many of my close friends ended up working for the Camorra, I never thought of them as heartless just because they chose a different path. You cannot force your heart not to love someone, even if you hate what they do and actively oppose it. I ask him how he dealt with the conflict of interest that arises when people who grow up in Mafia regions are compelled to denounce people who once were friends. Joe explains that he never had to investigate people who were forced to deal with the Mafia but who had no actual connection with them. "When I worked undercover for the F.B.I. I was asked if I had any information

about my neighbours, or friends I had grown up with. I said no, because I'd lived with them. So, you see, Southern Italy and New York aren't that different."

In six years of working undercover, Joe managed to see his three daughters (who lived in New Jersey, while he operated in Manhattan) only once every six months. It was a terrible hardship. "I would go home thinking I was still a father, only to discover that I wasn't any more. I was used to being a man without a family, and my family was no longer used to me. But I was convinced I was doing the right thing for my society and my country. I knew that in the long run my daughters would benefit from what I was doing. It was the only way to look at things. And my family understood that."

Pistone managed to have about 150 Bonnano clan members arrested. There is a bounty out for him for $150,000. It has never been collected and will go to whoever manages to eliminate him. During the killers' trials, many of his one-time friends mimed shooting a gun at him. I manage to say that his courage amazes me. When I was given bodyguards, the colonel of the *carabinieri*, Gaetano Maruccia, said to me, quoting Roosevelt, "The only thing to fear is fear itself." It was a way of telling me to keep on working, and not to fall into the trap of anxiety that the clan members hoped to create. "I agree entirely with that approach," Joe says. "I was never really afraid. If you're afraid, they see it in your face. I was always on the alert, I knew that if I made a mistake I could die, and fear makes you make mistakes."

Fine, I say, but what about afterwards? What about when the undercover work comes to an end? How do you find peace of mind? You cannot live like that forever, can you?

"We found out that the Mafia sent people from every corner of the States to kill me. Ultimately, things were no different from when I was undercover. In my mind I was still doing the same thing. I was doing what was right. And since it was right, there was no reason to be afraid. Because I was one of the good guys. And if I stopped to ask myself what's the worst thing that could happen? Death? I don't see it as such a terrible thing."

Underneath it all, Joe is a simple man. He is at peace with himself. He always kept in mind that his was a job, that he was right, and that he would do everything he could to do his work well. He never thought of himself as a hero or a villain. But it must have been hard for his family. "That was the hardest moment of my life: when they put a reward out on my family, and they all had to get new identities and move. Then I felt guilty because we no longer had a normal life. When you meet new people, you can't talk about your past, who you were, what you did. It's hard for them. It puts even more limitations on them than on me. I know how to take care of myself." I ask him if he ever thought about writing his memoirs. "The first thing I did was to tell the whole truth to someone, so that if something ever happened there would be someone who could tell my story. I told it to an F.B.I. agent, a friend of mine. I was also a friend of Falcone."

Then Joe starts to ask me questions. He says he cannot imagine the anti-Mafia movement in Italy actually winning. Today the Mafia is even stronger than it was back when he was Donnie Brasco, he says, back when the American clans had political connections, when they controlled drugs, shipping routes, garbage trucks and construction companies, connections they are still cultivating and strengthening here in Italy. Now the Italian bosses own companies and many regional bosses even have university degrees and enjoy high profiles. He almost gets upset at how outrageously bourgeois the Italian organizations are.

"You know, the American Mafia is made up of gangsters. They're considered gangsters and they see themselves that way. They come from the streets, like common criminals, and climb the ladder of the organization. Only in films do they ever play the roles of businessmen. They feel different from 'normal' society. They're a separate caste entirely. Here in Italy, you have doctors and lawyers who are part of the Mafia."

Joe tries to water down the myth of the Mafia. "In the States the Mafia don't really go in for villas and big homes. They concentrate their vanity on clothes, cars and women. It wasn't difficult to bring them down. Not like the Italian bosses who construct their own legends. In the States, only Gotti was capable of doing that."

When Joe says things, you believe him. I wonder how vulnerable the Italian-American Mafia made itself by not living out the cinematic version, while our Mafia followed the Hollywood version, not

only by building identical villas, but above all by realizing those dreams of grandeur and power. It helped them succeed. Of course, we have to talk about "The Sopranos", the television series that changed the course of television history and the Mafia image in both the United States and much of Europe.

"In America the Mafia exists mainly in big cities like Detroit and Chicago, because Mafia activities are focused on industrialized areas. In places like the South there is no Mafia, because there's no significant industry. The reason that series was so successful in our country was because people were fascinated by something that they didn't know, by the possibility of seeing the 'good' side of the Mafia families on T.V. As violent and corrupt as they are, no other programme ever showed that side. I like 'The Sopranos', but the Italian-Americans hate it. There are associations in the United States that are designed to protect the image of Italian-Americans. It's funny, but when you meet someone and they find out you're Italian, they always say things like, 'So you're a member of the Mafia.' I can't stand that."

I tell him about an incident that involved him personally. "Once, a Neapolitan boss said that you made a fool out of the Bonnanos, because they believed you were Donnie Brasco and you didn't even have the face of a Mafioso. Nonetheless, they consider you a real man. Meanwhile, Americans tell me that I'll never make it in the Mafia because of my face."

Joe laughs. "It's funny, because the bosses feel like they have to

rely on those kinds of macho excuses to justify themselves. I tricked them and that's all. There are no excuses."

He tricked them alright. Not because of his face, but for other qualities I discover as the evening progresses and Joe continues to fill his glass of wine. Joe has the gift of being able to read people. He weighs them with his eyes. He notices the details. It feels as if he can even tell when you last cut your nails or if you carry good luck saints in your wallet. He asked me about the dog tags I wear around my neck. "Military parachutist, right?" He wants to know more. "Why do you wear those three rings?" I try to explain that I wear them more for tradition than belief. Three, like the Holy Trinity. "Nice," he says. He shows me his Claddagh ring (an Irish symbol of friendship and love), a ring he and his wife both wear. These details prove that reality is much more intense than the fantasy world of films; and this man, with his even-tempered manner, his spryness and paunch, is so much more interesting than Johnny Depp. Take the Celtic ring, for example. It has nothing to do with Donnie Brasco and the whole Italian-American image. It represents his link to the woman who stood by him in the teeth of everything.

Joe gets up to leave. We have finished. He hugs me tightly, his arms around my shoulders, then he takes out a camera. Pistone and I look like a couple of slightly drunk tourists. No, more like an American uncle come to visit his nephew. We do not care about being noticed any more. We stand in the restaurant taking pictures just for memory's sake, the worst kind of pictures for quality, but the

best kind for capturing an important moment. It is a strange feeling, fun and serene. Joe puts on his hat and coat. He hugs me once more and looks me in the eye and says, "Keep at it. Italy's only at the very beginning."

We will keep at it, Donnie, I promise. I promise, Joe.

I I

Siani, a True Journalist

ON SEPTEMBER 23, 1985 GIANCARLO SIANI, A YOUNG JOURNALIST working for *Il Mattino*, was killed in front of his home in Vomero in Naples. He had written, carefully and competently, about the war between the Camorra clans. The city of Naples in which he was killed was profoundly different from the Naples we know today, which seems almost peaceful by comparison. Three hundred deaths a year classified it as a city at war with itself.

The motive behind Siani's murder remains a mystery. Nor is the truth, as established by the courts, altogether convincing. On June 10, 1985 he published a 4,000-word article in *Il Mattino* that upset the Nuvoletta clan. The young journalist had dared to suggest that the arrest in Marano of Valentino Gionta, the boss from Torre Annunziata, was the price the Nuvolettas had to pay in order to avoid an un-sustainable war with another Camorra clan, the Bardellinos. The Nuvolettas decided to end their awkward connection with Gionta,

whose business activities had invaded Bardellino territory, so they handed him over to the police. Having their actions exposed in the article upset not only the Marano-based clan, but their most powerful ally, Totò Riina, the head of the principal Mafia family in Corleone. So the Nuvolettas had the journalist murdered to show the Gionta family that Siani's hypothesis was false – while it was actually true.

Many people, however, felt that the article alone was not sufficient to explain Siani's murder. So they looked more closely into the research he had done on the rebuilding effort after the earthquake, including his exposé of the big subcontracting business that had filled the pockets of politicians, businessmen and especially Camorra elements. Siani had collected precious material, including names, dates and events, for a book that would never see the light of day.

The two hypotheses have one motive in common: Siani was killed for what he wrote. The young correspondent had managed to use the small space he was given in the newspaper to explore the Camorra and its power without ever making it a mere chronicle of facts and dates. Giancarlo Siani came up with new hypotheses using information he found in the field, or that were suggested to him by the facts. His journalism was based on an analysis of the Camorra as a power network, not as a criminal phenomenon. Consequently, the conjectures and hypotheses in his articles helped his readers understand the complex relationship between the Camorra, business and politics.

Looking back on the Siani case, we remember his brief life and

the sacrifice he made. It also makes us examine the current state of investigative journalism, which seems to have all but died out, as have all efforts to expose the complicated financial affairs of the Camorra. The coffin of investigative journalism has been sealed with a heavy lid of silence. Questions about the relationship between the Christian Democrats (D.C.), the Italian Socialist Party (P.S.I.), and the Nuova Famiglia (New Family) faction of the Camorra – the clan cartel that brought together every family in Campania in the 1980s and 1990s, and which the historian Eric Hobsbawm once described as the most substantial holding company in Europe – remain unresolved. After numerous delays, sentences and appeals, all judicial inquiries have ceased, as has the investigative work of journalists. Unfortunately, everything shut down just as the former clan boss-turned-informer Pasquale Galasso had begun to explain the Camorra's financial operations, investments and clientele, which in turn revealed how the Christian Democrats ran the State.

Siani's murder might have taken place twenty years ago, but it feels as if only a day has gone by. The Naples that Siani investigated and exposed does not seem to have been defeated: Antonio Gava, Paolo Cirino Pomicino, Alfredo Vito and Aldo Boffa continue to represent political and economic forces that are still going strong. The Camorra, meanwhile, are thriving. Their hegemony is total and extreme. If you add up the profits of all legal and illegal activities, the clans from Campania handle more than €10 billion a year, an astronomical patrimony that is woven into the economic fabric of Europe

and the rest of the world. Such figures make talking about organized crime absurd. It would make more sense to redefine the clans as a true business system, capable of accessing the "clean" markets while maintaining access to clandestine markets such as usury and drugs, and enjoying the added benefit of military protection.

We have never needed investigative journalism as much as we do today. It is the only means whereby we can detect and disrupt the patterns of investment that allow the Camorra clans to mutate into powerful businesses, controlling transportation, fixing and imposing prices and products. We saw it happen in the Parmalat case, where an alliance with the Camorra allowed the Emilian group to obtain a monopoly over milk distribution, and shore up votes and political power. The local newspapers are the only publications that provide any information at all about the Camorra, but they restrict themselves to the obituaries and reports on feuds in a constant flow of crime news that eschews any will to go into detail or to make accusations. The journalist should be an intermediary between the justice of the courts and the historical record, two realities that rarely coincide. A journalist concerned with the Camorra has to be able to construct and deconstruct elements, facts and hypotheses, *ad infinitum*.

Giancarlo Siani was twenty-six when he was killed. It was a warm September night. He was coming home from work in his Mehari jeep, after a happy day out, full of life. His short biography and the police photographs of his slim body twisted by pistol shots show just how fragile the boy was – and yet he made the leaders of the

most powerful organization tremble. Combining the power of denunciation with an awareness of the terrible frailty of the individual, we need to build a new kind of investigative journalism that is both far-reaching and effective. We have to stop forcing into heroic and solitary battle those few brave journalists in the provinces whose work, in any case, is falling on deaf ears.

12

The Lighthouse Keeper

ON THE MORNING I RECEIVED A TELEPHONE CALL FROM THE director of *L'Espresso* telling me Enzo Biagi had died, I stayed in bed and stared at the ceiling for a long time. I knew he had been ill, but I had not been worried. He had resisted old age. I thought he could hold out against time itself. I was wrong.

Biagi was a colossus, able to blur the line between print and broadcast journalism. He provided the structure – the beams and lintels – for democratic communication in Italy. But I do not think I can really do justice to his life and what he contributed to the information economy of this country. No, I cannot.

For me – and I think I can speak for my generation when I say this – Biagi was new, but in a strange way. It is odd that an elegantly dressed old gent sitting behind a desk became a reference point for younger generations. Bizarre. He was very different from the man he was when young: a tough newspaper editor, a toxic and multi-

focussed journalist of great gifts, involved with the D.C. and P.C.I. None of that was him. Biagi and his generation were nothing like the bearded revolutionaries of 1967. They read different sorts of books (not Mao) and had absolutely no Leninist leanings.

Enzo Biagi often talked about Corrado Alvaro, the Calabrian writer he very much admired, and whom he considered "an Italian storyteller capable of making Italy look at *Aspromonte*, the 'rough mountains', and see itself". For me, Biagi was different from the men of my father's generation, men who once prophesied huge changes, but who today say that change is impossible. Biagi was capable of looking at fragments of the daily news. He examined things bit by bit. He never jumped to a solution, but always advanced slowly one step at a time, and cautiously. He was interested in what people wanted to hear. He wanted to be valuable to people who did not have time to spare. He examined our daily concerns about taxes, terrorism, schools and health and used them to ask bigger questions. He wanted to explain, freely and to spread information and make it known, but to do this with discipline and control.

Biagi was not so much a guard dog of democracy as democracy's lighthouse keeper. And he was a lighthouse keeper in the vein of the wandering sailor Maqroll, as described by the Colombian writer Álvaro Mutis. Maqroll is intent on providing illumination until you reach the safety of the harbour. Rather than guide ships and indicate routes, he illuminates the destination so that people can make their own way. Biagi had the same talent. That is where he was an authority.

He spoke to his viewers as if they were gathered in his office. He never snubbed anyone, did not give in to snobbery and never treated the viewers at home like monkeys sitting in front of their television sets.

Biagi's ultimate objective was to do things well. He appreciated Elio Petri's maxim. He was capable of explaining Italy through data. This is rare for a journalist who despises opinions that become mere personal comments. He opted for two opposing facts: two ideas, two visions. He disliked ideological certainties, forward-thinking atheism, orthodox Catholicism, ranting politics and silent intrigues. He had a way of opposing things by proposing to do the opposite. If you hate politicians' bullshit, look for the clarity. If you hate approximation, look for exactness. He had a simple way of living: be the way you want to be; do not try to get everyone to like you; and decide what is worth fighting for. Making big decisions, for Biagi, was an act of faith in the people who listened to him. Only later did he worry about his own conscience.

When he returned to television, Enzo Biagi invited me to join him. There are moments in your life when it feels as if you are experiencing time differently, as if the seconds and minutes are woven together in a kind of blanket, forcing you to understand that every moment will remain etched in your memory. Experiencing the return to the screen of Enzo Biagi was one of those moments.

I went to his house and we dined alone. Biagi told me stories about life in Naples after the war. He told me about streets where I

had lived for years, but which in his memory were dark and bombed-out ruins. We travelled together through the maps of two different centuries. We discussed the state of things in a kind of recognition of potential disaster. We talked about how politics no longer has the geometry of good administration or the energy to instil passion. We talked about how our country is split into two. How north and south do not communicate. How everything you seem to see is not the real story. How you always end up understanding less of what is happening rather than more. We discussed how our attention is distracted in the world of politics. "The prognostications of a politician get more attention than what is actually happening," Biagi said. "The public come to understand a politician's sadness, but they're kept in ignorance about what's actually happening to their country." He told me about the time he went to the wedding of Giovanni Falcone, the magistrate killed by the Mafia, and spoke of their relationship: "No-one trusted him until the very end. He only got credit for the work he did after his death. Only then did people understand that his was the only way of changing the deadly relationship between the Cosa Nostra and politics. A country that recognizes these things only after an extreme sacrifice is a sick country."

They called us in before the show to do make-up, patting a sponge all over our faces. Loris Mazzetti called out to Biagi as he was being accompanied to his seat by his daughter, Bice. They looked at each other. "Enzo! It's been five years. Five years! We're really back!" Biagi got emotional. Mazzetti clenched his teeth to hold back his

tears. It felt like the longest hour had passed or as if the days of exile had ended. I realized that these were strong men. They had survived the most poisonous swamps: fascism, the Red Brigades, the D.C., the P.C.I., *Tangentopoli*, bribesville.

In the studio, Biagi smiled and whispered to me: "Without the South this country would be in ruins. It would be poor. I cannot stand people who complain about the South."

He invited his readers, his viewers, to look at the things that really matter. It will be hard to get over his death. I feel like a mathematician who has forgotten some basic formula to solve an equation.

That is how Biagi was. He thought silently about what he wanted to say. Like a jaguar, he would prowl around words and take apart their contradictions.

"Let's get together again soon," he said at the end of the show. "We have a lot to talk about. There are still lots of problems, but we can change things."

"Yes," I said. "Let's get together soon, Enzo."

We both knew we would never see each other again.

Farewell, Enzo. *Che la terra ti sia lieve.*

13

In the Name of the Law
and the Daughter

AS AN ITALIAN, I CAN ONLY HOPE THAT MY COUNTRY WILL apologize to Beppino Englaro. It has shown the rest of the world that it is cruel and incapable of comprehending the suffering of a man and a sick woman. My country needs to apologize, because it transformed one family's troubles into a shouting match – one side cheering and the other side making accusations, when really there were no sides to take.

It is not about being pro-life or pro-death. Beppino Englaro was not cheering for his daughter Eluana's death. His face had the expression of a father who has lost all hope of happiness – and beauty – because of his daughter's suffering. Englaro should be respected as both a man and a citizen, *especially* if you do not share his beliefs. He fought with and within the institutions to ensure that the ruling passed down by the Supreme Court would be upheld.

I have often wondered why Englaro did not take care of everything "the Italian way". People who know the world of hospitals whisper that if he had taken her to Holland his problems would have been solved. Or else he could have paid a qualified nurse €200 and got it over with quickly and quietly. In the film "The Barbarian Invasions", for instance, a terminally ill Canadian professor gathers his friends and family together in a house by a lake so that his son and a nurse can clandestinely administer a euthanasia drug.

I wonder how Englaro put up with it all and why he did not follow the example of others who are well enough off be able to emigrate in search of happiness. Some people leave the country for artificial insemination, which is prohibited in Italy. Others leave in search of a dignified death. It comes down to this: people leave Italy not only for jobs, but to be born and to die. Englaro's story presents us with the classic question we used to ask ourselves in philosophy class at university, only under a new guise.

Here, the Kantian principle "act only in accordance with the rules that you believe should become universal laws" is made flesh. This is why Socrates drank hemlock instead of running away. Holding out until the end, ignoring the escape route and repudiating the easy way out are not just gestures in the campaign for an individual's right to a dignified death, but a battle in defence of life for all.

Unquestionably, those who did not share Englaro's position had the right (and were compelled by their conscience) to show their

opposition to his desire to cut off the food and water supply that his daughter had been receiving for years. But the battle should have taken place at the level of individual conscience and not by trying to interfere with the decision of the magistrates.

Englaro went to law for assistance, and after many years the law confirmed that he had the right to decide his daughter's fate. Did that give people the right to unleash their hatred and anger on him? How can Christian charity call him an assassin? Christian history has taught me how to recognize the pain of others before all else. And I have felt it at first hand. But how can someone who knows nothing about what it is like to have a daughter in a coma, immobilized on a bed for years, compare Beppino Englaro to Count Ugolino, who devoured his children out of hunger? That people dare say such things in the name of religion is ludicrous. But the Church is not always like that. I know of religious orders that operate in the most desperate circumstances, where they are the only ones who lend dignity to the lives of migrant workers, to those who are ignored by institutions, to those who cannot survive this present crisis. Sometimes these good Christians are the only ones who will feed them and listen to them. The Comboni Fathers, the community of Sant'Egidio, Cardinal Crescenzio Sepe and Cardinal Carlo Maria Martini are orders, associations and Christians with key roles in preserving dignity in our country.

I know what Christianity is capable of, and I do not condone the kind that will gang up on an enfeebled father who has only the

law on his side. Out of respect for his daughter, Englaro hands out photographs of Eluana when she was beautiful and smiling. He wants her to be remembered as she was when she was alive and well. He could have shown recent pictures of her – deformed, emaciated, puffy, drooling, expressionless and bald. But he did not want to win his battle with the power of an image. He wanted to win the right to decide his own destiny. To those who think they can earn credit with the Church by faking closeness with Eluana, I ask: where were you when the Church thundered against the war in Iraq? And where are you now as the Church begs for humanity and respect for the immigrants stuck between Lampedusa and the bottom of the Mediterranean Sea? Where are you now, when the Church, the only voice of resistance, calls for some kind of intervention on behalf of the South against the Mafia?

It would be a mercy if Italian Christians would stop listening to those who engage in the kind of debates where you do not have to produce any facts. People have forgotten how to understand and perceive pain: the pain and suffering of a father, the pain of a family, the "pain" of a daughter who has been immobilized for years in an irreversible coma and who surrendered her will to her father. To believe that people who did not even know her or her father can question her will is nonsense.

Nor has there been much respect for the law. And yet, laws should be respected to an even greater degree when they contradict one's moral beliefs. This is the essence of democracy. I understand people's

needs to examine the law or even their need to try and convince others not to adhere to it, but not their desire to deny the law itself. In so doing, Italy shows that it is a country capable of profiting from tragedy.

Many politicians used the Englaro case to try and muster consensus or to distract popular opinion from the fact that criminal capital is devouring our banks, and that salaries continue to be suppressed. Our country is on its knees and there is no end in sight. But that is another story. The point is that precisely in a moment of crisis, at a time of clichés, at a time where there is no respect for laws, Beppino Englaro had the strength not to break the law in silence. By turning to the law, by fighting with and within the institutions, by demanding that the ruling of the Supreme Court be upheld, he transformed his private pain (watching his daughter rot in a coma for seventeen years) into my pain, our pain. He drew on one of the most marvellous and most often ignored principles of democracy: empathy. One person's pain is everyone's pain. And as such, one person's rights become the rights of all.

14

Felicia

FELICIA FOUGHT FOR TWENTY YEARS SO THAT HER SON'S memory would not be forgotten. So that everything he fought for and stood for would not disappear in the empty space where a sentence should have been passed, but wasn't. Journalists and politicians did their best to convince us that her son Peppino was nothing other than a terrorist who died planting a bomb on some railway tracks. The Mafia of Badalamenti invented a scenario that has lasted twenty-four long years, just so that they would not have any problems in their town.

But fragile Felicia, accompanied by her other son, Giovanni, always held her head held high among the people of Cinisi, the *carabinieri* and the men of Cosa Nostra. For two decades she waited for a fragment of truth to be unearthed that would finally condemn Tano Badalamenti, the Cosa Nostra boss who murdered her son. For two decades Felicia Bartolotta watched as her son's killer lived it up

around town. She watched him leave and return from one of his many trips to the States. Badalamenti was the king of Cosa Nostra's business affairs until Riina and Provenzano and the other family members from Corleone decided to take him down.

In an interview some years ago, Felicia was asked the usual, rude question that northerners often ask southerners: "Why don't you move away?" She replied in her usual stubborn and innocent way: "I can't move because my house is here, my son works here, and because I have to stay to defend the memory of my other son." And she really did defend him. At the court hearing, little Felicia pointed her finger straight at Badalamenti and accused him of not only being her son's killer, but of tearing him to pieces. She accused him of not only being a Mafioso but an animal. Badalamenti did not blink. Not even Andreotti had been able to do that. It was weird to see this man being accused by a little old lady. Felicia carried her son's memory with her until, twenty-four years later, a sentence was finally handed down and a successful film was made of the story. "The Hundred Steps" is a memorial and homage to the boy who did not leave town, who wanted to fight Cosa Nostra by telling people over Radio Aut and with a few photocopied flyers how they operated. His was a solitary and constant battle that had to be fought "before it's too late to tell the difference".

I used to send Felicia my articles about the Camorra as a kind of thread, to keep me connected to Peppino Impastato's battle. One afternoon, in the middle of August, I got a telephone call: "Roberto!

It's me, Signora Impastato!" I answered hesitantly, but she continued. "We don't have to talk, but I have to tell you two things, one as a mother and the other as a woman. As a mother, I say, 'Watch out.' As a woman, I say, 'Watch out and keep fighting.'"

A lot of young people gathered outside Felicia's house today to pay their final respects to the Signora who fought until the very end, who had no fear of losing. But the townspeople of Cinisi were not there. Nor the mayor. Nor the president of the region. Maybe it was better that way. The gentle smiles of people who came from all over Sicily to be there made the difference. Even though everyone knows the bosses are back in control. But she was there. Her body is at rest. The truth is out. Young people know who Peppino is, know who he was, know the path he took. Now they can follow him. Now she can rest in peace. Farewell, Felicia.

BUSINESS

15

The Magnificent Merchandise

NOTHING COMPARES TO IT. NOTHING CAN REAP QUITE SO much profit. Nothing is guaranteed such immediate distribution and constant demand. No product, no idea, no merchandise can compete with the exponential growth that it has enjoyed over the past twenty years. It has such wide appeal that it can support a limitless number of investors, salespeople and distributors. No product is quite as desired or desirable. Nothing else on this earth has acquired such a perfect balance between supply and demand. Demand is always growing, while the supply is constantly rising to meet it. It crosses generations, social classes, cultures.

Cocaine is the true marvel of modern capitalism, and it breaks all the rules. The most rapacious dealers call it "white oil". The most rapacious dealers are the Nigerian Mafia from Lagos and Benin City. They have become fundamental to the traffic of cocaine in Europe and America. According to *Foreign Policy* magazine, their criminal

networks in the United States are comparable to those of the Italian-American families.

If we spoke in images, cocaine would be the roof of any building, the blood of commercial routes, the linchpin of economies, the legendary powder on the butterfly wings of any large financial operation. Italy is the country where the great interests in the traffic of cocaine merge and consolidate into macrostructures, creating a hub for the exchange and handling of international capital. The business of coke is, without a doubt, the most profitable business in Italy. It is the largest enterprise in Italy, and it enjoys the greatest number of international connections. It can count on an increase of twenty per cent of consumers per year, an increase that is unthinkable in any other kind of business. Cocaine alone allows the Mafia to earn sixty times more than Fiat and a hundred times more than Benetton. Calabria and Campania have the greatest number of international dealers, while the largest European seizures of cocaine have taken place in Campania (they found a ton of coke in 2006). According to the information provided by the anti-Mafia groups of Calabria and Naples, the 'Ndrangheta and Camorra deal with close to 600 tons of coke each year.

Coke travels along African routes, Spanish routes, Bulgarian routes and Dutch routes, but always has one central hub: Italy. Close links exist between the cartels of Ecuador, Colombia and Venezuela, in Quito, Lima, Rio and Cartagena. Cocaine breaks down distances and cultural barriers. It nullifies differences immediately. Its market-

place is the entire world. Its one goal: money. In Europe, the 'Ndgrangheta and the Camorra are the most efficient organizations at moving cocaine. Often among themselves, they make new alliances with groups well beneath the radar of the Italian media, while Cosa Nostra continue improving their techniques for importing and handling cocaine. The younger affiliates (as the anti-Mafia squads in Calabria have found out) no longer call the 'Nndragheta by its old name. They call it Cosa Nuova. And Cosa Nuova is the perfect name for an organization that is constantly spreading and is in alliance with the Neapolitan and Casalesi cartels. A single umbilical cord now extends between South America and Southern Italy and through it runs coke and money. The channels are so well known there are practically runways and tunnels connecting the Italian clans to the South American narcos.

Once, on a beach in Salerno, I met a narco. He took pride in calling himself a narco. Stretched out on a sunbed, arms behind his head, he talked about himself freely, punctuating his monologue with all the right silences, so as to increase my curiosity. He told me things about himself without revealing sufficient details that could be used as proof. He led me to understand he had become something of a legend and said he was friends with one of the major Colombian guerillas, Salvatore Mancuso. The narco talked about Mancuso as if he were a kind of demigod, able to move vast capital sums around and to link southern Italy to Colombia in a single, indissoluble knot. But at that time, Mancuso's name meant nothing to me: an Italian name

in Colombia, one of many. Then, a few years later, I found out every-
thing about him, and his trouble with the law.

Salvatore Mancuso is the head of Autodefensas Unidas de
Colombia (A.U.C.), the paramilitary organization that has dominated
dozens of regions in Colombia for decades, maintaining towns and
coca fields for the F.A.R.C. guerrillas. Mancuso is responsible for the
deaths of more than 336 union workers, mayors, public officers and
human rights activists – killings which, according to him, were
ordered by the Commission for Peace and Justice, which was origin-
ally set up to negotiate between the paramilitary groups and the
government of President Álvaro Uribe.

By allowing himself to be arrested and held under the "pro-
tection" of the Justice of Bogotá, Salvatore Mancuso has avoided
extradition to Italy or the United States, where he would face charges
relating to several tons of exported cocaine. Instead, Mancuso was
given forty years for one of the worst massacres in Colombian history.
In the maximum security prison at Itagüí he began working on dis-
mantling the guerilla groups. Thanks to Colombian law Number 975,
his sentence has been reduced to eight years, which he is now serving
on a farm in the north of the country, from which he can obviously
handle both the best Colombian cocaine and the Italian cartels.

Mancuso's name reminds people of the witness who escaped the
A.U.C. massacres. During the trials, the man, a farmer, clenched the
microphone as if he were trying to squeeze the last bit of toothpaste
out of a tube, and said, "People who fight back have their eyes dug

out with spoons!" Mancuso had thousands of people in his service and a fleet of military helicopters. With entire regions under his dominion, he was a king of cocaine and of the Colombian wilderness. His nickname is "el Mono", the Monkey, which was probably suggested by his lightweight but awkward, orangutan-type body. The Galloway-Tiburon enquiry, coordinated by the District Antimafia Department (D.D.A.) of Reggio Calabria, shows that he has the largest number of business connections with Italy, and even has an Italian passport. Italy would be the safest country to escape to if Colombia ever became too risky for him. Mancuso is wanted in connection with several anti-Mafia enquiries (Zappa, Decollor, Igres, Marcos) and he is the narco-trafficker most responsible for supplying Europe with cocaine. The Italian government that brings Mancuso to justice in Italy will be the one that acts decisively against cocaine. But, for as long as he is in Colombia, every day is just another handshake on a deal.

The Italian criminal world is fundamental to the cocaine trade. It mediates the channels and guarantees constant investment capital. Money used to buy coke is called "*puntate*" (bets or stakes) and the *puntate* of the Italian clans are the fastest to arrive. They are punctual, substantial and guarantee producers a wide distribution, while freeing them of the worry of how their merchandise will be transported to its destination. Operation Tiro Grosso – coordinated by Antonio Laudati and Luigi Alberto Cannavale, and ended in 2007 by the Neapolitan *carabinieri*, the regular police force, the border police,

dozens of European policemen, the American Drug Enforcement Administration (D.E.A.), and the Central Anti-drug Offices directed by General Carlo Gialdi – forced people to look differently at the routes that cocaine takes. Suddenly, they understood that there was a new figure on the scene: the broker. And that there had been a major shift in the direction of international trafficking, from Spain to Naples.

After the March 11, 2004 bombings, Spain clamped down on its borders, which meant total control of ports and automobiles. As such, the country that was originally considered an enormous warehouse for cocaine by the traffickers became a problem. The drug was re-routed to other ports: Antwerp, Rostock, Salerno. The coke arrived after the *puntate* were paid, and the people contributing to the *puntate* turned out to be not only clans but couriers, brokers and anyone who wanted to invest in the magical alchemy that gave you a hundred-fold return. During Operation Tiro Grosso, the Neapolitan *carabinieri* intercepted a call from Gennaro Allegretti, who was suspected of being a courier; he was preparing for a trip to Spain and asking a friend if he was still interested in contributing to the *puntate*. The friend, who had just left his bank and knew he did not have enough ready cash, wanted to pull out of the deal.

"What are you doing on Monday?" Allegretti asked. "I have to be ready to go by Sunday . . . If you say you can't . . . Then on Sunday night I'll just get in the car and go. Otherwise, we can leave at dawn on Monday morning."

"I don't think I can. I went to the bank. I'm pretty sure I can't."

"*Compà* . . . Don't miss the boat! Half of Italy is involved in this thing. What are you waiting for? Next month you'll be going into the bank with three million more."

Brokers meet in hotels all around the world, from Ecuador to Canada. The best are the ones that create import–export companies. They deal with producers like Antonio Ojeda Diaz, who, according to the Tiro Gross investigations, organized his contacts with Italians through import–export companies from Quito and Guayaquil. Containers for Istanbul arrived, but the cocaine was unloaded in various ports in Germany and Italy. The old ways of trafficking are over. Cocaine is now hidden between cans of pineapples slices and inside crates of bananas, where little balls of the drug are sewn, one by one, inside the bananas.

South American mediators like Pastor or Elvin Guerrero Castillo often live in Naples and handle their business from there. Carmine Ferrara of Pomigliano is accused of acting as a drug broker in Italy. He handles the most important *puntate*. As he proudly declared in one intercepted telephone call: "Everyone wants to work with me." The *puntate* are collected by individual clans – the Nuvoletta, Mazarella, Di Lauro, the Casalesi, Limelli – groups that are often rivals among themselves, but who get their coke from the same brokers. Their form of trafficking is simple and businesslike. Brokers mediate with the narcos, then with the couriers who transport it, and then with the "big horses", the men who pass it on to the

clans, and finally to the "little horses" who hand the drug directly to the pusher. Everyone along the chain earns something. The price of cocaine has gone from €40 per gram in 2004 to €10 or €15 in the great piazzas of Italy. But the piazzas in the heart of Naples are an altogether different matter ...

The brokering system is fundamental for the coke producers: they are not connected and have only a very basic knowledge of the clan. Therefore, even if they are caught, they know nothing about the clan itself, and the clan knows nothing of them. If the brokers are arrested, the criminal cartel will manage to find a new broker and likewise if a family gets dismantled, the broker will continue to be able to deal with their contacts without major repercussions. They will simply go to other families or new families will emerge.

There was a short-lived scandal when it was discovered that more than eighty per cent of Italian banknotes had traces of cocaine on them, and that the sewers of Florence contain more coke residue than the sewers of London. The fact that cocaine is the prime engine of the criminal economy and that the criminal economy is doing very well has motivated numerous police forces to press on with their investigations, even though they work with insufficient resources.

Judge Franco Roberti, with his craggy face and deeply Mediter-ranean, almost oriental-shaped eyes, was coordinator of the D.D.A. of Naples until April 2009 and is an ex-director of the National Anti-Mafia squad. He always, especially prior to an emergency inter-vention, reminds us where the real problem lies. During press

conferences about the really big anti-drug operations coordinated
by his office he makes the seriousness of the situation crystal clear.
"Homicides in Naples are almost always linked to drugs. Cocaine is
like a river. It generates an incredible income. The clans compete
among themselves for control of the trafficking. If a clan invests a
million euros in a shipment of cocaine, it will very quickly get back
at least four million. Earnings quadruple with respect to the costs in
almost no time at all."

Operation Tiro Grosso showed how Neapolitan brokers have a
network that extends from Spain (Barcelona, Madrid and Malaga) to
France (Paris and Marseille) to Holland (Amsterdam and The Hague)
to Belgium (Brussels) and Germany (Münster), and how their
couriers and contacts handled Croatia, Athens, Sofia and Pleven in
Bulgaria, Istanbul and finally Bogotá and Cúcuta in Colombia,
Caracas in Venezuela, Santo Domingo, and Miami in the States.

The couriers are usually illegal immigrants who travel in
modified vehicles. And the modifications are remarkable. Coke and
hashish are prepared in a flat-bed truck that gets extended over the
axis onto which the chassis is mounted. This has been dubbed "kami-
kaze" by some mechanics because, as with the original kamikaze
pilots, traditional methods were no longer working. Narco-traffickers
realize that the only way to get through checkpoints is to organize
shipments that can only be discovered if the vehicle is taken apart –
which no motorway police patrol has the resources to do.

During one operation, a car was seized and the police were sure

there was cocaine inside, but they could not find it. They took the car apart piece by piece: nothing. The sniffer dogs smelled it, but could not locate it. They ran around in a state of confusion, frothing at the mouth. The coke had been hidden in crystallized form in the electrical wiring of the car. Eventually, an electrician spotted that there were more wires than necessary.

The drivers of these adapted vehicles usually come from the trafficker's family. That's the best way to distribute the goods. These people are not really clan members, but actual family members without papers; people who do lots of different jobs. They are offered a weekend in Spain and €500 a head for the trip. There is a lawyer on standby in case they get arrested. A family without I.D. – mother, father, child – leaving on a Saturday or Sunday morning – it does not sound suspicious. On the Rome–Naples autostrada last spring, the *carabinieri* stopped a family travelling in a Chrysler carrying 240 kilos of cocaine. When they arrested the parents, the police could not take the screaming child away from the mother. The Sunday traffickers were incredulous – as if they had had no idea what they were doing.

Chryslers are the perfect cars for traffickers. Coke can be hidden above the wheels in the pockets under the windows, which often get stuck because of the stash. In the 1980s the car of choice was the Fiat Panda, but now every trafficker wants a Chrysler. Furthermore, the traffickers are given help by relay drivers, who let the driver with the drugs know if there are roadblocks ahead and if they should get

off the motorway. No-one ever talks on the telephone about the coming or the onward passage of the merchandise. Sometimes they will not themselves know the whole route. All they know is that they have to get it to someone, and that this someone will be in touch with them when they arrive. Once they have delivered the car, they call to let people know that they are there, so that by the time investigators trace the call, it is all over. A new phone card for every trip. Then you throw it away.

In one recorded call, a trafficker who was about to go through a toll at the Caserta North exit realized that the *carabinieri* were waiting for him on the other side. He found a way to delay going through the toll just long enough to call the others: "They got me. Call the lawyer. Turn off your mobiles. Stand everybody down."

When a courier car is followed, the relay drivers try to shake off the unmarked police cars, while big trucks get into position in the autostrada rest areas so that cars can drive up the ramps into their holds and be whisked away. The truck disappears into the traffic. It is so hard to crack the system of relay drivers that to stop one courier last April the *carabinieri* had to land a helicopter on the autostrada near Capua.

The methods for putting the police off the scent are elaborate. A car, tailed by a juggernaut, arrived in Naples from Spain by taking the following route: it left from Ventimiglia, went to Genoa, then back to Ventimiglia, then down again to Rome, after which it went north to Florence, then on to Caserta and finally back to Naples.

Everything arrives in Naples, but things also leave from Naples. For Pistoia, La Spezia, Rome, Milan and then Catania. The whitened noses of Italians are sniffing coke that was baptized in Naples. Neapolitan coke gets everywhere! There is no criminal group that does not have dealings with Naples. Even the Turkish Mafia wanted to buy coke in exchange for weapons.

The investigations required to unravel the brokering of coke are complicated. The whole system of distributing contraband has been switched to cocaine. In fact, the Mazzarella family, it has been shown, gave their brokerage parcels to their one-time "captains", the sailors who carried cigarettes for them in the 1980s and who run now from Moroccan and Spanish ports to Naples, Mergellina and Salerno. Before being used, a motorboat has to be tested by these Neapolitan captains. And no-one ever finds them at sea. Apparently, the Russo brothers – the Nolani bosses who inherited the empire that once belonged to Carmine Alfieri – are in hiding on the ocean. They never set foot on land. They are forever sailing in the Mediterranean and other seas.

Naples is a city of many distractions and false leads. The micro-criminals and feudal powers sometimes put in orders that cannot be handled by the big clans and the bourgeoisie of coke, and the brokers know this. So sometimes things happen differently. The best person to explain this is General Gaetano Maruccia, the provincial commander of the Naples police force. When I first met him I knew immediately I was talking to a competent and tough strategist, but he

also had the *élan* of Captain Bellodi in Leonardo Sciascia's novel *Day of the Owl*. The two qualities were irreconcilable. Here was a man who knew what he had to do and would do it at any cost, but also a man whose sense of duty was motivated by human choice. Maruccia is of Pugliese origin. He has Calabrian blood and a history in Sicily and Rome. He looks like a mature Marlon Brando with his white hair combed back and his deep voice. He always has a cigar in his mouth, and keeps a strange machine in his office that sighs forth some kind of perfume intended to mask the heavy odour of the cigar.

Maruccia explained the problems of policing a territory in a constant state of emergency. He has clear ideas on the matter: "It's vital to understand not only how the legal market is infiltrated by capital that is generated by cocaine, but how it is actually determined by that capital. Understanding this dynamic is the hardest job. Our most recent investigations show that Naples is a major hub in the international traffic of cocaine and that it is also a starting point for the recycling of drug moneys, for reinvestment, a place where profits from trafficking can be mutated into legal funds.

"Finding the traffickers and the channels through which the drug passes, the ways that coke and hashish arrive here is only the first and perhaps the simplest, though the most fundamental, part of the job. Our job now is to focus on how the money metamorphoses, how the white powder becomes all sorts of other things. Businesses, companies, construction projects and bank transfers all poison the legal marketplace. We start with the macroeconomics and take things apart,

so that the micro- and middle-level criminals will have a harder time of it, and will eventually lose hope. This is the only we route we can take. We can't go at it the other way round."

The *carabinieri* of Naples have made important inroads. Recently, the whole Sarno clan, substantial traffickers in coke and weapons from Eastern Europe – using buses of future nannies as cover – were arrested. Even the drug dealing in Scampia has been hit hard, not only with mass arrests at a senior level (including of pushers), but with the breaking down of the clan's little garrisons from which they defended their stake in the piazzas. This was a new and hard-hitting method deploying hundreds of police which effectively stifled all possibility or ambition of resistance.

Maruccia has no dream of reincarnation. He knows only how to see beyond the chaos and through the rain of data that pours down on reality and which provides cover for criminal powers, while simultaneously accruing enormous business potential. "Undeniably, their greatest quality and skill is making business out of coke. Transforming a disaster zone like the suburbs of the north of Naples into a booming industrial centre – albeit criminal – took savvy, and we have to recognize that, and dismantle them the way large corporations are taken apart, not treat them simply as criminal gangs. The biggest companies have a presence in this territory. I fear ours is not a local phenomenon but one of the most important in the country. If we are to confront the problems of Naples we cannot be limited within regional boundaries – regional resources, materials and means are never enough. We

will never be able to give enough attention to the problem. While the routes might start and sometimes end here, they involve the whole nation, the whole world. The ever-growing cooperation between police forces against the traffic of drugs should not revolve around the drug dealers, but should be organized across the board. We have to hit the investment capital that the clans control. If you do not acknowledge this from the start, then you are only dealing with one part of the problem."

We have to stop thinking of cocaine in exclusively criminal terms. Cocaine has become a paradigm through which we can understand the entire European economy. We might not have oil – not the black kind anyway – but cocaine is a window into the Italian economy. All we have to do is follow the investments of the coke brokers from Campania and Calabria to determine where the future legal markets will be. Cocaine has an unimaginable value that can impact on thousands of people's lives. It represents an unknowable index of criminal talent, somewhat like a zero in mathematics.

The mathematician Robert Kaplan said, "Look at the zero and you see nothing. Look through the zero and you see infinity." Our motto needs to be: "Look at cocaine and you see powder. Look *through* the cocaine and you see the whole world."

16

Constructing, Conquering

OSAMA BIN LADEN MANAGED TO GET HIS HANDS ON ONE OF the most desirable neighbourhoods of Milan, near the Navigli canals, and Via Santa Lucia is one of its most elegant streets. It is quiet, genteel and almost invisible, yet it is only a few steps away from the most fashionable restaurants and the historic buildings where lawyers and notaries have their offices, and where businessmen look for apartments and showrooms so they can live next to the old Milanese families. That is what people want these days. The city has stretched and grown out of all proportion. Its suburbs have doubled and then tripled in size. But at one time it had a heart. There was unspoiled land where one could build and sell at €15,000 per square metre. Bin Laden got in there. He now owns a slice of the Milanese property pie.

The Bin Laden I am speaking of is not the terrible head of al-Qaeda. He is not Saudi. He is not a Muslim, and he knows no other

faith than Mammon. "Bin Laden" is the nickname of Pasquale Zagaria, the head of the cement clan, the Casalesi family. Originally from Casapesenna, a small town near Caserta where there are more building companies than inhabitants, he was given the nickname "Bin Laden" during the anti-Mafia investigations in Naples coordinated by Raffaelle Cantone, Raffaello Falcone and Francesco Marinaro, because he is so good both at disappearing and at inspiring fear. They say it started as a joke: if they had put a price on the head of Pasquale Zagaria the way the U.S.A. put a price on Osama bin Laden's, some of his colleagues say they would have turned him in. If you can earn money from loyalty, then you can put a contract out on it.

Pasquale "Bin Laden" Zagaria, according to the anti-Mafia investigation, is one of the few businessmen who holds an effective control over the subcontracts for the high-speed Naples–Rome line. He has control over the Alifana train line. He is poised to be involved in the Naples–Bari line and the metropolitan underground lines. He is even ready to handle the conversion of the Grazzanise military airfield to a civil airport, planned to become the largest in Italy. Zagaria's businesses have won him a nationwide reputation because his work is not overpriced, because of the speed with which he moves men and machines, and his swift completion times. He has put up buildings all over Emilia Romagna, Lombardy, Umbria and Tuscany. The exponential growth of Zagaria's activities, the way he has become one of the key figures in the construction industry, is due in part to the fact that he settled the heart of his empire, and that of the Casalesi, in

Emilia Romagna, and in particular in Parma, a northern city with countless ties to the Camorra, having absorbed much of the clan's capital into its economic fabric.

Colonization *per se* never took place. Actually it was the very opposite. In the North, building companies expand, work hard, construct, sell, buy, acquire and rent. But they often find themselves in financial straits. They therefore need new capital, men and groups capable of intervening immediately and reassuring the banks. The Casalesi offer ideal conditions: the most conspicuous capital, the best workers and absolute supremacy in resolving bureaucratic and organizational problems. And the Zagaria family, which holds the position of leadership in the cement clan, does better than any of its competitors at acquiring land, purchasing materials at the best prices and transforming swamps into appetizing land where luxury condominiums can be built.

The man who links "Bin Laden" Zagaria to Parma is Aldo Bazzini, the builder. A cement man with interests in Milan, Parma and Cremona, Bazzini apparently became Zagaria's puppet when their bond was fortified by marriage. In fact, "Bin Laden" married Bazzini's stepdaughter, and the father of the bride told his lawyer about it in the following way:

CONTI: Where's your daughter these days?

BAZZINI: She has married a . . . a big boss!

CONTI: How about that! And how is she doing?

BAZZINI: She's fine!

CONTI: You found her the right husband, didn't you, Bazzini?

BAZZINI: (*Laughing*) . . . That's right!

CONTI: I'd better stay on your good side, otherwise you'll end up finding me a husband too!

BAZZINI: (*Laughs.*)

CONTI: Is he really a boss?

BAZZINI: Yes, yes!!

CONTI: And will she lead the life of . . . a rich woman?

BAZZINI: Of a super-rich woman!

CONTI: Wow, super-rich!

And, in fact, their lifestyle improved. The *carabinieri* found notes pertaining to Zagaria's expenses: between cement diggers, tiles and grout he found time to spend €19,000 on a day trip to Monte Carlo and €20,000 on a shopping trip at Oro Mare, the jewellery city.

And so, after the boss's wedding, Bazzini's business, which had been tapering off, gradually began to pick up, all thanks to the Casalesi family. It is interesting to note that the names of Bazzini's businesses, which according to the D.D.A. of Naples are in fact handled by the Casalesi, are completely unconnected to the southern territory: Nuova Italcostruzioni Nord srl, Ducato Immobiliare srl.

Emilia Romagna has always been a popular region for the Casalesi clan. Guiseppe Caterino, who was arrested in Calabria two years ago, was a boss with feudal holdings in Modena. There has

always been a Casalesi stronghold in Reggio Emilia, Bologna, Sassuolo, Castelfranco Emilia, Montechiarugolo, Bastiglia and Carpi. All you have to do is follow the route of the building companies and the *émigrés* of Agro Aversano, who have been oppressed by their local clan members. Even the Casalesi's aggressive manners have been exported to the region. On May 5, 1991 a conflict started between Casalesi clan leaders in Modena. On March 14, 2000 there was an ambush in Castelfranco Emilia. And then in Modena, a few months ago, on May 10, 2007, Guiseppe Pagano, the owner of the business company Costruzioni Italia, was shot in the knees.

The connective tissue is cement. Cement is the main artery of Italy's economy. Cement helps you become a businessman, while all other investments are shaky. Reinforced concrete is the best. The cement clans have taken hold of Italy. Their strength is built on silence and the knowledge that their renown does not extend beyond Campania. The clan is unknown in most of Italy, but where it is well known, it is feared. Magistrate Raffaele Cantone, during a trial against the Zagaria clan, said: "We find ourselves in front of bosses who act, think and relate to each other like businessmen. And they are businessmen. To say that the Zagaria clan exists and holds sway over this area is like saying that we breathe air."

In the South, the clan became all-powerful because it controls the cement cycle. It regulates supplies, handles subcontractors and dictates the rules of the racket for every job. It's a perfect system. Extortion is the tool that connects everyone and everything to the

same economic network. The victims of extortion become part of it. Businessmen call the clan leaders and say, "Let me have the job." And other telephone calls are made, warning people not to take part in land auctions: "We're from Casapesenna — that land is ours." Just mention the name of the town you are from and any good businessman will understand. They have a monopoly on concrete. Whoever wants to work has to deal with them, and they manage all the producers of cement.

Building sites must use companies approved by the Casalesi. The story of an interesting episode came up during the investigation: a company that was not well known was working without a "permit" at a building site in Caserta. The clan put out an order – "Block the trucks, don't let them work" – only to discover that the company was actually one of the smaller ones they owned. People went back to work.

The businesses run by the clans manage to save money. They win subcontracts in the South while improving their quality in the North. By constantly growing, they manage to land the big jobs. In 2003 Silvio Berlusconi opened several huge construction sites. According to the D.D.A. of Naples, a summit was held in a hotel in Rome to try to get the clans into the project. Rome is well known to the Casalesi. They have worked there before and are partners with Enrico Nicoletti, the boss of the Magliana gang. The meeting was held in a room in a hotel on Via Veneto and those present included: Aldo Bazzini, Pasquale Zagaria and Alfredo Stocchi (politician and former

Socialist councillor). Under interrogation one witness explained that Zagaria was introduced to him as a businessman, which is partly true, of course, and he said that he ignored rumours that he was also a Mafia boss. The enquiry ended there. What happened later will never be known. What is clear is that the clans do not need large projects. On the contrary. Cement calls for better cement and better prices.

Pasquale "Bin Laden" Zagaria then went into hiding. They looked for him in vain while his two satellite companies continued to win subcontracts. He then turned himself in and asked for a quick trial. At the trial, in Naples, all the big clan members were there. It was the best strategy: the law becomes something that has to respect his business and economic interests. And it was pointless challenging them when you could not get anyone to talk. The judge had no choice but to cut his losses and keep the damage to a minimum. After all, you cannot fight the ruling power.

When the judge, Raffaele Cantone, realized how things worked, he established important enquiries into the cement clan and suc-ceeded in seizing building sites valued at more than €50 million. The clan considereded blowing him up. Apparently, they even ordered T.N.T. from their Calabrian allies. But the media ignored most of this. The judge's bodyguard was doubled and the tension rose. The 'Ndrangheta and the Camorra have always been allies. Silent twins, unlike Cosa Nostra. But, luckily, the doves won out against the hawks and the clan realized that it was not the right time for a murder. The most ruthless clan in the region – a clan responsible for killing young

Federico Del Prete, a union organizer, and one of their own affiliates, because he had homosexual relations in prison and in their view had dishonoured the clan – decided to end the violence. They did not want any television crews around. They did not want national attention. They wanted to remain unknown. And so the clan revoked the judge's death sentence.

Pasquale Zagaria is Capastorta's brother. Capastorta is Michele Zagaria's nickname. On the run for eleven years, he is now the most wanted boss in Italy, even more so than Bernardo Provenzano. Michele is the military leader of the Casalesi and their uncontested leader. In reality, he is more of a vice-president, sharing the job with Antonio Iovine (nicknamed "'o ninno", the baby), while the real boss, Francesco Sandokan Schiavone, is in prison. Michele Zagaria is responsible for putting together a strong clan. His life story is the stuff of legend, legend based on myth rather than invention. Informers have said that his house in Casapesenna has a glass dome for a roof so that a tree planted in the living room can grow. But beyond this characteristic architectural arrogance, the boss's strategy is practically Calvinist. Michele Zagaria never started a family, which is to say he never officially created one. It has been said that he has a daughter, but that he does not have the courage to acknowledge her and give her his last name. He is not married and he lives alone. At one time he went into hiding in a church. He used to meet his men in the confessional: no confession, only business.

The Zagaria clan is all about discipline. They will not use cocaine

among themselves. When the younger men in the clan started using it, Pasquale Zagaria intervened and shut them into a cage with pigs. But even the boss gave in to the drug at one point. In an intercepted telephone call, one of his men, Michele Fontana (nicknamed "'o Sceriffo") a timid and respectful man, told a third party about the time he asked Michele Zagaria if he had ever tried cocaine: "I said, Michele, I just have to know . . . did you ever do it? . . . and he just looked me in the eye and said, 'Don't you know that I'm like a priest? Do what I say, not what I do.'"

Michele Zagaria is very careful about his image. Once, a very powerful businesswoman, Immacolata Capone, met "'o Sceriffo", who said he had a surprise for her. He accompanied the lady to the front seat of his car. Right away she heard sounds coming from the boot and a voice complaining that it could not stand it any longer. When she asked for an explanation, "'o Sceriffo" mumbled something like "Signora, don't worry about it." When they arrived at a huge villa in the Casertano countryside, Michele Zagaria hopped out of the boot and walked into his house. Donna Immacolata was so shocked to see him that she could not utter a word, even though they had been business partners for years. According to some, the boss then took his place at the centre of a living room panelled with rare marble and started to stroke his pet tiger and talk about cement, building, land and subcontracts. This is the stuff of films. It helps create the myth of the clan and nurtures the image of a power based on murder contracts and disappearances.

Donna Immacolata was able to create a strong business and political foundation. She was from the Moccia clan and had become a key connection to the Zagaria clan. She was envied by many Camorra members who courted her in the hopes of becoming the companion of a high-calibre businesswoman-boss. Apparently, the political figure who helped her business thrive was a regional counsellor from the U.D.E.U.R., the popular political party, Vittorio Insigne, whom judges Raffaele Cantone and Francesco Marinaro wanted to put away for three years and eight months for affiliation with the Mafia. Insigne is said to have intervened on Donna Immacolata's behalf and obtained an anti-Mafia certificate for her businesses. In a phone tap transcript, there are constant references to the politician and how the two of them would split the profits. Allegedly, Insigne intervened so that Immacolata Capone won subcontracts, then he got kickbacks from the earnings. At the time of the investigations Vittorio Insigne was a part of the Transportation Commission for the Campania Region. He was acquitted of the charges.

The Neapolitan anti-Mafia organization coordinated by Franco Roberti discovered that Immacolata Capone also had connections with the Air Force colonel Cesare Giancane, the director of the site at Nati di Licola. As a matter of fact, the Zagaria clan even worked for N.A.T.O., building the central radar installation near Lago Patria, a fundamental part of the N.A.T.O. military activities in the Mediterranean. But perhaps she was just too good at what she did:

Immacolata Capone was killed in a butcher's shop in Sant'Antimo. A few months earlier, her husband had also been murdered.

The clan does what it likes with politicians. They are not under anyone's thumb, as they were in the 1990s. Quite the opposite. Today, politics is dependent on business – on the Camorra, in other words. In a wiretap, Michele Fontana ("'o Sceriffo"), revealed his involvement in the recent elections in Casapesenna: "My horse won," he said. The politician he had bet on was apparently Salvatore Carmellino. "'O Sceriffo" called him his "horse": from that point on, he knew he had someone at the Municipal H.Q. who would look out for him and who might also become a business associate. Local politics is where people do business. National politics can be used, abused or ignored. If, as Clausewitz has it, war is nothing more than the pursuit of politics by other means, and if, as Michel Foucault has it, politics is nothing more than war conducted by other means, then business clans are no more than economies that use every possible means to win economic wars.

The Raggruppamento Operativo Speciale (R.O.S.), the elite unit of *carabinieri* in Rome who conducted the search for Capastorta, should start looking for him again. It is almost certain he is in Casapesenna. A military leader cannot leave his territory. The police in the area need support. The search needs to be intensified. Every aspect of the cement business needs to be monitored and tracked. The clans have to be stopped from monopolizing the business, destroying the free market. Everything they get away with reeks of connivance.

The Centre-Left have done too little. They have been too loose, distracted and soft in their battle against the criminal entrepreneurs and the bourgeois leaders directly connected to the clan. The government must intervene in the subcontracting process and in the way that large machinery is rented out, so that it can be traced. Indeed, the whole process should be outlawed. The clans should not be allowed to lease to subcontractors. The whole system of contracts should be so regulated that companies from the North cannot win all the contracts and then pass them on to someone else.

But silence is the guiltiest accomplice. The Spartacus trial has proved to be the largest Mafia trial of the last fifteen years. When the leader of the clan was sentenced it was not even reported in the papers, and on that same day the Camorra tried to have all of his twenty-one life sentences annulled. It would be a tragedy if this rare attempt to stop one of the criminal overlords of cement slipped out of our hands. The clan's defence team – the enormous army of lawyers hired by various Camorra families, such as the Schiavone, Bidognetti, Zagaria, Iovine and Martinelli families – want only silence. They want people to look elsewhere. They want people to look at these issues as if they were peripheral, negligible. They are often helped by the way the intelligentsia distance themselves from such problems, and the way the political class do not appear to understand these problems unless they are mired in them. It is interesting to listen to the wiretaps and hear how the zone bosses and the clan's business leaders are happy when the nation's attention is diverted

towards cohabitation or the war in Iraq or terrorism in any of its forms.

In the coming months we must not take our eyes off the Spartacus trial. The accusations against the bosses are not definitive. The Court of Cassation can erase any kind of sentence. It is vital that we, as a nation, keep our eye on the trial and follow the smell of cement, so that cement, garbage, transportation and supermarkets stop being an endless well for the recycling of money and major sources of investment for the clans. Otherwise it is going to be too late. The demarcation between the legal and the illegal economy will evaporate. My fear is that language will fall short, that words will be silenced or rendered incomprehensible, as if they came from some far-off world. My fear is that every legal trial will become a business pact between judges, lawyers and criminals, where things will get taken care of as slowly as possible and with the least amount of information being published. My fear is that homicide will start to seem normal. I fear that the words we need to describe these things will become incomprehensible.

17

The Plague and Gold

IT'S ALWAYS NIGHT HERE. AND THERE'S NO END IN SIGHT. YOU know things are serious when the simplest rights suddenly become luxuries: getting a usable road, breathing air that's not fetid, being able to have modest hopes or to live without having to consider joining the military or emigrating. The night that has fallen on this land is a dark one. Cancer has become a shared destiny, as inevitable as birth and death. Those who hold positions of power continue to talk about culture and electoral democracy, the shooting stars of Byzantine culture, and those who are opposed seem to be devoured by the fear of not being part of the business, rather than interested in modifying its mechanisms. We're dying of a silent plague that is born inside our bodies and which leads us to die in the oncology wards of half of Italy.

The most recent data from the World Health Organization shows that the situation in Campania is horrifying. There has been a

vertiginous increase in the numbers of cancerous illnesses, including those related to the pancreas, lungs and bile ducts. There have been 12 per cent more illnesses in Campania than in any other part of the country. In 2004 the medical review the *Lancet Oncology* mentioned that there were 24 per cent more incidences of liver tumours in areas near waste dumps, women being the worst affected. It is worth remembering that data from the most at-risk areas in the North of Italy show an increase of more than 14 per cent.

But perhaps this is happening in another country. The people who govern and those who fight back, the people who tell the stories and those who discuss them all reside in separate countries. If they lived in this country, it would not take streets piled high with rubbish to make people notice. It can't be that in our country the president of the Commission for General Affairs of the Region of Campania is the owner of a company – Ecocampania – that collects rubbish from every corner of the region and beyond, and at the same time is also suspected of links with the Mafia. Rubbish is big business in Italy, which is not so much the case elsewhere. Everyone profits from it: it is a source of income for businesses, politicians and the clans. It is a resource that comes at the price of bodies crushed and the earth poisoned.

The rubbish collectors do well from it. These days those from Campania are the best in Italy. They do business with the most important rubbish-collection companies around the world. The Neapolitan companies are actually the only ones in Italy that can

do business with the French group E.M.A.S., a network of environmental companies whose goal is to reduce and limit the environmental impact of businesses that work in the area. If you go to Liguria or Piedmont you'll find a large number of factories are handled by the companies from Campania and that they follow all the criteria and standards. In the North they clean, they collect the rubbish and they are in harmony with the environment. In the South they bury it or burn it.

And the politicians profit from it. As magistrates Milita and Canone showed in their anti-Mafia investigation of the Orsi brothers (businessmen who passed from the centre-right to the centre-left), the current criminal trend that blends together three different powers – political, business and the Camorra – is the consortium system. A public-private consortium is the ideal system for resisting all the mechanisms of checks and controls. In practice, these consortia have helped create monopolies for businessmen close to the Camorra. Monopolies arose because businessmen believed public companies ought to gather rubbish from all the municipalities in the area where the consortia were based. The profits were beyond their imagination. Milita and Canone discovered that a consortium bought the collection company Eco4 for a hugely inflated sum (about €9 million) with fake invoices. The private companies kept the earnings for themselves, and the losses were down to the consortium. Politicians earned 13,000 votes from the consortium and €9 million a year, while the clan earned €6 billion in two years.

The owners of the rubbish dumps also profit enormously, as the story of Cipriano Chianese shows. Chianese, a businessman-lawyer, is the feudal lord of a small town, Parete. For years he ran Setri, a company that specialized in transporting special waste from abroad: he transferred waste from all over Europe to Giugliano Villaricca. His illegal loads never needed to be authorized by the region. He had the only authorization required – that of the Camorra. Accused by the anti-Mafia magistrates Raffaele Marino, Alessandro Milita and Guiseppe Narducci of illegal subcontracting in association with the Camorra and of severe and continual extortion, Chianese was the only person who ever received precautionary measures signed by the judge of Naples.

At the centre of the inquiry were caves X and Z, illegal dumps near Scafarea in Giugliano, owned by Resit and bought by the government commissioner during the rubbish crisis of 2003. According to the investigators, Chianese is one of those businessmen who know how to take advantage of an emergency. With his waste-management business, Resit, he was able to help the special commissioners earn more than €35 million between 2001 and 2003. The dumps that Chianese used ought to have been closed and cleared. Instead they became goldmines.

Thanks to his friendship with members of the Casalesi clan (or so informers say) Chianese acquired the land and holdings at a very low price. He got the backing he needed during the 1994 elections (as a candidate on the Forza Italia list, although he was not elected)

and obtained clearance for handling the clan's waste. The judge placed all the businessman-lawyer's traceable holdings under temporary seizure: tourist resorts in Formia and Gaeta, as well as numerous apartments between Naples and Caserta. During the rubbish crisis, as the city filled with trash and the dumpsters overflowed and people protested, politicians up for election saw Resit and their dumps in Tre Ponti between Parete and Giugliano as the only possible solution.

Companies in north-eastern Italy also benefit from waste-management companies in Campania. As Operation Houdini showed in 2004, disposing of toxic waste in the correct manner meant prices rising from 21 to 62 cents per kilo. The clan offered the same service for 9 or 10 cents per kilo. The Camorra clans managed to guarantee that 800 tons of earth contaminated by hydrocarbons from a chemical company were dealt with at a price of 25 cents per kilo, transport included. That is a saving of more than 80 per cent on the normal price. If we piled up all the illegal waste material of the clan, it would create a mountain 14,600 metres high with a base of three hectares. It would be the largest mountain on the planet. When the *Moby Prince* ferry collided with an oil tanker and caught fire in 1991, no-one wanted to deal with it, so the Camorra stepped in. According to Legambiente, they eventually dumped the ferry in Casertano, broke it up and left it to rot in the countryside's dumps.

People need to watch the documentary "Biutiful Cauntri" [*sic*], a documentary by Esmeralda Calabria, Andrea D'Ambrosio and Peppe Ruggiero. It shows how toxic waste from all over Italy has

been buried in the south, killing sheep and cattle, and making fish and apples smell rancid.

In other countries they would let people know who the perpetrators are. In another country they know the names of the perpetrators, yet they are still not guilty. In another country the major economic force is organized crime, yet the media is still only obsessed with politics, filling the news columns with polemics, while the clans which destroy and then rebuild the country do so without ever being challenged by the media, who are too busy with news, with disasters.

The Camorra did not start the rubbish problems. They do not profit from creating emergencies and they do not need them. They earn enough from their other interests and the waste and everything else they do, day in, day out, whether there is an emergency or not. They simply pursue their own interests, and do not want people involved in their businesses or their territory. They like it if the rest of the country entrusts them with their toxic waste for an unbeatable price. They think they can just wash their hands of it and forget about it.

The next time you throw something in the rubbish, or under your sink, or when you tie up the rubbish bag, do not fool yourself that it will be transformed into compost or into foul-smelling stuff for mice and pigeons. It will be transformed into business shares, liquid capital, football teams, buildings, financial forecasts, businesses and votes. We do not want this state of emergency to end: we profit from it. No, emergencies are never created directly by the clans. The

problem is that the politicians in recent years have not been able to end the waste cycle. But there aren't any dumps left. They pretend not to understand that landfill sites have saturation points. Very little should in fact be put into a dump, but instead everything ends up there. The waste flows and chokes everything.

What makes it tragic is not that the dumps are full or that the roads are damaged and blocked by "bags" of rubbish. It is that the next generation is being damaged. People born now will never be able to change what our generation cannot bring to an end. These martyred lands have 80 per cent more birth defects than the national average. Think of what we learn from Beowulf, the epic hero who tore off the arm of the monster that attacked Denmark: "The worst enemy is not he who takes everything away, but he who wants us to get used to having nothing." That is what it is: we are getting used to losing the right to live in our own land. We are getting used to no longer understanding what is going on. We are getting used to having someone else make decisions for us. We are getting used to having nothing.

WAR

18

Vollmann Syndrome

I MET WILLIAM TANNER VOLLMANN ONCE ON THE AMALFI
coast. Meeting Vollmann on the Amalfi coast after having read every-
thing about him that has ever been published in Italy was somewhat
like meeting Mike Tyson at La Scala. Like all great writers, Vollmann
has the ability to transform himself without actually losing sight of
his identity, and to get into the most unusual situations without ever
losing his perspective. One part of a writer's identity always gets
involved in the masquerade, but you never really let yourself fully
become whatever it is you want to understand. So instead you talk
about it.

Vollmann was in Ravello, alongside the writer Antonio Moresco,
at the invitation of Antonio Scurati. The audience was mainly
summer visitors who wanted a different sort of evening, rather than
just listening to the usual gossip, or concert or comedian. Vollmann
and Moresco started to read from their notes. The audience grew

restless and started whispering. Soon they could hardly sit still. For them, literature is something for long summer afternoons. They were troubled, disturbed by the cruelty being described, by the fact that they were being forced to come to terms with violence and history. One lady started to wobble in her seat, then tipped sideways. She fainted. What the writer was reading had made her unwell.

Later, when Fabio Zuchella, the director of "Pulp", interviewed Vollmann and asked him what literature meant to him, Vollmann replied that he only realized a short time ago what he wanted from writing: "Making that woman faint when she expected writing to take her to new heights – her body gave out. My words got to her. That's what I want."

Then Vollmann leaned a little closer to the director and whispered, "Where can I get a Nigerian woman around here?" Zuchella replied that he was from Pavia and he did not have the least idea where Vollmann could find a Nigerian on the Amalfi coast. As he was driving down from Naples he had not seen see any Nigerians on the side of the road. Vollmann replied drily: "A city without Nigerian whores isn't worth visiting." This verdict was uttered in what is considered one of the most beautiful places in the world.

Vollmann, who is forty-eight now, writes about history and humanity, but in particular about the latter. Nothing human is foreign to him. His book *The Ice-Shirt* was recently published in Italy. It is more of a delirium than anything else, a marvellous delirium, composed of mythic stories and unknown events. It is an incredible book,

and the first part of a larger project, which is to write the history of the United States of America. Vollmann goes back to the year 1000, when the North American continent was discovered by Vikings, and the genius Erik the Red conquered the new continent. Long before Columbus arrived, Europeans discovered the American continent and deliberately decided to abandon it. The Norwegians conquered Greenland, which today is an autonomous Danish territory, then discovered America and called it Vinland, the land of grapes. Wherever they went they saw wild vines. This had an impact on the Scandinavian imagination. The Norwegians called the redskins "wild beasts", or rather *skræling*. They were beasts to the Norwegians, because they ate deer marrow, wore animal skins and had a primitive manner of fighting. The Norwegians and the native Americans fought a lot. But when the Vikings got over the initial excitement of colonialism, they left Vinland–America and went back to the lands of northern Europe. America remained unknown to the rest of the world for almost 500 years.

In his vast cycle of novels called *Seven Dreams* Vollmann tells the story of America before European colonization. He travelled to the Arctic Circle, 700 kilometres from the closest inhabited centre, to understand the migrations of the Eskimo people.

The Ice-Shirt is a kind of saga, made up in part from ethnological and historical texts and turned into a myth through its narrative structure. The amount of invention that goes into it has less to do with actual history than with how the story is told. Vollmann conceives of

his novels as if they were a series of events happening before his eyes; as if he were an old shepherd sitting in front of a fire telling stories of the past to a younger generation. *The Ice-Shirt* is an incredibly dense book. Vollmann writes tomes, and is perhaps one of the most prolific authors in the world today: "Sometimes I write for eighteen hours at one go." For years he has suffered from carpal tunnel syndrome, which afflicts his wrists with lacerating pain and which comes from spending so much time in front of the computer. Vollmann is keen on telling the story of the vast gulf between man and humanity. He navigates between concrete everyday episodes and events that stretch across epochs. And – much of the time – myths link the two.

In another book, *An Afghanistan Picture Show, or How I Saved the World*, Vollmann writes about his experience at the age of twenty as a volunteer in the Afghan *mujahideen* against the Russians. He went to Kabul hoping to use a weapon and to find something to believe in. He wanted to understand Islam. Vollmann is the kind of writer who lives his stories. Naturally, the best way for a writer to do his job is to be doing the jobs of others. Vollmann excels at this. In his non-fiction writings he is right there. He steps into a particular reality and explores it to the full. He is also present in his historical novels, illustrating the facts and letting witnesses speak, but also using his own voice. He always writes in the present tense. *Europe Central*, which is still not translated into Italian, explores the devastating war between Germany and Russia through a series of stories. He narrates history. He interprets the data he gathers and the biographies he devours. He

does not create a historical novel so much as an epic novel, where singular events are transformed into mythical stories. This is the key to his literature.

Vollmann lives in symbiosis with his writing. He has the same illness as Xenophon, the historian and the mercenary: he can only write about the things he knows everything about. Antonio Scurati explains on the dust jacket of *The Ice-Shirt* that Vollmann blends reality with imagination, truth with lies, elements which in our times can no longer be appreciated by the canons of data and invention, verifiability and fiction. The reader understands that what he is reading is truth transformed into vision. By all means, there is data, but it is transformed into myth, which is not the negation of history but the sublimation of it into the genre of historical novel or short story. The aim is to launch ideas.

It is like his other project, *Rising up and Rising down*, which is as lunatic a literary project as any. Its 4,500 pages are devoted to the history of violence. (In Italy an edited version was published under the title *Like a Wave that Rises and Falls*.) Vollmann says of it: "I tried to come up with a moral algorithm to calculate when a particular act of violence is justifiable. Violence is always related to either blood or numbers, and sometimes it's so vast that we don't even see it." *The Ice-Shirt*, too, is filled with battles and comparisons, reflections on the earth, on the noble cavaliers of yore and their conquests. "I shot to kill and they fired back. I listened to the solitude of many men. I know a great deal about violence."

Writing about human misery or drug dependency or whores or callous exploitation does not mean that Vollmann is attracted to despicable things or sings the praises of decadence. He understands the present by looking in it for traces of the past. A kind of archaeologist of humanity, he is interested in commonalities, in the way man has always been obsessed with power, blood and conquest.

Why Vollmann decided to risk his life by injecting heroin so that he could understand it, why he picked up a gun in Afghanistan to understand Islam and the war, why he gradually lost his eyesight from poring over books about American history, why he exposed himself to the snipers of Sarajevo, can all be justified in the following way: "When I was little, my sister and I often went to a lake. She was six and I was nine, and I had to look after her. One day she drowned, and it was my fault because I got distracted. Her death made me realize that I would never be a good person. That's probably why I always try and help and feel compassion for people who are losers: because I am a loser too, ever since I made that terrible mistake."

A writer can never be a good person. Often he comes to writing precisely because he realizes he cannot be a good person. He ends up writing with a sense of guilt for not being able to change things, in the hope that his indirect actions will multiply in his readers' consciousness, that they might act in his stead or alongside him, creating the ultimate dream of a community of people who understand, feel and walk together. People who live.

19

Apocalypse Vietnam

DISPATCHES IS A NOVEL ABOUT WAR WRITTEN WITH BULLETS.
It is a novel about Vietnam, a non-fiction novel, a novel where the
style is literary but the subject is reality. The research methods include:
sight, sensation, data, perception, interviews, combat, nausea, joy,
cynicism, cruelty, euphoria and damnation. The method is writing
and the method of the writing is the human eye.

Michael Herr went to Vietnam as a writer, not a journalist. The
soldiers to whom he carefully explains this difference do not seem to
care very much. Being a writer and going to war is a lot like going
into the jungle: you go in with no specific destination and no need
to bring back specific information. You might return with only a
handful of sensations. You might write nothing or just collect details.
You might study military maps, learn how a machinegun is put
together, spend hours talking with a soldier, or read the plans for an

attack. Add to this the smell of napalm and the sudden bright dawn
of the Far East. This is what reporter-writer Herr had in mind. And
that is what he did. He gathered, observed, chewed up and mixed
everything together. He took ten years to write *Dispatches*. And after
Dispatches he wrote nothing else. Maybe he wrote nothing else
because, as John le Carré has said, it is the most beautiful war book
written since *The Iliad*.

"Conventional journalism couldn't shed light on this war any
more than the power of conventional weapons could win it," Herr
writes. "All it could do was choose the densest events of that
American decade and transform them into a soft pudding for the
mass media. Journalists took the obvious stories and transformed
them into some kind of conspiracy. The best correspondents were
aware of this and knew better . . ."

Of all the wars, Vietnam figures most in our minds and collective
imagination. It is more a part of us today than the Second World
War, the Thirty Years' War, the Six Day War, the Punic Wars, the
Napoleonic Wars, the Spanish Civil War and the American Civil War.
It is also much more than any of the conflicts that came later: from
Somalia to Bosnia, Iraq to Afghanistan. And it might even be more a
part of us than the mother of all the modern wars put together, the
one that not by mere chance is called the Great War. That war had
Céline and Junger, Remarque and Barbusse, Luss and Slataper and
all the great English poets. But they did not have American cine-
matography. There was no "Apocalypse Now", "Full Metal Jacket",

"The Deer Hunter", "Hamburger Hill", "Rambo", "Good Morning, Vietnam" or "Platoon".

The Vietnam War flies in the face of the sentence uttered by Hermann Göring during the Nuremberg Trials: "History is written by the conquerors." The story of the Vietnam War was written exclusively by the conquered. The only war lost by the United States has become the war with the most representations. "Vietnam" is referred to endlessly by the nation that started the war, by the country that invaded and devastated the country and then pulled out of the war, vanquished. Is it for the first time in the history of humanity, that we find an epic tale of loss and shame? And is Hollywood the only instrument of telling it?

Hollywood tried to tell the story of the Second World War, the victorious war, the just war. But when we really think of war, we think of the helicopters in "Apocalypse Now" and Marlon Brando's desolate expression. We hear the whirring of the pistol barrel in the Russian roulette scene in "The Deer Hunter". We hear the Marines singing "Mickey Mouse". It is one thing to make an epic about the Spartans who sacrificed themselves at Thermopylae to slow down the advance of the Persian armies, or the Serbs who were beaten by the Ottoman Empire on the Merli plains, or the Sioux Indians at Wounded Knee, or any other resistance of a small nation or tribe. But when we transform the loss of imperial troops into an epic, and that very same empire is the one creating the story being told, then a paradigm has truly shifted.

No panoply of images can convey the contradictions the soldiers faced in that hell of torrid heat and insects, surrounded by an invisible enemy who were so alien that the soldiers could not tell them apart or decipher their language or read their signs or their most basic gestures. Everything that happened to these men happened in a vacuum. They remained naked and crude. War stopped meaning anything. There was no meaning. When war is denunced as a horror, as evil, a lost war only means perdition.

And yet to find oneself there, at ground zero, offers the strong and courageous writer an enormous opportunity to measure himself, to witness, to tell a tale. And that is what Herr did. *Dispatches* is a strange novel. The two cinematographic masterpieces of the war against the Vietcong – Stanley Kubrick's "Full Metal Jacket" and Francis Ford Coppola's "Apocalypse Now" – were both based on this book. And what is more, Herr collaborated with the screenwriters on both films. Antithetical films about the same war, both of which have scenes that have taken root in our collective imaginations – vast landscapes, bruised and sparkling colours, baroque and psychedelic apocalypses, cold planning that turns into circumscribed delirium, massacres of small jungle villages. Both stem from the same author, the same book. Today, American soldiers watch these films during training. The images in them come from the deep mine of *Dispatches*, and that mine of words is richer than both films put together, because it was written by someone who was there. Great epics, even epics about losing, have to give meaning to what they depict, even if they have

to do with the end of the world, or the systematic destruction of the human race.

Herr, on the other hand, chose to stay deep inside his Vietnamese mine and make a link between the things he saw: animal terror and unimaginable cruelty, obscenity and desperation, confusion and death. He collected the contradictions that those kids (only a little older than himself) absorbed and threw them down on the page without even trying to make them fit neatly together. If you put together two of the greatest films ever made and compare them with this 300-page book, you begin to understand what the written word can do that cinema cannot: the written word holds everything, even when it is simply told, and that alone is enough to understand its complexity. *Dispatches* is a unique literary work that manages to respect reality, with beautiful descriptions and portraits that very few writers have known how to reconcile with tales of horror and degradation.

The first pages explode with anger, but not the kind of anger that comes from the gut. This anger comes from further away. Herr goes to Vietnam, into a war where you have to pick a side, and tells the story of how soldiers go and get killed in the most atrocious ways and die from the worst kinds of wounds. He writes about having seen someone shoot an armoured car with a machinegun and, looking at the holes in the metal, wonder exactly what those bullets would do to a man. He does not only write about wounds. He writes about the human condition. The human condition in war is a one-sided matter. I always revered Xenophon for his partiality. He knew

the storyteller's gaze can only be honest if he declares he is partial, and Xenophon knew that to write about Greek mercenaries he had to become one. In his book, Herr sides with the Marines because that is the side he chooses, not the side he prefers. He knew that people always have an initial prejudice. "We don't weep for the soldiers who murdered Vietnamese families," some Democrats said. To which Michael Herr replied: "When have you Democrats ever been able to cry for anyone?" The belief that we can have a balanced and fair point of view, and the idea that we are able to distinguish between right and wrong, good and evil, are both radically contested by *Dispatches*. There are only sides, wars, ideas and political choices. There are things that need to be told, faced and examined over and over again, without pretending to be on the good side. Or the bad, for that matter. This book teaches us how to deal with these subjects, which are the kinds of extreme tests a writer has to be able to face.

Michael Herr's dry sentences are worth more than any number of artfully crafted words. "You behave the way you have to, and that's all." War is an inhuman condition where all values are suspended. And this state of suspension is a laboratory for writing. This perhaps is why *Dispatches* has accompanied me like an obsession. It is writing that sees and feels everything: a soldier has a nervous breakdown because he cannot take it any more; another masturbates forty times in succession. There are deadly excesses of alcohol, sex and drugs that are the only way to survive. Or else he writes about death, about men who got shot: how the bullets hit their bodies, as if the bullets

were able to express something new. "When you look at a body full of bullet holes, you never forget it," he says. Herr is never cynical, never plays the tough guy who just puts up with things without giving in. He is never simply a surgeon of words. He's just too close to things to be tough. Too close to the massacred bodies and their stench. To the insanity and the baseness.

This book is beautiful because even just a hint of the horrible things that go on makes the reader feel as if he would have done the same things if he had been there. Or if he hadn't done the same thing, it would have been a physical decision, not a moral one. "How can you shoot women and children?" a war reporter asks a soldier in *Dispatches*. The answer: "It's easy. It takes less bullets." In "Full Metal Jacket", the same line becomes: "It's easy, they run slower." That same war reporter vomits when he is riding in the helicopter. Herr drags the reader into the war. He not only gives us images, but behaviour. You experience the stench of blood and napalm. You feel anger and fear. You feel how ferocious you could be. How a man has to stop being a man when he needs to survive. If I had never read *Dispatches* I could never have written what I have. But this would have been a lesser ill. If I had never read *Dispatches* I would never have understood the life I lead. The human condition in war is always the same.

From the Punic Wars to the Gulf War, only the details change, and that's exactly where the writer's voice needs to be. In *Dispatches* there's continuous action: soldiers meet soldiers, soldiers stop being men, soldiers go beyond the human condition and towards objectives

they never imagined. None of the Marines actually believed they went to Vietnam to fight Communism. No-one believed they were bringing democracy to the slaves in Ho Chi Minh City. But that was not a good enough reason not to fight and die. We kill each other when we have enemies. Some military operations meant certain death and escape was impossible. But the Marines did not flee. You kill and die for your brothers in arms. And for the pleasure of risking everything.

"Apocalypse Now" begins with the words "Saigon shit." The people who volunteered to go to Vietnam were looking for shit. There were people who risked their lives just to see how far humanity could be pushed. Michael Herr does not care about telling a well-constructed story with the right kind of commentary and digestible information, the kind where the writer can say later, "I did my job well. I was rigorous. I sought distance from things so I could be objective." He probably had times when he said, "Who cares? I don't care if I make a mistake. I don't care if I get branded for collusion. I'm going to tell it how it is. How my feet are rotting inside my boots. How I have blisters on my hands from the guns. How perverted people are. I'm going to write about the kid on the stretcher who got his leg blown off by mortar shells and whose hands have been burnt off. He's smiling. He's not crying for his mother. He's laughing. He's laughing because he knows that the stump of his leg and the blood that he sees pouring out from his wounds mean 'home'. Return, family, America. No more mosquitoes, bullets, rain-

forest, fever, Vietcong faces. No more dreams, no more officers' mistakes, no more drugs in place of medicine for fatigue and pain, no more sudden insanity in soldiers who were too calm and too good." Herr manages to look the horror and the beauty in the face. He finds pleasure in the battle, and in the uniform that makes you look stronger and tougher than you really are to the girls back home.

Herr did not want to unravel a conspiracy theory. He wanted to describe what was right there in front of everyone's eyes, but which no-one knew how to mention. Thanks to Herr, Vietnam became the lost war not only because of bullets and Vietcong guerilla tactics, but simply because it was told. Writing about what went on during that war meant destroying all the arguments that led to the conflict, and made the place where a man ceases to be a man, and the closeness that exists between soldiers, the only law of survival. Vietnam, Vietnam. The fact is, we were all there.

20

Today Is Yours Forever

IF YOU KNOW THE STORY OF THERMOPYLAE, OR IF YOU HAVE always seen human conflict through the lens of the three hundred Spartan hoplites who stood firm against a planned Persian invasion in 480 BC, you know what it's all about.

Leonidas and his three hundred men, chosen from the best soldiers, all or most of whom had sons who guaranteed them an heir, confronted the largest armed force that the world has ever seen in the narrow straits of Thermopylae, knowing very well that in all probability they would die, but hoping that the Greeks would be able to step in and come to their help in time.

The film "300" is based on a comic book by Frank Miller that falls under the category of great literature. Actually, it's a graphic novel, the term given to the combination of text and images when "comic book" is too reductive. Miller tells the story of a battle between worlds and cultures that were economically and geograph-

ically close, yet incredibly different. The paradigm is the same as ever: the struggle between good and evil, freedom and slavery, honour and betrayal, convenience and sacrifice. Frank Miller created his Leonidas the same way that he created his superheroes Batman and Daredevil, and the Persia of Xerxes is an ancient Sin City that looms large. The split is always Manichean, the enemy is much stronger but he is corrupt. He is stronger because of his corruption, yet also weak because of it.

Elementary articulations of good and those of evil lead down labyrinthine paths. That is what an epic does. An epic is a container full of values, legends, myths, pride, moral laws, calls to conscience and creatures of blood and earth. People can see their reflections in an epic, and people who want to be part of a community can find the mortar therein to do so. Or if they are looking for something to oppose, they can find that in an epic too. The story of "300" offers all of this. The moment when the Spartans sacrificed themselves so that Greece was not tyrannized is a unique point in history that has been passed down through the ages. And yet it remains unique. When the story turns epic, the facts that are related become the foundation stones of an imaginary world and a constellation of values. "Spartans, today is yours forever!" Leonidas encourages his hoplites. The battle of Thermopylae is a moment in history that contains everything necessary to explain life, to understand it, to synthesize it. And the epic moves in a certain direction. It has a vector. It is determined by who tells it, whose eyes

have scrutinized it, whose stomach has digested it, and for whom it gets told. This comes as no surprise. It is the dialectic between opposing epics. Frank Miller's epic comes from the West, from the rejuvenated gaze of Herodotus, moulded in his image in the infinite way that poetry, novels, dramas and even films and graphic novels can be narrated. Here in the West, the West is always becoming more Western.

The United States is the last country to make an epic. Epics get rooted in cultures where the sense of belonging to a civilization is strong, and which becomes even stronger when that civilization is threatened. Epics establish and protect people. They help people stand up to others. That's just the way it is.

No European director could ever make a cinematographic epic of this magnitude, with its muscle, earth and instinct. It would feel too Fascist for an Italian. But Frank Miller, with the enormous scope of his vision, which he used to translate the words of Herodotus into the Yankee language of the comic strip, managed to bring back the epic strength and the historiographical data of the epic. And what is more, the film was a success.

What is strange is that Frank Miller's book is art, while the film adaptation is not. The film is more of a comic strip than the book. It is boorish, violent and predictable. And even if it has all the production values of a Hollywood blockbuster, it is still crude and clumsy, with an adolescent kind of awkwardness. Underneath it all, it is propaganda. It is the product of a superpower that has been wounded and

that tries to be ferocious and does not realize that it does not look at all like the Sparta it is trying to reflect.

Nevertheless, the film gets to you. It is as if someone is sitting behind you in the cinema and winding you up with a crank in your back. When Xerxes' messenger goes to speak to Leonidas and offers Sparta the chance of becoming an autonomous satrap of the Persian Empire through a gift of earth and water, Leonidas invites him to look into the depths of the deepest well in Sparta and see how much water he can see.

"This is blasphemy," the emissary says. "No-one has ever threatened an ambassador before. It's insanity."

And Leonidas, holding his dagger under the messenger's chin replies, "Insanity? This is Sparta." And he kicks him into the deep well. The cinema-goer's leg jerks instinctively. Leonidas' gesture was a strategic error. He would have saved lives, Sparta would have maintained its autonomy and Persia would have been a stable ally, organized and peaceful at the same time. But in the epic vision of things, that kick symbolizes a refusal of any kind of submission or compromise. Before the final battle, Leonidas (as played by Gerard Butler, who looks like a portrait on a Greek vase) shouts: "Spartans! Tonight we dine in Hell!"

"300" is a celebration of violence. Heads are chopped off, necks are sliced, daggers are driven into collarbones. In this respect, the film remains faithful to the historical truth as well as the audience's taste for pulp. Looking at the hundreds of bodies of the Immortals, the

Persian king's guard, up against the hoplite forces, seeing their lances plunging into stomachs, bodies getting stabbed, muscles being torn off, eyes dug out, one can only think of one of the greatest war writers of all time: Lucan. In *De Bello Civili* (*On the Civil War*) Lucan describes the pools of blood that appeared in the battlefields; how the earth was soaked with blood. The fighters collapsed only when all the blood had drained from their bodies. They emptied themselves. They chopped each other to bits. They stabbed their way through each other. In the film, the soldiers swim through blood, bodies pile up, one on top of another, creating a wall of death. It is almost as if you can smell the stench of so many dead, so many massacred.

The ordinary viewer does not experience the film the way classicists do. They feel betrayed because sword handles are the wrong size, because of inconsistencies in the plot and because some of the feathers and even the wounds are not historically accurate. But "300" powerfully recreates an imaginary world. An imaginary world mediated by Frank Miller, borrowing from history and inspired by ancient images. And its fidelity to the history and legend are notable. The headwear, the helmets and the shields of the Persian soldiers, for example, and even the scenes where they show the multiple ethnicities of Xerxes' armies – from Ethiopians to Indians, by way of Mesopotamia and Libya – add something new to the historical truth and to the epic of Thermopylae. And there are even aspects to the conflict that have been hard to represent up until now, and therefore

hard to conceive of in antiquity. An example of this is *agoge*, the mili-
tary training that every young Spartan had to go through, from which
you either come back ready to be a soldier or not at all. The film
opens with these chilling words: "As soon as he was able to stand he
was baptized by the fire of combat."

Spartan children were taken from their families and divided into
teams when they were seven years old. Their educators tempered and
trained them with physical exercises, privation and suffering. They
wore the same uniform summer and winter. They went without head
coverings and without shoes. They were not fed much, and if they
needed more food, they were allowed to steal. But if they were caught
stealing, they were brutally punished – not for stealing but for getting
caught. They slept on cane reeds and once a year they were whipped
until they bled.

Leonidas' *agoge* ends with the slaying of a wolf that is so large,
and so mythological, that it seems to endow him with all its ferocity.
In fact, in "300" there are also monsters reminiscent of the minor
characters in Peter Jackson's "Lord of the Rings": orcs and trolls of
Tolkienian origin. Herodotus, who was always afraid of the enemy
army, said that the enemy was so large it dried up riverbeds when it
stopped to drink. He described it as a vast, monstrous body. The
film clearly pays homage to Ridley Scott's "Gladiator": there are corn-
fields and warm-coloured filters. All American epics, precisely because
they are epics, are reminiscent of "Gladiator", as well as "Troy" and
"Alexander". The director, Zack Snyder, seems to have wanted to sit

with the Spartans the way a boy decides which team to be on – it's either them or the Athenians. He experiences things through a boy's eyes and is almost dismayed by the Persian attempts at diplomacy. As a matter of fact, Iran's President Ahmadinejad did not like the way the Persians were represented. He said they were portrayed as being too cruel, too bossy, too effeminate. The film certainly does not point out that Persia was a political ally that Athens and Sparta called upon whenever they needed someone to help them destroy their enemies, nor does it mention the fact that Persia was one of the most peaceful empires in history. It is a film about Thermopylae. Having said that, the exaltation of death as the supreme sacrifice and the only way to achieve glory, should interest Ahmadinejad. It might even help him see that he is closer to the three hundred hoplites than the sumptuous gold of Xerxes and his Persians.

Repeated images of bodies remind us of the ultimate sacrifice, beginning with the scene when Leonidas sets off with his men to Thermopylae, the soldiers' red cloaks fluttering like a single river of blood. When one of Xerxes' leading men, a dark, moustached, Palestinian-looking man declares, "Our arrows will darken the light of day," a Spartan retorts: "Then we will fight in the dark." Storms of arrows rain down on Leonidas' hoplites, who are protected only by their shields, in beautiful scenes in which we see the coastlines of Asia Minor crowded with soldiers. The words of Herodotus are heard as the camera drifts over immense battlefields and landscapes: "Spartans! Surrender and hand over your weapons!" This, of course,

is followed by: "Persians! Come and get them!" Anyone, from Casavatore to Caracas, who has ever been asked by an enemy to give up knows what this sentence feels like. Leonidas' Spartans cannot give up. Sparta does not recognize this as an option in its military code or in the soul of its soldiers. Sparta does not take prisoners. It has no pity and does not know how to retreat.

Leonidas meets Xerxes: the latter is almost twice as tall as Leonidas. He appears on a marvellous throne with a golden tower on either side of him and is preceded by two huge lions. Xerxes tries to convince Leonidas to join his ranks: "Imagine the fate that awaits my enemies if I would joyfully kill each one of my men for a victory." Leonidas replies: "I would die for each one of my soldiers." The two visions clash: men in the service of a god-king versus fighters who are led by a warrior-king. When the Immortals – Xerxes' guards – are stabbed, the man who thought he was a god feels a very human shudder go up his spine. The Spartans do not have writing, money, libraries, Mesopotamian astronomers, geometry or thousands of subjected people. But they know how to tell a story. And Leonidas knows that without the story the sacrifice means nothing.

When Delio, one of the hoplites, is wounded in one eye, he is sent to Sparta to describe what is going on, he tells a story of victory, although of course it is the most atrocious massacre. You never really know if it is the special effects or the stories they told you when you were a child, but at the end of the film you have a strange feeling. You feel like taking your son, if you have one, or some kid in the street,

to some place in Italy where there are still traces of Magna Grecia, like the temple of Poseidon at Paestum, the temple of Serapide in Pozzuoli, or Selinunte on the Sicilian coast, and telling him about Thermopylae and how the three hundred – three hundred free men – fought back against the vast army of soldier-slaves. You feel like grabbing him and yelling the words of Leonidas at him so that he will never forget: "The world will learn that free men opposed a tyrant, that the few fought against the many, and that even a god-king can bleed." In the name of Ahmadinejad.

NORTH

21

The Ghosts of Nobel

TO BE INVITED TO THE SVENSKA AKADEMIEN — THE SWEDISH
Academy that has awarded the Nobel Prize for literature since 1901
— is a little nerve-racking. It is impossible to forget that you are
being welcomed to literature's holiest place. But when I arrived in
Stockholm I was surprised. Everything was covered in snow. I have
seen snow only three times in my life.

At the airport everyone was on edge because of the storm, but
I felt a childish joy at venturing out into that vast whiteness, even
though the temperature was very cold and my coat, perfectly fine
for a Mediterranean winter, was of no use in Sweden. The first thing
they explained to me when I arrived at the Academy were the rules.
They are strict. Inflexible. You have to wear an elegant suit. Every
gesture has to be agreed upon. The members of the academy are
nominated for life — eighteen of them, whom I imagine as the
last haruspices of modern letters: venerated, hated, mythologized,

minimized, poked fun at for all their power, courted by all the world. I cannot even picture them. In a special room I meet two of their number: an elderly gentleman who has taken off his shoes and a lady who is helping him put them on again. With natural elegance she shakes my hand, and then says: "Your book entered my heart." Right away I understand that Sweden is very aware of what goes on elsewhere. Perhaps more than any other nation, it feels the contradictions that take place in other countries as its own. Later some of the members ask me questions about Italy in a way I never would have expected. All of them, every single one, asks me about the Nobel laureate Dario Fo – how he is doing, what he is up to – and they ask me to give him their best wishes, as if we spend a lot of time together.

And then they ask me what people think about Giorgio La Pira, the famous mayor of Florence in the 1950s, and also about Danilo Dolci, Lelio Basso, Gaetano Salvemini and Ernesto Rossi. The Italy they know has been entirely forgotten by Italians. They not only remember these people, but believe they are the only ones worth remembering. A gentleman comes up to me to put a microphone on and starts speaking in Italian. I am caught off guard: "Why are you surprised? You're at the Nobel. We speak every language here."

Salman Rushdie is already waiting for me in his special room. We hug each other warmly. The generosity that he has demonstrated towards me since the first time we met comes from someone who cannot forget what he has been through. He wants to convey to me something that he learned from his own experiences. He wants me

to regain more of my freedom with less of a struggle. Just knowing
that I am not alone in my experiences is precious to me. It is strange
but when the *fatwa* was issued against him I was just a boy in elemen-
tary school. The *fatwa* he received from the Ayatollah Khomeini and
the threats that I have received from the Camorra are totally different,
but the consequences for our lives and the repercussions on our
careers as writers have ended up being practically identical. We both
experience the burden of being a prisoner, something that is hard
for everyone to understand. We both experience the same constant
anxiety and the same struggle with the kind of diffidence that can
easily lead to defamation, and which wounds you most because of
its injustice. That is the hardest thing to tolerate. Everything that
Rushdie says about the difficulties – of crossing a street, a flight,
finding a house, everything that makes a protected life impossible –
finds me nodding in agreement. "It's true. That's exactly how it is."

We decide how the talk will be organized, and there are precise
rules for this, too. After finishing my talk, I have to quickly beat my
retreat and not stay too long at the podium, even if there is applause.
Then it will be Rushdie's turn, and then there will be a dialogue.
When that is done, we are not allowed to stop and shake hands or
sign books for anyone. We have to get up, walk across the room and
leave. When we have it all straight, we enter the Academy hall. I had
imagined it to be completely different: a large, sumptuous theatre, a
great stage with balconies and stalls. Like most mythical images, it
proves to be the very opposite. It is a small, intimate, elegant and

refined wood-panelled room. There is a kind of fenced-in area in the centre for guests, publishers, relatives and the permanent secretary to the Academy, Horace Engdahl, together with a few hand-picked journalists.

As Engdahl makes his introductory comments, I start to feel the way I did when I had to defend my university thesis. Everything that I had prepared vanished. My head felt heavy. My mouth was dry. My heart felt as if it had stopped. I thought of all the Nobel laureates who had made their speeches from the same stage where I was about to speak. In 1996 the Polish writer Wisława Szymborska spoke about how both science and poetry had pushed back the confines of the world. Isaac Newton would never have discovered the laws of gravity and Marie Curie would have gone on being a respectable professor of chemistry if both of them had not been obsessed by the phrase: "I do not know."

Even poets have to keep saying those words, Szymborska said. "The world – whatever we might think when terrified by its vastness and our own impotence, or embittered by its indifference to individual suffering, of people, animals and perhaps even plants – for why are we so sure that plants feel no pain? Whatever we might think of its expanses pierced by the rays of stars surrounded by planets we have just begun to discover, planets already dead – still dead – we just do not know. Whatever we might think of this measureless theatre for which we have got reserved tickets, but tickets whose lifespan is laughably short, bounded as it is by two arbitrary dates. Whatever else

we might think of this world – it is astonishing. But 'astonishing' is
an epithet concealing a logical trap. We are astonished, after all, by
things that deviate from some well-known and universally acknow-
ledged norm, from an obviousness we have grown accustomed to.
Now the point is, there is no such obvious world."

I think about this tiny woman's life and how she lived through
the occupation and the war in Poland, how she saw her country
become a satellite of Soviet power, then fall. I think of her words and
how they were able to connect vast stellar spaces to the language of
her poetry, "where every word is weighed".

Her words are stored in that room. They have been absorbed by
the wood. The wood has absorbed all the words of all the people
who have ever received the Nobel Prize: Saramago, Kertész, Pamuk,
Szymborska, Heaney, Márquez, Hemingway, Faulkner, Eliot, Montale,
Beckett, Solzhenitsyn, Singer, Hamsun, Camus. I think of the ones
that come to mind, the ones I know best or have loved, and my head
starts to spin. How did Pablo Neruda hold onto the podium? Did
Pirandello look down at his notes or did he look the academics in the
face? Did Elias Canetti feel like he was talking to the whole world
or just to the people in the theatre? Did Thomas Mann have a presen-
timent of what his Germany would go through shortly after he was
awarded his prize?

I try to take a deep breath, partly to calm down and partly to
breathe in their presence – the way they tell you to breathe in when
you are a kid at the seaside, so that you will be protected from the flu

and winter germs. I try to breathe in the atmosphere of everyone that has been there, hoping they might help me fight off the winter. And then it is my turn. I take my place at the podium. I want to say so much. I want to give so many examples of how hard it is not to have freedom of speech — of what it is like to live under a continual threat simply for having upset some criminals. I want to talk about writers and journalists from Mexico — where the narco-traffickers killed Candelario Pérez Pérez — to Bulgaria — where the writer Georgi Stoev was killed.

But they told me not to put too much meat on the fire and not to talk for too long, so I concentrate on my most important experiences so far. I speak about literature and power, and how writing becomes dangerous because a dangerous category of person exists: the reader. I explain how it is not the word itself that frightens the powers that be, but how the word breaks through the wall of silence. I express my faith in the kind of literature that is able to transport anyone to the most horrible places, from Auschwitz with Primo Levi, to the gulags with Varlam Shalamov. I think of Anna Politkovskaya, who paid with her life for having brought the plight of Chechen people to the hearts and minds of readers around the world. The difference between Rushdie and me is that he was condemned by a regime that does not tolerate opinions that run counter to its ideology. In my country, where censorship does not exist, oversight and indifference take its place: background noise muffles the potential power of the media.

Sometimes I think I am considered someone who comes from a country that is too often, and mistakenly, considered an anomaly. But the things I say do not just have to do with southern Italy and its oppression by the Mafia. As obvious as this seems to me, many others, who are not in my position, see the picture differently. Many intellectuals, who miss having a role in Western society, continue to consider success with diffidence or look down their noses at it, as if it automatically invalidated one's work, as if it could not be anything other than the result of the marketplace and media manipulation, as if the public who made it happen is nothing more than a critical mass. These intellectuals are committing a huge error, especially as regards the public. Just as not all books are equal, not all readers are equal either. Readers can have fun or be understanding. They can be passionate about the most imaginative things or the most painful story. They can even be all of these at different times. Most of all, they are capable of choosing and distinguishing. And if a writer does not understand this, if he does not confide in them and send out his message in a bottle in the hope of having it fall into the right hands, he not only gives up on writing and publishing but on the potential for his words to communicate and have an effect on people. In so doing, he wrongs himself and all the people who went before him.

When Salman Rushdie takes the stage he reminds the audience that literature is born of something deep within human nature: our need to tell stories. He explains how it is through narrative that we represent ourselves and that only people who can tell their stories

are free. Rushdie never wanted to be more than that, a weaver of stories, a novelist with no boundaries, and what hurts him most is not the verdict of an ideology that could not tolerate him, but the defamation by people in the free world who wanted others to believe that he was guided by secondary goals: money, celebrity, career.

I get a lump in my throat while he is talking. I think about how Rushdie spent ten years in hiding and how he managed not to go crazy. Only a person who lives a very calm and protected life can imagine trading freedom for the shadow of death. Salman keeps talking without getting emotional. He finishes his speech and we pass on to the last part of the talk.

At the end, when we stand up to receive the applause from the academicians and the public, we are handed flowers. I know my guards are going to tease me about this later. In my part of the world, this is considered effeminate. We dine in a room where the laureates have eaten. They tell us that the chef is the one who cooks also for the Queen. I cannot swallow a thing until we get to the dessert, a masterpiece of cinnamon ice-cream and caramelized apples.

The dinner ends. Etiquette has it that no-one gets up from the table until the President does so. We walk back through the wood-panelled awards room. It is empty and the lights are low. Rushdie tells me, without a hint of irony, to "continue to have faith in words, to go beyond condemnation, go beyond threats. They will accuse you of being a survivor. They will blame you for not having died. Do not listen to them. Live and write. Words will triumph." We go back up

on the stage and take each other's pictures with our mobile phones. Laughing, we hug each other like children on a school trip who have climbed over the fence to play at being Pericles in the Parthenon. They call us. We should have our coffee, say goodbye and leave.

Someone turns off the lights and for a minute I stand there in the dark. And then, as if in a sudden decompression of air, everything rushes by me: all the days I have spent alone in a room, punching the wall, mistrustful of everyone, feeling as though people are lying to me and betraying me. I hear their insults and accusations in my head: "You are too much in the news." "You show too little of yourself." "It's all fake." "It's all a confidence trick." I think of those who have told me, without a trace of embarrassment, that I should shut up, that I went looking for trouble, that I am a sly one, that many live like you without making such a fuss, that I should not complain, that it is all my fault, that I like the limelight, that I am a shit, a con-man, a copycat. I think of the graffiti in my streets, how people spit at me when I walk by, how friends evaporated at the first sign of trouble, how they were so quick to judge my absence while they just sat there fiddling on their PlayStations, using the precarious job situation as an excuse for their laziness. But then I think of all the kind words I have heard, the invitations to dinner I could not accept, the old ladies who light candles and say prayers to St Augustine for me, the petitions, the hugs and tears, the readings in piazzas, the international press, the writers from all over the world who have stood by me, including some who have been here to receive their Nobel Prize. And as I stand

there in the dark, I take one last deep breath of the moist, woody air that seems to have preserved the essence of the laureates.

"For myself, I cannot live without my art. But I have never placed it above everything. If, on the other hand, I need it, it is because it cannot be separated from my fellow men, and it allows me to live, such as I am, on a level with them. It is a means of stirring the greatest number of people by offering them a privileged picture of common joys and sufferings. It obliges the artist not to keep himself apart; it subjects him to the most humble and the most universal truth. And often he who has chosen the fate of the artist because he felt himself to be different soon realizes that he can maintain neither his art nor his difference unless he admits that he is like the others. The artist forges himself to the others, midway between the beauty he cannot do without and the community he cannot tear himself away from."

Albert Camus said these words at the Academy in 1957, three years before dying in a car accident. I feel as if I can touch him. And I wish I could thank him. I wish I could tell him that his message is still true today: words stir people up and unite them. Words win. They keep you alive.

22

Speech at the Swedish Academy

IT'S OBVIOUSLY AN EMOTIONAL EXPERIENCE FOR ME TO BE here and to have received this invitation. When I heard that I had been asked to come and speak, together with Salman Rushdie, about our situation and our writing, it occurred to me that this is the best protection my words can ever receive.

I wonder if it is going to be hard to explain, here in Sweden, how a book can strike fear into a criminal organization. How can literature create panic in an organization that is made up of hundreds of men and billions of euros?

The answer is simple: literature strikes fear into the criminal world when it reveals how the system works, and it does not do it the same way that news does. Literature is frightening when it reaches the heart, guts and mind of the reader.

Totalitarian regimes tend to condemn and denounce every text and every author that goes against them. Writing a book, a poem or

an article can bring on an attack. It is not that way in the West, where you can write, shout or produce whatever you want. The problem arises when you cross the line of silence within those societies, and a lot of people do. And that is when Western societies make you a target.

It was once said about Primo Levi's masterpiece *If This is a Man* that after that book no-one could say they had not been to Auschwitz – not that they did not know what Auschwitz was, but that they had not been there. That book took you there. That is what criminal organizations fear the most: that all readers feel that power as their problem. That is what happened to Anna Politkovskaya: a lot of people wrote about Chechnya, but she did most to make it an international issue. Her writing turned the problem into a citizen of the world.

When you receive a telephone call from the *carabinieri* saying your life has changed forever, or when a caller leaves a message with the actual hour of your death, your first thought is that it isn't fair. The first question that comes to you is, "What did I do wrong?" You start to hate your own words and what you have written. While your words might travel far and wide, you yourself cannot go out for a walk. You cannot talk to just anyone. You cannot have a life. All this feels strange. In some ways the writer feels – and I am talking from experience here – that his words are no longer his, that they have become the words of many. And therein lies the danger. But only you end up paying for them. You are alone.

The magic of literature, the magic that literature can "create", becomes visible under extreme situations, such as the one where you end up losing your freedom because of something you wrote.

I often think of Varlam Shalamov. Varlam Shalamov wrote a masterpiece entitled *Kolyma Tales*. This book is not only an amazing document about the gulag and Soviet persecution – it is about the entire human condition. Paradoxically, and I do not mean this to sound ironic, what scares the powers that be, and the underworld power too, is the kind of literature that not only reveals facts but transforms those stories into stories of the human condition. Suddenly the stories are no longer simply about Naples, Moscow or Chechnya. They have become real stories that the world cannot ignore and which you cannot stop. Suddenly, you cannot stop the movement, the power of word of mouth. You can try and stop the writer, but the writer's strongest ally is the reader. For as long as the reader exists, nothing can suppress the words of a writer.

When you find yourself in a situation like mine – and this might sound strange – you realize that most of the accusations you receive do not come from the criminal organizations themselves: they put a price on your head and that's that. But you receive endless accusations from civil society. They accuse you of being a clown, a show-off, someone who only wants success, a profiteer.

It wounds me to hear people accuse me of defaming my land simply because I talk about its contradictions. For me, talking about the contradictions is a form of resistance. It is a way of paying respect

to the healthy part of my country. It is an act of hope and it offers people a chance to make things better. The story is never the teller's responsibility. I did not create the contradictions I write about.

The Italian Mafia organizations make €100 billion a year. They comprise one of the largest financial powers in Europe. They invest everywhere, even in Scandinavia. In my town alone, since I was born, they have killed almost 4,000 people. They deal in everything from cement to bread to petrol. Their business affairs are handled by bosses who are doctors, builders and psychoanalysts. Their bourgeoisie is poisoning southern Italy with the illegal traffic of toxic waste.

Once I saw some graffiti about me in my town. I know this kind of thing happens to people who become public figures. But, for me, the really incredible thing was that there has never been any graffiti against the people who were responsible for the increase in cancerous illnesses in my area. There has never been any graffiti against the people that ruined the area. I ask myself: can a writer be held responsible? Can he be guilty for simply having written about things? Are the people who committed those wrongs really innocent?

In this regard, the writer has a huge responsibility. He has to let his words be heard. His stories should not be thought of as something distant and remote. Obviously, I am talking about a particular kind of literature. In my case, I wrote a kind of documentary novel – as Truman Capote would have called it – that tried to talk about reality. The writer's job is to let people hear his words. His job is to have

Swedish, Russian or Chinese readers feel as though the bloody, innocent deaths are happening nearby. They have to feel it happening while they are reading.

I often ask myself: how did I become obsessed with blood and violence? But that is not the way it is. Anyone who has an idea of what beauty is or who knows what it means to live freely and to love would not be able to put up with the stench of compromise, corruption and devastation.

That is why I like to say, and I am paraphrasing Albert Camus: "Beauty and hell exist – in as much as possible, I would like to be faithful to both."

*From the exchanges that followed the speeches
of Roberto Saviano and Salman Rushdie*

HORACE ENGDAHL: I would like to thank you both very much. I think we have had a splendid introduction to our theme on both levels, as Salman Rushdie pointed out, the theoretical and the practical.

I do not know which level to start at, but let us try to begin at the top, with the eternal question of freedom of expression and freedom of the Press.

Do you believe – and this question goes to Roberto Saviano first, and then to Salman Rushdie – that the concept of freedom of speech and the independence of literature is gaining ground in today's world, or on the contrary, is it being more and more restricted?

ROBERTO SAVIANO: I think that people today realize the enormous
potential of communication that comes primarily from the Internet,
but also from independent television channels and from the fact that
journalists can connect with one another around the world when
there is a crisis, but not only at times of crisis. How we face these
enormous possibilities is an entirely different problem, which is to say:
when there are enormous quantities of information, it is no longer
possible to identify the information which will help you to under-
stand.

I believe that this is the greatest danger we face today: there is an
enormous, uncontrollable mass of information, and it is hard to make
sense of it. The people who extricate themselves from the crowds
and help people make sense of the mass of information take on a
dangerous responsibility.

For example, in Mexico, very many journalists have been killed
for writing about narco-trafficking. In a country where it is only too
easy to corrupt the police, and as easy to corrupt the Press, those
who reveal the truth about trafficking are the only reference points
that understand what is really happening, and therefore they become
extremely vulnerable.

It is my belief that intellectuals should take on the responsibility
of helping people understand that having a great deal of informa-
tion – be it in the form of newspapers, books, or films – is deceptive.
The writer's responsibility should be to show that many things do not
get reported, not only because people are violently opposed to this,

but because the man in the street has a difficult time accessing and processing that sort of information.

That is how the Mafia functioned for years: stereotypes of "The Godfather", Michael Corleone, and "Scarface" led people to see the Mafia as something glamorous, violent and terribly fascinating. The public did not want to hear about it in any other way. Sometimes it becomes the listener's job to limit the freedom of those who write, too.

HORACE ENGDAHL: I would like to ask you something. You have described for us — and rather well in my view — why literature is more dangerous than journalism: because it makes the world it depicts and its victims terribly real. It brings us close to them. When we watch the news or read a newspaper, the facts always seem to happen somewhere else, in another world, on another planet. Things seem to happen to someone who does not look like us. We just take stock of things and shake our heads in weak dismay. But when the same events are brought to our attention by a strong writer, someone capable of having us feel the victims' suffering, of making us feel like one of them, of being able to identify with one of them, everything changes. As you said, at that point it is no longer a question of Chechnya or Moscow or Naples. We are all *there*. This, I believe, exemplifies the power of writing as witness. As in Primo Levi, we are there with him in the extermination camp. I find it fascinating that people who are threatened by books like *Gomorrah* or

The Satanic Verses can actually see that the book is much more dangerous to them than the everyday news is. Even if journalists stick to the facts and try to nail people to their criminal actions, what really turns out to be dangerous is when a talented writer takes hold of a subject and transforms it into something immediate, something that is happening while you are reading. At the very moment we open a book it becomes real for us. Do you think this is what the Mafia hates? That you write so well?

ROBERTO SAVIANO: While it might seem paradoxical, if I had written an essay or a novel and had not chosen to merge the two rivers in a single riverbed, I would have definitely been ignored by them and their vindictive instincts. My book contains elements of the essay in the data I refer to – the information, transcriptions of wiretaps, and the enquiries – but my book also has a novel's read-ability and a desire to speak directly to the reader, to invade his space. Literary writing is dangerous precisely because it manages, as you say, to draw everyone in, it allows people to make the story their own. On an imaginative level, literature has more power.

I will conclude with a story about Shalamov.

Shalamov was in a gulag. His cabin was being inspected. The police asked the prisoners to hand over everything they had on them: everything, including artificial limbs, false teeth, everything. One man took out his false teeth; another man popped out his glass eye; another unscrewed his fake leg. Varlam Shalamov was young and

healthy and had none of these, so the police started joking around with him: "What are you going to hand over?" they asked. "Nothing," he replied. The policeman said, "No, you have to hand over your soul."

Shalamov answered, instinctively: "No, I won't hand over my soul."

Annoyed, the policeman said, "A month of punishment if you don't hand over your soul."

"No, I won't hand it over."

"Two months of solitary confinement if you don't hand it over."

"No, I'm not handing over my soul."

"Four months of punishment," which in the gulag meant certain death.

"I'm not giving you my soul."

Shalamov survived the four months of solitary confinement. When he got out, he wrote, "Never in my life, up until that point, did I even believe that I had a soul."

23

The Demon and Life

I CAN IMAGINE HIM SITTING IN HIS SMALL STUDY PORING OVER
short stories and demons, intent on observing how rational calcula-
tions can be upset by the unpredictable details of life. Isaac Bashevis
Singer would have celebrated his 100th birthday in July 2004, no
doubt resembling a venerable Old Testament prophet, the kind of
figure he revered, even if they could make no sense of life or find any
satisfaction in a partial truth. Singer, meanwhile, seemed in his later
years to have become less of a prophet and more like one of his
benevolent and terrible demons, with pointed ears, a Mephisto-
phelean smile, bald pate and sharp, beady eyes.

One of his assistants once said that she had never seen his shadow
and was certain therefore that he had metamorphosed into a literary
demon. Despite the delirious nature of this assertion, I do not think
Singer ever received a greater compliment. In his lifetime Isaac
Bashevis Singer constructed a narrative opera in the vanished – or

rather exterminated – language of Yiddish. A mélange of Hebrew, Polish and German, capable of complicated sounds and hybrid meanings, Yiddish is the language of exile composed of the phonemes of the Diaspora. Theodor Herzl, a founder of the Zionist movement, imagined an Israel where all languages could be spoken, since all of them belonged to the Hebrew patrimony – except for Yiddish, which Herzl considered the language of the ghetto, of marginality, a language created to enable the excluded to communicate. In short, a grammar of shame. For Singer – and for huge numbers of Jews in exile – it was not like that at all.

He left for the United States in 1935 to escape Nazi persecution, and thereafter chose not to write in English but in Yiddish, opting for the language of the *shtetl*, the villages of Jews in Eastern Europe. His choice was not determined by a love for the past – because he had been suckled on Yiddish – nor did he keep in touch with his Polish homeland (in fact, he never wanted to see it again). Singer was interested in using the dregs of a civilization condemned to constant exile, a language capable of communicating the entire baggage of the Talmud and holy texts through popular speech. He wanted to use the language of cultivated plebeians who consulted with God, the language of the rabbis of small Polish, Romanian and Hungarian towns. Yiddish gave Singer access to the ironic mythology of the Hasidic community, while also allowing him to create an entirely new one. His pages are a florilegium of images and stories transformed from the Hebrew tradition. The Torah and Zohar, for him,

were not just holy texts and religious references but symbolic
labyrinths he used to interpret the trials of daily life. Singer managed
to create an anarchic teleology where the relationship with God and
the Law is defined by breach, error, heresy and continual reflection,
leading man to an impossible message, an invisible key, the essence of
truth.

Judaism is more than a faith. It is – as the author himself states –
"a compromise between God and demons", and the novel *Satan in
Goray* is a unique expession of it and a masterpiece.

The novel tells of an historic event that took place in seven-
teenth-century Poland when the Jewish community was turned
upside down by the fiery words of Sabbatai Zevi, a Messianic
prophet. After all the persecutions, the exile, misery, torture and
pogroms, Sabbatai Zevi proclaimed the imminent arrival of absolute
goodness to the Jewish people – the Messiah redeemer. "Everyone
wholeheartedly prepared to follow the Messiah, abandoning their
homes in exile for the utopia of the Land of Israel." Singer writes
about the small and tough little town of Goray, and the largest and
most fascinating heresy that affected millions of Jews from Eastern
Europe and the Near East. According to Sabbatai Zevi, you had to
indulge in the basest human instincts: you had to transgress, spit on
the sacred texts, reject the Talmudic precepts, refuse all authority,
loosen the knot of the family, reject your children, repudiate your
faith, drive yourself into the most abject squalor possible – so that a
new world could be unleashed from the abyss, a world that would

be reconciled and pure. Perfection would rise out of the truly abominable. Sabbatai Zevi condoned a period of errors in order to precipitate a period of justice and total happiness. Soon, however, people discovered that Sabbatai Zevi was a false Messiah. He did not have the Messiah within him, nor was he able to lead the Jews to liberation. He betrayed himself and his delirious dream of redemption.

Singer was fascinated by the false Messiah; even though he himself was the kind of intellectual who abhorred subversion, he was well aware of the positive and useful power of infraction on the Law. He knew that a code existed so that it could be broken, and thanks to this dialectic it was possible constantly to create and eviscerate the world.

Satan in Goray was written while Singer was still in Poland. It feels like an extra chapter of the Bible that has been hidden away by the last custodian of an unconfessable truth. Even though Sabbatai Zevi was not a real Messiah, those who followed him continued to pursue the dream of redemption, because even greater than the Creator is the notion of creation itself.

Singer wrote in *Shadows on the Hudson*, "God needs the help of human beings to bring the cosmic drama to a beneficial ending." Literature thus becomes a divine instrument, capable of linking together worlds within the only world we can know, which (even without exploring Leibniz) we recognize as the world we are forced to inhabit. Gimpel, the legendary character in the story "Gimpel the

Fool", recognizes that "this world beyond is altogether imaginary, alright, but it is a close relative of the real one." And precisely because of this relationship, the only thing to do is consider the force of imagination as a founding force of reality.

The story of Gimpel is quite simple. When he was a child, people played tricks on him. His friends from school, townspeople, adults and children alike – everyone teased Gimpel for being gullible, and that's how he ended up with the nickname "Fool". Gimpel is hoodwinked not because he is stupid, but because he believes that "everything is possible, as it is written in the Sayings of the Fathers". Even as an adult he is duped: he is tricked into marrying the most dishonest woman in town, who pretends to love him but then says she doesn't. In the meantime, she gives birth to six children fathered by other men. But Gimpel does not harbour any ill will towards her – he loves his wife, the children that are not his, and his neighbours. He helps those who betray him. The Rabbi even gives him some advice: "It is written: it is better to be stupid your whole life than evil for an hour."

But temptation finds its way into even the best of hearts. Gimpel, a baker, is tricked by the Spirit of Evil, who tells him there is no God in the world beyond, only "a deep bog". The Spirit of Evil tells Gimpel to get his own back on everyone for all the jokes he has had to put up with. He is to mix, instead of water, a bucket of his urine which he has collected over the course of a day into the flour. Gimpel suffers a moment of weakness and makes the foul bread, but imme-

diately afterwards has doubts. He buries the bread, abandons every-thing and, in order to make amends, decides to become a mendicant and wander from town to town telling stories. This is how he prepares for death. "No doubt, the world beyond is entirely imaginary, but once it is removed from the real world, when the time comes, I will go with joy." Gimpel says yes to life.

Gimpel the Fool seems to be Isaac Bashevis Singer's reponse to Melville's Bartleby or Coetzee's Michael K. In these tales the "no" men are beaten by the "yes" idiot. The *schlemiel* (which means "fool" in Yiddish) is the one who rejects shrewdness and calculation and who lives by being who he is. And so, at the cost of being insulted, Gimpel became a paladin. A "no" would have been a vote for silence. And, for Singer, silence is the worst option. It is a prison, and it does not do justice to the sublime versatility and the filthiness of being in the world.

Singer did not follow Adorno's maxim, according to which after Auschwitz there is no room for poetry. Nor did he approve of Paul Celan's suicidal leap into the Seine. Nor did he believe, as did Primo Levi, that if there was Auschwitz then there cannot be a God. Even though he lost his mother and his younger brother to the Holocaust, Singer cultivated the human voice as a form of resistance to hatred, which (in keeping with Spinoza) he believes incapable of generating anything other than good.

In Singer's novels, this is how the Yiddish world continues to live on despite being erased by the long night of the Shoah. The writer

always had difficulty making reference to his own personal family tragedy. He kept everything inside him like an ulcer, with no hope of healing.

The short story "The Manuscript" shows what literature can mean to people in desperate times. A group of Jews who had lived in cities now erased by bombs and are awaiting deportation ask Menashe to organize a literary debate, because "that's the way people are: a few moments before dying they have all the desires of the living".

In Singer's writing, literature is a kind of howl. He does not write about deportation and extermination to show the dark side of man. He knows what the human beast is and he represents it touchingly through the creation of two demons: Shidda and Kuziba pray with all their might for protection from the monster that is man.

When you read Singer, you end up getting attached to the demons. As Guiseppe Pontiggia wrote, "We might not believe in sprites, little people or demons, but we believe in Singer's dybbuks." Little people and demons are the product of an imagination that reality produces when nothing is as it seems. Demons are neither rational rebels nor cultivators of the abominable. They are different. They come from Yiddish culture and are considered evil because they are interested in forging a new path, one that is opposed to the Law. Sometimes they play tragic jokes, as in the story "The Black Marriage", where an innocent daughter of a Rabbi gives birth to the son of a demon. There was no crime. No-one needed to be punished.

And no prayer can save her. No gesture can justify the act or comfort the young mother. Here again, the imaginative powers of humans to love in spite of everything allows people to find meaning in tragedy by transforming it into a sweeter form of existence. Demons also always refer to children: "It's necessary to remind them from time to time that there are still mysterious forces at work in the universe," a character says in "In the Court of My Father". Demons are an emblem of an unchartable world without poles, a world where there is no backwards or forwards. One must live in its chaos, where every law is necessary and fair, as well as arbitrary and superfluous. The chaotic circularity is reflected in the mirror that apparently only shows what is in front of it. This mirror represents the privileged instrument of demons to make themselves invisible: "Everything that is hidden gets revealed. All secrets long to be discovered. All loves pine to be betrayed. All that is sacred must be profaned."

Singer considered himself a passionate believer, yet he was also fascinated by rebellion. In fact, the function of the rabbi (the career Singer was pushed towards as a young boy) is to raise doubts about all the Laws until they are keenly observed. In the story "The Butcher", for instance, Yoine Meir is chosen by his community to slaughter the animals that are to be eaten. Poor Meir is obsessed with the guts of the animals, the look in the eyes of the calves, the birds' feathers – and even if the Torah says, "You cannot be more merciful than God," he wants to be and he claims to be. He chooses to reject a God that makes animals suffer. If there is the possibility of love,

there is also the possibility of heresy and sin. Singer's characters are an essential part of everything: they all exist to the same degree, and when they are not inhabited by fear and religious submission, they can be elevated to interlocutors with God in a direct dialogue.

Singer was a diligent student of Spinoza and his *Ethics*. He particularly admired the Dutch philosopher for having endowed his pages with the fresh breeze of life and the possibility of error. *Ethics*, according to Singer, is a continual invitation to live life as an adventure, to confront the powers of reason and sense. Emblematic of this is his sublime short story "The Spinoza of Market Street". In this story, Spinoza's *Ethics* become standard procedure for the life of Doctor Fischelson, who "found comfort in thinking that he, though a man of no importance, being created of the mutable substances of the absolute infinite, was nonetheless a part of the cosmos and made of the same celestial bodies; as he was part of the Divinity, he knew that he could not altogether perish." Fischelson, who spends his life studying the *Ethics*, considering it a sort of medication for rational and sombre perfection, loses all control one night because of the beautiful Dobbe the Black. His passions end up taking the place of the austere rationality that he had spent his life cultivating. "Forgive me, divine Spinoza. I have become a fool," Fischelson says to himself. Sexuality is one of Singer's constant obsessions. It is an explosive force, capable of nullifying all good intentions and resolutions and throwing every last rational plan into crisis.

Sex throws off those who believe that moral reasoning is capable

of governing every aspect of life, including hormones and hunger. Yentl, a student at the Yeshiva, a secondary school for Talmudic studies, suddenly discovers sexual ambiguity in everything he sees and hears. He has an almost ungovernable desire to turn towards the only thing that his reason has not yet fully mastered: the passion of bodies. Yentl loses to sex, as do all of Singer's men and women who attempt to arrest their susceptibility to the magic of amorous attraction, which is obviously not a force one can oppose. Claudio Magris once wrote, "With the impartiality of an epic poet, Singer reveals the whole range of amorous experiences, from conjugal idylls to nauseating laziness." But sex and carnal passion also become untameable forces that manage to eternalize life against conceit and contrition. For Herman, the protagonist of the story "The Letter Writer", "The idea of raising children seemed like an absurdity: why prolong the human tragedy?" Singer agreed with Herman and with Schopenhauer, the other philosopher besides Spinoza who guided his life as a writer and perhaps also as a man.

Singer knew, however, that the rational non-life cannot do battle with the diabolical folly of carnality. You can decide not to give life, but you cannot deny people the choice of living out their hell on Earth. You cannot deny them pain, anguish and misery. Passion and love do not follow a plan; the stories of Singer show that sexuality just happens without paying attention to what it will be and what it was. Baudelaire wrote: "The singular and supreme voluptuousness of love consists in its certainty to cause pain. And man and woman know

from birth that in evil lies all voluptuousness." The idea of existing, of being, the desire to drink from the well of life in a spasmodic search for an illusory meaning and for forgotten origins is characteristic of a man in exile.

Singer manages to make the Diaspora a major element in Jewish literary and human experience. Only from the damnation of the margins can one enter into the heart of the human condition. Questions about existence surface when there is no homeland, when there is no constitution or patriotism, when there is lawlessness. A tense dialogue with God makes the journey more interesting than the destination, since the destination represents the end of universality and of one's thoughts, like a Job without a burden, or the way, when a dream actually comes true, it ends up being nothing more than a shadow of itself. The stories and the novels of Isaac Bashevis Singer follow in the wake of the human Diaspora as it wanders in search of an ultimate reconciliation and a utopia of happiness that exists only for as long as it is being sought, and that imagines seeing it in the infinite and concrete realm of thought.

The pig dreams of acorns, not pearls.

24

The Infinite Conjecture

ON AN ISLAND IN THE MOUTH OF THE RIVER MEDWAY, IN HIS home in Sheerness, on the night between February 22 and 23, 1984, Uwe Johnson died of a heart attack while trying to open a bottle of wine. No-one noticed his absence. No-one was interested in looking for him, finding him, talking to him or seeing him.

Nineteen days later his body was found, by chance, swollen with alcohol. If it is true, as someone said, that the end of a man's life should accord with the way he has lived it, this writer's end would definitely undermine that hypothesis. The extraordinary private life of Johnson is riddled with suspicion, he having been under continuous observation by the Stasi and all the secret services in the socialist bloc. Uwe Johnson was not under surveillance for subversive activity or politics, but because what he wrote seemed to hide something. His chaotic precision aroused the curiosity of the sour, paranoid censors. His end was a bizarre tragedy: a man who

was observed and spied on for all of his life died without anyone noticing.

Johnson was born in 1934 in Pomerania. He studied under Walter Ulbricht in the German Democratic Republic (D.D.R.) at the University of Leipzig and became a star student under the critic Hans Mayer, who immediately recognized his genius and encouraged him to write. Early on, Johnson believed in the politics of the D.D.R. (as did Brecht and Ernst Bloch) and was active in the Communist Party, seeing in its politics the possibility of a new form of history that the prehistoric bourgeoisie had denied mankind. But soon he came to understand that the D.D.R. was a dictatorship ready to accept every decision that its government took as the right and best one, silencing every doubt, stifling every criticism.

He escaped to West Berlin in 1959 when he refused to organize the break-up of the Junge Gemeinde, a German religious organization. As soon as he got out of the D.D.R., Johnson became known for his book *Speculations about Jakob*, a singular publication that imposed a new model of writing. The book, like all of Johnson's early works – *The Third Book about Achim* (1961) and *Two Views* (1965) – is based on a framework of conjectures, or a structure of hypotheses, inquiries, memories and descriptions which proceed to reveal the story, or the era of facts, without at any time following a linear narration.

Jakob, who works for the railway, one day gets killed by a train as he's walking to work along the same route he has been taking for the

past seven years. The opening of the book ("Jakob had always walked across the tracks") immediately lets the reader know what form the story will take. All the questions about his death and the most disparate hypotheses that emerge (none of which are sustainable without the other conjectures) characterize the aesthetic of the novel. Suicide, homicide, accident – everything could be real or invented in the infinite hypotheses of Jakob's life. The only parts that can be satisfactorily grasped, however, are memories, remembrances, words said and overheard, and it is thanks to their recomposition that we are proposed one final conjecture on modern mankind and our times.

Literary elements that have always been considered fundamental to a novel – dialogue, narrative voice and character description, for example – do not exist in Uwe Johnson. Dialogue is suddenly inserted. The descriptions are of the most minute things and done in such an obsessive way that they distract you from the plot. Hans Magnus Enzensberger, Johnson's friend, and often the target of his criticism, said that Johnson's prose "rubs you the wrong way", because "the reader who might be capable of guessing is ignored". In Johnson's pages, that which is left out – what Wittgenstein called the inexpressible in his theory that "it is better to pass over in silence things of which we cannot speak" – seems to have a persistent presence (perhaps that is why the secret service was interested in his work!). It is as if everything had to be written in a more complex manner because a simpler style would never have been able to express

the idea fully, as if the hidden subject was the ghost of freedom. Johnson's own freedom no longer resided in his hopes: the Germany of Bonn, the democratic Bundesrepublik, had deluded him; he never found a solution to the division of Germany. As we see in *Two Views*, Johnson detested the West Germans' desire for money, their frenetic obsession with cars, their endless accumulation of material goods, and their silent retreat into private, individual spaces.

In *The Third Book about Achim* we are introduced to Karsch, a West German invited to East Berlin by a friend. Karsch is stunned by the extreme contrast between German socialism and West Germany. He feels no affinity whatsoever between himself and the East Germans. When it is suggested that he write a book about a friend of his friend, Achim, an ex-bicycling champion and a political figure in the D.D.R. (the relationship between sport and politics was dear to socialist dictatorships), Karsch suddenly finds himself in great difficulty. Nothing helps. Events, memories and conjectures can help to build memories in the present human history, but not to recreate the life of an individual – in this case, Achim. The journalist is not satisfied with what he has written. He cannot write about an alternative reality he has never known, or about a particular situation that cannot be captured in words alone. In a state of great despair, Karsch returns to the West, to Hamburg.

In 1966 Johnson moved to New York. He no longer wanted to live in his country. Germany, guilty about its past, its ineradicable Nazi history, was divided between socialism and capitalism, and still

a carrier of inhumanity. He considered it responsible for systems that ground down the life of man and crushed him under the wheels of history. Johnson managed to scrape a living, first in the United States and then in England, both countries that are more democratically mature and better at hiding their own contradictions.

In New York Johnson began writing his masterpiece, *Jahrestage* (translated in English as *Anniversaries*). This monumental work is divided into four volumes which came out in Germany in 1970, 1972, 1973 and 1983. It is hard to find words adequately to describe it.

It is one of the great literary masterpieces of all time. It resists all critical reduction or analysis. *Jahrestage* narrates the day-to-day life of Gesine Cresspahl and her daughter, Marie, in a blending of family histories all connected to present-day history, historic facts and the essential events of twentieth-century history. The critic Hans Mayer suggests that readers of *Jahrestage* should surrender themselves entirely to the book, as one would to Proust's *À la recherche du temps perdu*, a work impossible to take in unless the reader commits to it entirely.

It is useless trying to read *Jahrestage* with the linear logic we usually apply to narrative. The writing is extremely slow. It includes meticulous and obsessive descriptions of shapeless and enigmatic situations. Only by losing oneself in the labyrinth that has been built with the patience and care of a monk is it possible to spend your days with Gesine Cresspahl. The reader moves from one chapter to the next by way of dialogues, nursery rhymes, thoughts and interactions with other characters and situations.

Feltrinelli have published the first volume of *Anniversaries* in a new (and excellent) translation by Nicola Pasqualetti and Delia Angiolini and with a rich introduction by Michele Ranchetti. This volume focuses on the days of Gesine Crespahl from August to December 1967. Gesine had already made an appearance in *Speculations about Jakob* – her daughter, Marie, was Jakob's child. But now she lives no longer in Germany but in New York, where she works in a bank.

The text is loosely constructed and anchored on three levels: the story of Gesine, the story of Marie, and a story of the *New York Times*. That's right. The *Times* functions as the counterpoint to Gesine's life. There is no moment in the narration that is not connected to the news of the day. "Since 1961, close to 13, 265 American citizens have died in fighting in Vietnam – but what a lovely child, you've done very well . . ."

The news about Vietnam, the arrival in America of Svetlana Stalin (the dictator's daughter), a sighting of Che Guevara in the woods, the riots in Harlem, and thousands of other bits of news create the context for the lives of the people in this book. The context is life, and it is in continuous motion. The *New York Times* is a voice of the present consciousness, a metronome that marks the passing of time in the world that Gesine inhabits. The paper is referred to as Auntie Times, and in fact, in the course of the narration, it does become a kind of character: well mannered, courteous, a little insistent on occasion, very much like an old aunt "who can't call an arrested person

guilty" or who insists that "you don't call the President by his first name" and who "lets everyone have their say, even the people you don't respect". Johnson discovered, among other things, that the *Times* was one of the best newspapers precisely because of its investigative methods and its writers.

Johnson's literary oeuvre stands like a solitary building in a flat landscape. It is based on an autistic kind of prose that devours its surroundings thanks to the paths of memory that are created by newspapers, train timetables, magazines and office dialogues. This archaeology of the present does not catalogue the fragments with the intention of climbing back up towards the origin of civilization. It gathers events, moments, sensations and conversations in order to recover a sense of individuality squashed by the injustice of history and the emptiness of the everyday. What Gesine feels and records, what she says and thinks, is all bunched together and sorted out in a vital flow with no specific order. It is as chaotic as the life of this German emigré. Adorno suggested that one could say that Johnson channels the life of his characters through the flow of "powers unleashed in decadence".

Gesine decides to record her life story for her daughter Marie. This decision in the first volume of *Anniversaries* creates a second plane within the narration, a plane that is based on her past in Mecklenburg. Gesine, born in 1933, during the first hundred days of Chancellor Hitler, tells her daughter about her family, Nazism, misery, times of abandonment and times of happiness. Feeble and

packaged memories are transformed into a culture, into gestures and conversations.

The past in Johnson's writing holds no solutions. This is not a historical novel where one can expect preordained events or where the reader is well prepared by the narrator. There is a constant trans-migration of intentions and memories, an interpolation of ideas and comments. The constant exchange of voices is a way of mapping that which was and that which might be, a way of establishing a path between resistance and loss in the attempt to beat back the endless tides of history. Even if you have just finished the book, if you go back and reread some of the pages, it feels entirely new. Critics have recognized the influence of Thomas Mann's *Buddenbrooks* on Johnson's writing, but William Faulkner might be a closer cousin: both writers' works are real but not realistic, both invent reality without betraying history. However, the writing of *Jahrestage* was interrupted after the third volume.

While Johnson was taking notes for things he wanted to include in the life of Gesine Cresspahl, someone was spying on him – and not from outside through binoculars or by tapping his telephone. He was being spied on from within, in the intimacy of his emotions, in his most private affections. In 1975 his wife Elisabeth confessed that she had a lover, a Czech agent in the secret police, to whom she sent detailed reports of her husband's activities. Johnson's wife had helped him with the drafts of *Jahrestage* and he had dedicated the entire project to his daughter Katharina, on whom he based Marie, the

daughter of Gesine and Jakob. For a writer who had just put the final full stop on his novel it was as if the characters he had created came knocking on his door and he found himself face to face with an unexpected and monstrous apparition.

The event traumatized Johnson. He had writer's block for ten years. He suffered two heart attacks and became an alcoholic. His wife's betrayal had been constant and silent, and had wound its way into his daily life. Ten years after the publication of the third volume, in 1983, shortly before his death, he published the fourth and final instalment of *Jahrestage*. It concludes in Prague in 1968, with Gesine Cresspahl confronting the Soviet invasion. Life should not be substituted for by writing. This is especially true for Johnson. Writing has to be real, but not realistic, capable of giving meaning and justice to a confused and unfair reality, but it can never take the place of life itself.

This is why Michele Ranchetti, one of the finest of Italy's intellectuals today, hits the nail on the head when he says that Johnson's books do not fall into any specific narrative genre. The modern age has no need for traditional genres such as the critical essay and the novel, nor does it need a new metaphysics of phenomenology. Johnson wanted to write something that was transversal at every level and capable of embracing multiplicity, so that he could discover, understand and preserve what exactly, in the life of an individual, is indomitable.

Walter Benjamin's work was marked by the hope of finding a door that would lead him into another world, a different world to the

one we are forced to inhabit. Johnson shows us that even if we found the door, we would not be able to open it. We would not have the key. We can only come up with guesses, not solutions. Perhaps not even perspectives. We can make only guesses about Jakob's death, recall his life, hypothesize about his demise, listen to the voice of Auntie Times to find out what was going on while we were busy planting roses in the garden, tell Marie what happened. We can but keep searching for paths. We can but pine for the meaning of life as it is measured out and marked by days and years.

25

Never Again in a World Apart

A WORLD APART BY GUSTAV HERLING, WHICH WAS RECENTLY republished by Feltrinelli in paperback, should be consumed in one bitter gulp. Reading it in one go is like getting punched in the gut or slapped in the face. Your dignity will be offended. You'll fear falling into the same circle of hell that he describes. It is a terrible and fertile text, a rare testimonial of the Soviet concentration camps and the barbaric acts that millions of victims suffered as a result of the Stalinist regime.

Gustav Herling was twenty years old when he decided in 1939, after the German invasion of Poland, to cross the Russian-Lithuanian border in the hope of organizing an anti-Nazi resistance movement in Russia. However, he was arrested by the Soviet police for his plan. This episode, which might seem bizarre, is actually a tragic paradox. In 1939 the U.S.S.R. and Germany had signed a non-aggression pact, the celebrated Molotov–Ribbentrop pact. Therefore, according to

the Soviet secret police, Herling had indirectly conspired against the U.S.S.R. by trying to leave Poland to fight Germany. Young Gustav was deported to Yertsevo, a labour camp that was part of the prison district of Kargopol on the Baltic Sea. This camp, where prisoners worked as lumberjacks, was a veritable industrial centre, with railway lines and a village built entirely by the prisoners for the free personnel. The living conditions of the camp were barbaric. The men worked in temperatures of minus forty degrees. They worked constantly. They were massacred by work. They worked around the clock on only three grams of bread and a ladle of soup for sustenance.

With the skill of an historian, Herling describes the organizational hierarchy of the labour camp, and the relationship between the workers and authorities. There were three different levels of prisoners: the *bytoviks* or common criminals with short prison terms; the *urkas*, hardened criminals who were the true lords of the prison; and finally there were the *byelorutchki*, the political prisoners. The *byelorutchki* had the least hope of survival, since they were treated the worst and given the heaviest jobs. The *urkas* had the most rights over the other prisoners. They were responsible for making sure the work got done and that people respected the political structure of the camp. Herling describes them as terrible people: men who thought that freedom was as repugnant as the idea of a camp was for any normal person.

The majority of political prisoners were Bolsheviks or commu-

nists who had fought for the socialist cause. Stalinism had snaked its way through various institutions and generations. It was responsible for purging, deporting and imprisoning communist revolutionaries, officers and directors who had acquired too much power, or else common people who had transgressed Stalin's ideology without realizing it. Informers were rife and were often used as an instrument to keep neighbours, colleagues or family members in check. People denounced each other to ruin a rival's career, to get a promotion or to save their own skins. All this was common practice in Stalin's Russia.

Work was the chosen method of oppression and torture in Soviet prison camps. It was intended to destroy the prisoners. Bodies were broken down by fatigue and fever. People went blind from a lack of vitamins. The only way to survive was to be hospitalized in the infirmary. The hospital was like a church, offering sanctuary from an all-powerful Inquisition. As a result, self-mutilation became common. As in the trenches during the First World War, when soldiers shot themselves in the hands or legs so they could be sent away from the battlefield, Soviet prisoners used their axes to amputate fingers, hands and legs. After noticing many such cases, the Soviet authorities decided to punish everyone, including those who had been wounded accidentally, by forcing them to continue working. "I saw a young prisoner make his way back from the forest with his foot cut off."

There is a particularly touching character in *A World Apart* named Kostylev. His story is valuable not only because he offers a unique

perspective on the camps, but also because he endows the book with a quality that transforms it into something more universal. Before being imprisoned Kostylev dedicated his life to the Bolshevik cause. He admired European communists as if they were saints and saw them as freedom fighters on a continent oppressed by the bourgeoisie. He learned French in order to understand the speeches of Maurice Thorez, general secretary of the French Communist Party. When he read Balzac, Stendhal and Constant, however, Kostylev discovered "a different air. I felt like a man who, without knowing it, had been suffocated his whole life." After this experience as a reader, Kostylev changed his mind about the West and Bolshevism. He abandoned Party work and spent all his time reading, wanting to discover the truths that had been hidden from him. Foreign books, which he bought clandestinely, got him arrested. The secret police accused him of being a spy and tortured him until he confessed to false charges. When Herling and Kostylev met in prison, the latter had recently and deliberately burned his arm. Kostylev preferred to have a wounded and swollen arm rather than work for his warders. A friendship was born.

Exempted from work, Kostylev spent his days in the prison cabin, reading. Herling never understood how he managed to get the books, but he was not jealous. He felt only profound admiration. Reading had changed Kostylev. Yes, it had led to his being imprisoned, but it also continued to be the strongest affirmation of his humanity in that circle of hell. Preserving and conserving one's humanity was not only

impossible in a labour camp, it was almost always lethal. Helping a wounded companion or passing him food was dangerous, because it meant depriving yourself of resources that your own weakened body required. Also, it could drive you crazy, as it reminded you of your past life. Remembering that you are a human being under such inhuman conditions is deadly. Life in a prison camp can only be tolerated when your memory and spirit discard everything that reminds you of freedom. The power of this book – evident in all of Herling's writing – is how the writer manages to create a new code of judgement: you cannot judge an individual for his actions when he is being held in inhuman conditions. The betrayal, the informing, the prostration and the prostitution generated by hunger and illness are no longer considered human behaviour, even if committed by men.

I, too, have reached the conclusion that man can only be considered human under humane conditions. It is absurd to judge him severely based only on his actions in inhumane situations, just as it would be absurd to measure water with fire.

The systematic repression in the Soviet Union represented the most idiotic bureaucracy that ever existed on the face of the earth. Every arrest had to be given a motive and formalized. Thousands of people were incriminated using the most sordid and ridiculous accusations: sabotage of Soviet industry, espionage, conspiracy against the fatherland, betrayal, insurgency. Through these condemnations the Soviet system found justification for each of its crises and every slowdown of the economy. Thousands of innocent and often harmless

people, the total opposite of political enemies, were whisked away, victims of an illogical and ruthless internal war.

In Yertsevo Herling met a prisoner who had been denounced by the N.K.V.D. (the terrible secret police who later took on the name of K.G.B.) for putting a bullet in a poster of Stalin by mistake when he was drunk. This absurdity got him ten years in prison. Unlike the German concentration camps, where individuals were gassed, massacred and arrested without a farcical trial, but simply for being Jewish, communist, Jehovah's Witnesses, gay, etc., the Soviet system extorted confessions, invented sabotage plans, forced their people to come up with some ridiculous proof. And it formalized every *mise-en-scène*. "It's not enough to shoot a man in the head. He has politely to ask to be shot during the trial."

Gustav Herling managed to be saved because he was a Pole, and got himself shipped off with the force commanded by Lieutenant-General Anders. After a pilgrimage to Baghdad, Mosul, Jerusalem and Alexandria, Herling landed in Italy. Sick with typhus, he spent his time recovering in Sorrento, where he met Benedetto Croce's family. This event proved a determining factor in his life. Many years later he met the daughter of the philosopher, Lidia, whom eventually he married, and they had two children, Benedetta and Marta. Herling ended up living a large part of his life in Naples. He dedicated his life to writing and worked on his monumental book, *Journal Written at Night*, until he died. This colossal narrative is composed of more than twelve volumes. Only one of these has been published in Italy,

covering the period 1970–87. This intellectual endeavour is a combin-
ation of philosophical reflections, moments of profound wisdom,
invective and docile, lazy reflections. *Journal Written at Night* is prac-
tically a geological site where you can explore the different strata that
were laid down as they emerged from Herling's mind.

In the labyrinth of the *Journal* there is a disturbing episode that
describes a meeting between Thomas Mann and Ignazio Silone in
Switzerland. The two men were discussing how different political
systems should be judged. Silone believed that "it is sufficient to see
what kind of role has been reserved for the opposition". For Mann,
however, "the supreme test is the place that has been reserved for
art and artists". Herling was deeply disturbed by Mann's aesthetic
posturing and profoundly critical of the German writer when he
discovered that Mann was indulgent towards the Soviet system and
that he analyzed it exclusively on the basis of the sales of Goethe in
the U.S.S.R.

For Herling, the intellectual must stand against human pain. He
must be a sentinel of human freedom, and he must never delegate the
defence of human dignity to others. In spite of his literary eminence,
Mann negates all of this by prioritizing art.

There are also some lacerating personal memories in the *Journal*,
many of which are profoundly moving: the story of how Herling
found a wounded puppy in the Iraqi desert during the war and
lovingly cared for it is one example. Or the pages from 1980, when
he describes the earthquake that hit Naples: the faces of people in

Irpinia, Lucania and Partenopeia, their voices, their fleeing, the clusters of people, the absolute impossibility of being angry with someone. Paradoxically, this diary-like narration never seems to be inflected with personal experience. The title suggests the somewhat posthumous role of thought, like Hegel's night of the world that arrives too late, when day has already come: the author does not offer a sum of what happened to him, but what happened through him. It is a narrative that has a departure point, but not a destination. It starts off for a precise reason, but is then seized by the power of impulse. Inspiration for this lifelong work can be found in the fragment of the text entitled "A Brief Tale of Myself", edited by his daughter Marta: "I write because I have an inner need to challenge myself to think about specific issues. If you are alive, you are alive because you have kept to a mission ... I always wanted to leave something of myself behind. I really only write for myself. I write because it gives me pleasure."

Even the texts that were published as distinct and free-standing works are actually part of the connective tissue of the *Journal*. Two stories, "Requiem for a Bell-Ringer" and "The Island", are narratives that appear like landforms out of Herling's vast ocean of words. There are also short stories that reveal strong traces of ancient Naples, such as "Don Ildebrando" and "Venetian Portrait". In "Don Ildebrando" Herling tries to paint a fresco of the Italian landscape, while simultaneously maintaining his distance as an exile and recognizing the sense of complicity that comes from being an Italian

citizen by adoption. This piece of writing offers a portrait of Naples as a city of chaos. A city determined by a whirling force that knocks it back and forth between the misery of street urchins and the sumptuous baroque of Spanish domination, and compelling it to amalgamate its superstitions, popular traditions and highest ideals. The story entitled "Ex Voto" reveals the heart, chest and body of Herling's dear Naples, the city where he lived with his father-in-law, Benedetto Croce; the city of San Domenico Maggiore, where Thomas Aquinas was trained and came of age. Naples, for Herling, provided more of a spiritual map than a geographical or historical one. The prose of his stories is elegant and respectful. He possesses a rational passion that seems to care little for what in literature is defined as "talent", imaginative sparkle or the meaning of a sentence. Herling's writing is a continuous kind of writing, ready to trace and communicate rather than express. As the writer Cristina Campo has observed, "the great ceremonial words of horror and piety traverse his discourse with the ease of an autumn breeze blowing rain through the trees and against the windows".

Herling introduced narration into the plot through his role as witness. His work contains many, many characters, all races of an orchestra of the damned. They transcend the details of the Soviet work camps, the earthquake, the Nazi persecution, his experience of war, ruined Naples, and come to represent the human condition in the twentieth century. Perhaps it is true that all stories that emerge from the deepest reaches of memory resemble one another. The pages

of Primo Levi, Varlam Shalamov, Herling and Elie Wiesel reveal a common genetic disposition towards forgiveness, even before being linked by the shared barbaric experiences their writers suffered. Their final words, their hinted judgements and their understanding of pain were written to give humanity the option of living differently, the chance to remember and change. We will never know whether these authors forgave their guards – their banal jailers – and ultimately it does not matter. But we do need to recognize that they forgave the primary executioner: the human being. Writing one's memoirs is a seal of faith in man for future generations. Dark memories, in other words, express the promise and hope of a new path for humanity.

26

He Who Writes, Dies

ANNA HAD JUST RETURNED HOME FROM DOING THE SHOPPING. It was the evening of October 7, 2006 and she looked tired. She had been to the supermarket on the Frunzenskaya, the road that runs along the Moskva, and earlier had gone to visit her mother, who was dying from cancer, in the hospital. Her father had died from a heart attack as soon as he heard of his wife's illness. Bad luck just kept piling up.

Divorced, with two grown up children she rarely saw, Anna was greeted at the door by Van Gogh, a dog she had saved from abuse as a puppy. About him she once wrote: "It's evening. I turn the key in the lock and Van Gogh is there. He always jumps up on me when I come home, no matter what, no matter if he's in pain or if his stomach hurts from something he ate or even if he'd been fast asleep. He's the source of a constant flow of affection. Everyone leaves you, everyone gets tired of you, but a dog never stops loving you."

She has three shopping bags in her car, so she parks in front of her building, Lesnaya Ulitsa, Number 8. It is not hard to find a place. The area is safe and residential, elegant even. It has become the neighbourhood of choice for the rising professionals of the new Russia. Anna enters the code for the front door of the building, takes the lift up to her apartment and puts down the first two shopping bags, which are full of food and household goods. Then she goes back downstairs to get the third bag, which contains articles of personal hygiene for her mother that are lacking in the hospital. She takes the lift back up to the first floor. As soon as the doors open, even before she steps out on to the landing, she sees a man and a woman. He is young, thin, and wears a baseball cap with the peak pulled down over his eyes, or so say the witnesses. Next to him is the woman. One of them points an Izh pistol equipped with a silencer at Anna's chest. The left side. They fire three times. Two shots go directly into her heart, ripping it into three parts, while the third bullet ricochets up to her shoulder. Just to make sure they have completed the job, even after her body crumples to the floor, they shoot her in the nape of the neck. They had followed Anna home from the supermarket, knew the code to the building, and waited for her on the landing. After the murder, they drop the handgun – serial number erased – in the pool of blood and leave. Later, a neighbour summons the lift. When the doors open, she screams and mumbles a prayer. Anna's body is lying there.

It was President Putin's fifty-fourth birthday, and Anna's death came as a gift. Anna Stepanovna Politkovskaya, *née* Mazepa, was born

in New York and buried on October 10, 2006 at Trojekurovo ceme-
tery. She was forty-eight. In the first row of mourners at her funeral
are her two children, Ilya, twenty-eight, and Vera, twenty-six, as well
as her sister, her ex-husband and her dog. Her words could not have
been stopped by any means other than bullets. Three years later,
Anna's killers were all acquitted: Sergej Chadzikurbanov, ex-officer
with the Ministry of Internal Affairs; the two Chechen brothers,
Dzabrail and Ibragim Machmudov; a third brother, Rustam, who was
also implicated, but managed to escape abroad and has never been
arrested; and Colonel Pavel Ryaguzov of the Security Forces. The
president of the military court also acquitted the two individuals who
followed and shot Anna. To this day, neither a guilty party nor an
assassin have been found. And yet Anna's words are still thorns in the
side of Russian power.

A Dirty War is a dangerous book. Anna Politkovskaya wrote it
because she wanted to talk about an open wound that was about
much more than a remote area in the northern Caucasus Mountains.
By writing the book, she made the war in Chechnya a reality for
everyone. And that is precisely what got her killed: her ability to make
Chechnya a hot topic in London and Rome, Madrid and Paris,
Washington and Stockholm. Her words were nitroglycerine for
Putin's government. The book became more incendiary than a tele-
vision programme, an eye-witness report or a trial in the international
court. A Dirty War brings together everything that Anna saw in one
of the worst wars human kind has ever fought, a war in which raped

women and tortured soldiers were forced to declare they were actually at fault. Her philosophy can be summed up by an aphorism from Marina Tsvetaeva, whose poetry was the subject of Anna's dissertation: "All my writing is careful listening."

Anna worked under tough conditions. She got a mere $30 for each of her trips to Chechnya. She could not live off her writing, and she received no financial satisfaction from her work. She received nothing for travel expenses, and the majority of her salary ended up going to defence lawyers contesting the allegations that rained down on her every time one of her signed articles appeared. At first her enemies tried to snuff out her fire by wearing her down. They tried to discourage her with libel suits. They did not want to kill her, just to destroy her image. They wanted to make the many people who adored her think she was a rampant careerist.

I will never forget the words pronounced by Alexander Politkovsky, Anna's ex-husband, on the day after her death: "In 1994 she covered the struggle between the two oligarchs, Vladimir Putin and Vladimir Gusinsky, over control of Norilsk Nickel, the world's largest producer of nickel, when it was being privatized. Putin ultimately won, but at a certain point in time Gusinsky met Anna and showed her a defamatory dossier that he had scraped together on our family. Anna was frightened. I went to pick her up and the two of us sat in the car and talked for a long time. That was when she decided that she would press on with her work, even though she feared being discredited more than death itself." Better to die than be discred-

ited. That is the only consolation there is. It is terrible and tragic, but it is true.

At least since her death they have stopped trying to discredit her. That was the first method of attack her opponents used. They threw mud at Anna and tried to show that she and her family were conniving, corrupt and criminal. They went to the families of the victims that Anna had interviewed and pressured them into saying that she had invented everything, that it had all happened very differently. They spread rumours and lies. They said Anna was a liar, a megalomaniac, that she was insane, a clown, an opportunist. Actually, hundreds of journalists in Russia hated her because her husband had done well for himself during *perestroika*, earning a position as an authoritative, critical voice, even if it was for Soviet television. And then there was the fact that Anna wrote for a newspaper whose equity was in part controlled by Mikhail Gorbachev and by the oligarch Alexander Lebedev. The winds of calumny blew in such a way that the revolutionaries stood on the same ground on which the old communist bosses had once stood. It was not hard for those who held political power to find pretexts for wrecking her reputation, much in the same way that hundreds of journalists all around the world continue to defend her and to do what they can to investigate what really happened.

Anna's husband explained why she feared more than anything else being discredited: "She wrote articles to bring about change. Each piece was supposed to help someone or to counteract an

injustice. She always needed to produce something, even if it was minor. If she lost her credibility, she would not have been able to go on. And it almost happened once, years ago, when Ramzan Kadyrov, the pro-Russian governor of Chechnya, threatened to drag her into a sauna and take photographs of her in compromising positions with naked men." They would have drugged her, kidnapped her and captured her – the oh-so dangerous journalist – in porno shots with oiled men. "So here's how that woman, the one who writes about our country as if it were hell, really lives," people would have thought. Who would ever have believed she had been drugged and kidnapped? People would have accepted the smutty pictures as the truth. They would have complained about her vices, the orgies, the indulgences of the new courtesan who considered herself a fighter. Indeed, if it had ever come to pass, if the photographs had gone up on the front pages of major newspapers and gossip sites around the world, no denial or evidence could have wiped the mud from her face. It would have cast doubts on every article, every enquiry, every single word she had written. And that was only the first risk Anna ran.

Before bullets – or when bullets cannot accomplish the desired effect – they try to destroy your credibility, weaken your authority and nullify your words without actually dealing with the words themselves. They try to create a system that empties those words of all meaning, reducing the word to a shell. On more than one occasion Anna decided to put aside her role as a journalist and actively to participate in what she was seeing and writing about. In October

2002 she entered into talks with the terrorists who had taken over the Dubrovka Theatre in Moscow during a performance of *Nord-Ost*. She did it by offering to bring water to the hostages. In September 2004, during the occupation of the school in Beslan, she wanted to act as a mediator. She would have succeeded, too, because both sides respected her, but Anna declared that she had been poisoned on the flight to Ossetia. The poison was supposed to kill her, preventing her from helping to resolve the crisis. Their weapon: a cup of tea. After just one sip, Anna's head began spinning and her stomach started to contract into spasms. Before fainting, she called a hostess for help. They brought her to a hospital in Rostov. When she woke up, a nurse whispered, "My dear, they tried to poison you, but the blood tests have been destroyed – orders from above." I clearly remember Italian journalists ribbing each other and saying things like: "Our Anna has seen too many Bond movies. When you're in danger, you don't blab about it at every conference. Silence is your defence." This is the sort of thing people said after Anna was poisoned.

But Anna knew that silence would have been a huge gift to the forces that were trying to delegitimize her. Over time, she had received very many threats, and had even once been given a private bodyguard by her newspaper, *Novaya Gazeta*. On September 9, 2004 she published an article in the *Guardian* called "Poisoned by Putin", but many people – too many people – rejected her claims. For some reason her colleagues' envy of her visibility became enmeshed with the power of her words. This led on the one hand to an increased

awareness of the struggle for human rights in Chechnya, whereby she was transformed into a symbol. On the other hand, it also helped the government to portray her as a narcissistic, opportunistic woman. She was totally isolated. In the *Guardian* she said that "This is nonsense, but was it not the same in Soviet times when everyone knew the authorities were talking rubbish but pretended that the emperor still had his clothes? We are hurtling back into a Soviet abyss, into an information vacuum that spells death from our own ignorance . . . For the rest, if you want to go on working as a journalist, it is total servility to Putin. Otherwise, it can be death, the bullet, poison or trial – whatever our Special Services, Putin's guard dogs, see fit." Her books and articles alone stood by her.

In *Memories of a Revolutionary* Victor Serge writes: "I am more interested in speaking than writing. Others are better at blending words with facts. I don't have time. I just have to speak." The same was true for Anna. Her books are immediate, swift. They have the power of discovery, of news, of unknown information being made known. And this is what made her vulnerable.

"To those in the West who say that I am the key militant against Putin, I reply that I am not a militant, I am a journalist. That's all. And a journalist's job is to inform. As for Putin, he has done some unimaginable things and I have to write about them." Her politics were absolved by the need to write. What is more, she detested writing editorials: "It doesn't matter what I think; it matters what I see." So the reports and articles kept coming.

Anna Politkovskaya understood that her readers would defend her. Since she had participated in several international conferences, she knew that the public's interests and experiences would support her. They were her real bodyguards. Her tools might have been interviews and reportage, but when a public figure, whether politician or bureaucrat, was evasive or mendacious, Politkovskaya moved on to indictments. In fact, she was a witness in dozens of cases. In an interview that appeared in the *Guardian* on October 15, 2002 she said: "I went beyond the role of journalist. I put aside my job and learned things I never would have if I had stuck to being a simple journalist, someone who stands still in the crowd, like all the others." This motivation may have been the driving force behind her explorations of Chechnya in 1999. Ever since then, in article after article, she collected information for the book that today represents one of the most important documents for understanding the physiology of every conflict, ferocious, hidden, abominable, terribly modern.

Politkovskaya was a child of the dissident tradition of the 1970s, which opted for a pacifist and non-violent approach to undermining the regime. To unmask the lies in her country she utilized the very channels the Russian state had created, not stopping at newspaper articles, but furthering her fight by legal processes. She went beyond journalism. She wanted to stare into the eyes of the guilty parties. She sought out stories of the victims of torture and rape and then brought the criminals to court. When successful by dint of evidence

she introduced, Anna brought about their conviction and punish-
ment – and allowed the victims to taste justice.

One essential element above all others shines through her book:
the power of language. What weight does the written word have?
How can language be used to different degrees? She grappled with
the questions that torment writers and readers alike. Literature is an
athlete, Mayakovsky wrote, and the image of a word leaping over
obstacles and struggles is a powerful one for me. I believe the specific
weight of literary language is determined by its actual presence in
the flesh of the world – or by its absence.

In a debate about writing with Giorgio Manganelli, Primo Levi
once declared that obscure writing was immoral. I believe that
literary writing is naturally labyrinthine and multiform, and while I
do not think there are any unambiguous roads, I can recognize the
ones under my own feet. When Philip Roth said that after *If This
is a Man* no-one could ever say they had not been to Auschwitz,
he did not mean people simply became aware of the existence of
the camps, he meant that Levi brought us there, that because of
his writing we, too, have waited in line for the gas chambers. Such is
the power of his language. While books which are neither docu-
mentary records nor reportage do not actually count as evidence,
they can most definitely take the reader into the same territory, and
let him know what it is like to be in someone else's skin. To some
degree this is the difference between an article and a work of litera-
ture. It is not the subject that matters, or the style, it is the possibility

of using words to whisper or shout, to express – not just to commu-
nicate. To make the reader feel a part of what he is reading. It is not
about Chechnya, or Saigon, or Dachau. It is your home. The stories
in *A Dirty War* are our stories.

Shortly before his death, Truman Capote wrote, "Truth and
fiction are two rivers divided by an island that is gradually shrinking,
and that are about to meet. Eventually, the two rivers will flow
together." A writer does not run the risk of revealing secrets, or of
having discovered who-knows-what kind of hidden truth. A writer
runs the risk of saying it. And saying it well. That is what makes a
writer dangerous and feared. He reaches people with words that carry
information. Certainly, his words can be obscured, interrupted,
defamed, denied, but he conveys something to the reader that ulti-
mately only the reader can deny or confirm. The power of literature
lies in its ineffability. It cannot be reduced to a single dimension. It is
not just one thing. It is not just news or information, sensation,
pleasure or emotion. This multiplicity makes it possible for literature
to go beyond any limits, to go beyond any single community or
professional circle, to enter anyone's daily life. It is a totally ungovern-
able instrument and can pass through any interface. This power is
what made Soviet governments more concerned about Pasternak's
Doctor Zhivago and Shalamov's *Kolyma Tales* than the effects of the
spying of the C.I.A.

The *élan vital* of writing continues to be the necessary condition
for distinguishing a book worth reading from one that is better kept

closed. The universe of concentration camps seems to have squeezed quite extraordinary drops of life from literature. Personally, I am not interested in literature as a vice. Nor am I interested in literature as a lesser philosophy. I do not care about beautiful stories that cannot be bothered to deal with the blood of our times. I want to smell the rot of politics and the stench of business. Yes, there is a kind of literature that can have amazing qualities and meet with favourable consensus. But that kind of literature does not interest me. I agree with Graham Greene when he said, "I don't know what I'm going to write about when I start, but what matters is that I write about something that matters." I want to try and understand how things work, the machinery of power, the nuts and bolts of the metaphysics of our customs. The world is full of substance in need of an artificer.

I want to write without being afraid of going outside the literary margins. Excluding data, addresses, percentages and weapons, I want to contaminate everything. Style is fundamental, of course, but as Hemingway famously observed, "Style is grace under pressure." The writer's grace, sense of timing and profundity all need to be held hostage by the pressure of the situation, by the need to be spoken, to be revealed. Literary truth lies in language, not in the individual. And the truth of language in our era is paid for with one's life. We have come to expect things to be this way. We have trained our minds to think like that. Of this, I am ever more convinced. Surviving has actually become a way of generating suspicion, a way of subtracting truth from your words. The actual truth of your language, and its analysis,

has no greater proof than death. Paradoxically, surviving the truth of language means a diminishing of truth in language itself. Truth in language always gets a response from power, if it is well constructed. And "power" is a generic and whorish term, applied to all kinds of institutions: the military, the criminal world, culture, industry.

Their response to Anna's words did not have the effect they intended. They killed her, but not her words – because the proof that you have struck power in the heart is to be shot in the heart. An equal and opposite reaction. A ferocious reaction. This reaction can either bring about a new, shared truth, which is somehow acceptable, or we turn to the truth of images captured by cameras. Artistic and moral truths rely very little on the individual and more on the eye, as if man were dismembered and every organ isolated. The intellect is destined to receive the same separation as in the *Apology* of Menenio Agrippa: the reporter is the eyes, the writer is the hand and a bit of mind. The journalist is the eyes with a bit of hand, the poet is the heart, and the narrator is the stomach. The time has come perhaps to create a monster with more hands and eyes, a monster that can invade, include and abuse every tool available to him. This is the work of the writer who concerns himself with reality and writes for the sake of it. Language continues to be an essential part of it, but the solitude of the writer and the dangers implied in writing are enormous.

Stanislav Markelov was Anna Politkovskaya's lawyer. He fought against the early release of Colonel Yuri Budanov, who was the

highest-ranking official to be convicted of war crimes in a Russian tribunal. On January 19, 2009 Markelov was assassinated. In the case against Budanov, Markelov had represented the family of Elza Kungaeva, an eighteen-year-old who had been raped and murdered by a group of Russian soldiers in Chankala. Elza's father, who has lived for years in Norway, received regular death threats. Colonel Budanov was to all intents and purposes an untouchable and Elza's murder became a symbol of the abuses committed in Chechnya by Russian soldiers. The episode takes up several pages of *Putin's Russia* by Anna Politkovskaya. She mentions Budanov by name. He probably would never have been indicted if it had not been for the media attention Anna's book generated. Budanov was arrested in 2000, found guilty and sentenced to ten years in 2003. Recently he was freed, in spite of Markelov's campaign against him.

Markelov was murdered alongside his colleague Anastasia Baburova, a journalist from *Novaya Gazeta* – the paper Anna worked for – who had taken over Anna's investigations into Chechnya.

He who writes, dies. Anastasia was shot in the head when she tried to stop the hitman from killing Markelov. The assassins thought she was crazy for reacting like that and not running away. It confused them. Anastasia was killed for fighting back against her executioners. She was twenty-five.

Since the campaign of defamation did not destroy Politkovskaya's reputation, and since her words survive her, everything now rests on her readers' shoulders.

I do not want these words to seem like an introduction to Anna's oeuvre. They are instead a solemn plea to the readers who decide to spend some time with her writing.

A prayer that her readers will continue to fully experience the world of *A Dirty War*. A prayer that the sacrifice she made to tell the story is never forgotten. A prayer that the reader can feel every hour of Anna's life, a life spent knowing it had an end point, yet knowing that that end point was purely physical, and that it would lead to the diffusion of her work into a constellation of stories that would wait patiently for readers to make them their own.

Acknowledgements

THIS BOOK SEEKS TO PAY HOMAGE TO ALL THOSE WHO HAVE BELIEVED in me over the past few years. To those people who have been able to stand by me and take part in my story in so many different ways, beginning with those who nurtured me with their trust and their teaching, and allowed me to draw on those resources as I continued to write.

To people like Vincenzo Consolo, who listened to me when I was still a boy and who, together with his wife Caterina, welcomed me into his home, itself a kind of storehouse of affection, a place where I learned about the responsibilities of literature and the power of the written word.

To Goffredo Fofi, the first person to urge me to really look out of my window, who taught me how people have etched their words and actions onto a landscape.

To Guiseppe Montesano, who practically adopted me, and who opened literature's door to me, with whom I had endless discussions on boundless worlds that only literature can create.

To Corrado Stajano, the author of a book without which I never would have found my way, which taught me how to be strong in the most difficult circumstances.

To the memory of Enzo Siciliano, who believed in my talent and made room for my words.

To Helena Janeczek, who was there for me at the start and will always be there, no matter what.

To Tiziano Scarpa, who invited me to be part of the Indian Nation and gave me the opportunity to communicate with my first readers and a community of writer friends who have never abandoned me.

To Francesco Pinto, who urged me several years ago not to be afraid of television.

To the people at Mondadori who have worked with me and for my words, who have believed in me since *Gomorrah*, who have given me their support through the most difficult times, and who have consistently gone beyond their professional obligations. To my foreign editors, who have worked with passion and keen intelligence on my behalf.

To the director and staff at *L'Espresso*, who took my side from the very beginning and who believed in my articles.

To the director and staff at *La Repubblica*, who gave me their best pages and stood by me.

To every other Italian newspaper that has defended me, and to foreign newspapers that have allowed me to communicate what I believe in to the rest of the world.

To all those people working in television and radio who have been so

accessible and generous, who have given me and my story airtime, inter-
views and programmes. They have contributed a great deal in bringing the
issues to the attention of the public, and have ultimately had an effect on
public opinion.

My thanks also to Mikhail Gorbachev and Elie Wiesel, who were
among the first to sign a petition voicing their solidarity with my situation,
and to Lech Walesa and Archbishop Desmond Tutu. Thank you to Shirin
Ebadi, Betty Williams and Adolfo Pérez Esquivel, who won the Nobel Peace
Prize for their own battles, and who continue to follow my story. To Rita
Levi Montalcini and Renato Dulbecco who, together with Dario Fo, used
their authority to intervene on my behalf when things got tough for me.
Thanks to Orhan Pamuk, who listened to me in Germany and said: "Here
is my wish, and I pray that you listen: live." To Wisława Szymborska and
Günter Grass, who stood up for me in Poland and Germany. To John M.
Coetzee, who signed a petition in my name, as did Elfriede Jelinek and José
Saramago. My thanks also to Salman Rushdie who, having been through a
similar situation, gave me advice on how to deal with everyday problems
when living under siege.

Thanks to Joe Pistone, a.k.a. Donnie Brasco, who allowed me to
become part of his experience, offered me his friendship and made sugges-
tions as to how to deal with asphyxiating loneliness.

Thanks to Claudio Abbado, who did me the great honour of dedicating
one of his concerts at San Carlo in Naples to me.

To Martin Scorsese, who defended me from the usual accusations of
having defamed my country.

To Fandango, who decided to produce the film of *Gomorrah* when the book had only just come out, and did so in such a way that won us the Grand Prix in Cannes and the David di Donatello.

To Mario Gelardi, Ivan Castiglione and all the actors who produced a stage version of my book and performed it all over Italy, making it one of the most well-attended plays of recent years.

To all those colleagues and figures in the cultural arena who took my story and words to heart, and who offered me their support in a variety of ways: Martin Amis, Paul Auster, Ingrid Betancourt, Junot Díaz, Umberto Eco, Nathan Englander, Hans Magnus Enzensberger, Jonathan Safran Foer, Jonathan Franzen, David Grossman, Siri Hustvedt, Tahar Ben Jelloun, Jonathan Lethem, Caro Llewelyn, Mario Vargas Llosa, Claudio Magris, Javier Marías, Colum McCann, Ian McEwan, Patrick McGrath, Suketu Mehta, Adam Michnik, Taslima Nasreen, Chuck Palahniuk, Francesco Rosi, Cathleen Schine, Peter Schneider and the Taviani brothers.

To the musicians who decided to dedicate their songs to me or to include me in their projects: Massive Attack, Subsonica, Fabri Fibra, Lucariello and 'A67.

To my country Italy, which has defended me, and in particular to our President, Giorgio Napolitano, who has shown me his sincere concern and support on more than one occasion.

To the *carabinieri* forces that protect me, to the lucid intelligence of General Gaetano Maruccia, who has been a significant reference point for me, and to the support and friendship of Colonel Ciro La Volla.

To Nando, Leo, Aristide, Francesco, Marco, Michele and Sebastiano,

who are by my side every day and who show courage, professionalism, affection and personal sacrifice without ever making me feel that I am a burden.

To the associations that have laboured on my behalf, to the people who have brought about spontaneous actions in my favour, to Alex Pecoraro and those on the web who have built a network of information and solidarity. To those who used social networking sites like Facebook and MySpace to create a network of support and to generate publicity.

To all those Italian cities that have offered me honorary citizenship – Rome, Turin, Bologna, Florence, Venice, Ancona, L'Aquila, Mantua, Montebelluna, Orvieto, Pisa, Reggio Emilia, Viterbo, to name but a few – showing that my problems were shared by the whole country, and allowing me still to feel at home in Italy.

Thanks to all those countries that have offered me hospitality: to Spain, my home for many months; to Sweden, which gave me asylum; to Germany, which showed its solidarity and friendship on many occasions; to President Shimon Peres, who offered me refuge in Israel; and to France, which offered me honorary citizenship of its capital. I acknowledge that I have received a great deal both from my own country and from the rest of the world.

Lastly, I thank my family; I hope they can forgive me for everything that they have had to go through because of me.

R.S.

Appendix I: Sources

Aside from the preface ("The Dangers of Reading") and "Brittle Bones" ("*Ossa di cristallo*"), all of the articles in this book have been previously published. The publications in which the original versions first appeared and the dates on which they first saw the light are listed below.

SOUTH

"Letter to My Land" as *Lettera alla mia terra*: La Repubblica, September 22, 2008.

"Miriam Makeba: The Anger of the Brotherhood" as *Miriam Makeba: la rabbia della fratellanza*: La Repubblica, November 11, 2008.

"From Scampia to Cannes" as *Da Scampia a Cannes*: L'espresso, July 18, 2008.

"Fighting Evil with Art" as *Combattere il male con l'arte*: La Repubblica, November 11, 2008

"Truth, Despite All Else, Exists" (*La verità, nonostante tutto, esiste*): introduction to a pamphlet accompanying the film adaptation of *Gomorrah*,

published in a reduced form with the title *Come sta la verità nel paese di Gomorra* in *La Repubblica*, July 27, 2007.

"When Earth Shudders Cement Kills" as *Quando la terra trema, il cemento uccide*: *La Repubblica*, April 14, 2009.

MEN

"Playing it All" as *Giocarsi tutto*: *La Repubblica*, February 15, 2008.

"Tatanka Skatenato": *L'Espresso*, July 31, 2008.

"The Man that was Donnie Brasco" as *L'uomo che era Donnie Brasco*: *L'Espresso*, July 31, 2008.

"Siani, a True Journalist" as *Siani, cronista vero*: *Il Manifesto*, June 11, 2004.

"The Lighthouse Keeper" as *Il guardino del faro*: *L'Espresso*, November 9, 2007.

"In the Name of the Law and the Daughter" (*Nel nome legge e della figlia*): began as a joint publication in *El País* (February 11, 2009, with the title *Pidan perdón a Beppino Englaro*) and *La Repubblica* (February 12, 2009, with the title *Chiedete scusa a Beppino Englaro*, and June 23, 2009, with the title *La rivoluzione di un padre*).

"Felicia": Nazione Indiana (www.nazioneindiana.com), December 8, 2004.

BUSINESS

"The Magnificent Merchandise" as *La magnifica merce*: *L'Espresso*, March 8, 2007.

"Constructing, Conquering" as *Costruire, conquistare*: *La Repubblica*, July 6, 2007.

"The Plague and Gold" as *La peste e l'oro*: *La Repubblica*, June 5, 2008.

WAR

"Vollmann Syndrome" as *Sindeom Vollmann*: *L'Espresso*, November 14, 2007.

"Apocalypse Vietnam": *L'Espresso*, May 31, 2008.

"Today Is Yours Forever" as *Questo giorno sarà vostro per sempre*: *L'Espresso*, March 26, 2007.

NORTH

"The Ghosts of Nobel" as *I fantasmi dei Nobel*: *La Repubblica*, December 14, 2008.

"Speech at the Swedish Academy": a speech performed during an evening at the Swedish Academy dedicated to Salman Rushdie and Roberto Saviano on November 25, 2008.

"The Demon and Life" as *Il demone e la vita*: *Pulp* no. 58, November/December 2005.

"The Infinite Conjecture" as *L'infinita congettura*: Nazione Indiana (www.nazioneindiana.com), February 27, 2004.

"Never Again in a World Apart" as *Mai più in un mondo a parte*: *Pulp* no. 48, March/April 2004 and Nazione Indiana (www.nazioneindiana.com), June 3, 2004.

"He Who Writes Dies" as *Chi scrive, muore*: introduction to *Cecenia. Il disonore russo* by Anna Politkovskaya, Fandango Libri, Roma, 2009.

Appendix II: Glossary

page 5 CARABINIERI: Originally part of the armed forces, the *Carabinieri* are police charged with both civil and military duties.

page 10 CAMORRA: One of the oldest and most powerful criminal organizations in Italy, originating from the Campania region and its capital, Naples.

page 16 GIOVANNI FALCONE: Palermo-born prosecuting magistrate who spent his working life trying to bring the Mafia to justice, culminating in the *Maxiprocesso* ("Maxi Trial") in Sicily in the mid-1980s, which saw hundreds of defendants convicted. He was assassinated in May 1992 when a bomb was placed under the *autostrada* between Palermo International Airport and the city of Palermo and detonated when his cavalcade passed. Falcone, his wife and three bodyguards were killed in a blast so powerful it registered on local earthquake monitors.

page 21 DIREZIONE INVESTIGATIVA ANTIMAFIA: An office of the Department of Public Security of the Ministry of the Interior. Formed in December 1991 to curtail Mafia activity, it brings together the units of the *Carabinieri*, the *Polizia di Stato* and the *Guardia di Finanza*.

page 27 DANILO DOLCI: (1927–97.) A social activist, sociologist and poet
who campaigned forcefully against poverty and the Mafia's strangle-
hold on Sicily. He was awarded the Lenin Peace Prize in 1958 and
became a cult figure for Northern European and American youth, who
were moved by his searing accounts of the desperate conditions of the
Sicilian countryside.

page 31 'NDRANGHETA: Criminal organization from Calabria in the far
south of Italy, which became the most powerful crime syndicate in the
country in the late 1990s and early 2000s.

page 55 TANGENTOPOLI: A term – often translated into English as
"bribesville" – coined by the famous journalist Piero Colaprico of *La
Repubblica* to describe the endemic corruption in the Italian political
system revealed by the *Mani pulite* ("clean hands") investigations, which
ran for four years from February 1992. The wave of scandals led to the
disappearance of many political parties, and a number of politicians and
industry leaders committed suicide when their corruption was exposed.

page 110 BONNANO: One of the "Five Families", the Italian-American
crime families that dominated organized crime in New York from the
1930s onwards. In the wake of the Donnie Brasco infiltration, they
were the first family to be forced from the Commission – a council of
Mafia bosses formed in 1931 by Charles "Lucky" Luciano.

page 130 THE RED BRIGADES: The *Brigate Rosse* were a Marxist-Leninist
paramilitary group who were responsible for a number of political assas-
sinations during "The Years of Lead". Their aims were to create a
revolutionary state and have Italy withdraw from N.A.T.O., and their
boldest move saw them kidnap and subsequently murder the former
Christian Democrat leader, Aldo Moro.

page 130 CHE LA TERRA TI SIA LIEVE: May the earth lie light on you.

page 133 COUNT UGOLINO: A thirteenth-century nobleman who partici-
pated in the struggles between Ghibelline (imperial) and Guelph (papal)
factions, and in the conflict between Genoa and his home city of Pisa.
In 1288 he was locked up in the *Torre del Muda* ("Tower of Hunger")
with his sons and grandsons, where he starved to death the following
year. Dante, in the account of Ugolino's death in his Divine Comedy,
has the Count's sons begging him to eat their flesh to sustain himself;
eventually Ugolino's hunger overwhelms his grief. In 2001, a forensic
investigation of the remains found in the tower concluded that Ugolino
was the first to die, and could not have eaten the younger men.

page 144 F.A.R.C.: *Fuerzas Armadas Revolucionarias de Colombia*
("Revolutionary Armed Forces of Colombia") is a Marxist-Leninist
revolutionary organization based in Colombia, which is heavily in-
volved in the ongoing Colombian Armed Conflict.

page 144 ÁLVARO URIBE: 39th President of Colombia from 2002 to 2010.
He was succeeded by his former Minister of National Defence, Juan
Manuel Santos Calderón, despite strong opposition from the
Colombian Green Party led by Antanas Mockus.

page 172 FORZA ITALIA: Political party led by Silvio Berlusconi, four-times
President of Italy. It was founded in 1993 and won its first election in
May 1994. In 2008 it was absorbed into *Il Popolo della Libertà* ("The
People of Freedom"), Berlusconi's later political venture.